A World of Decent Dreams
VIETNAM IMAGES

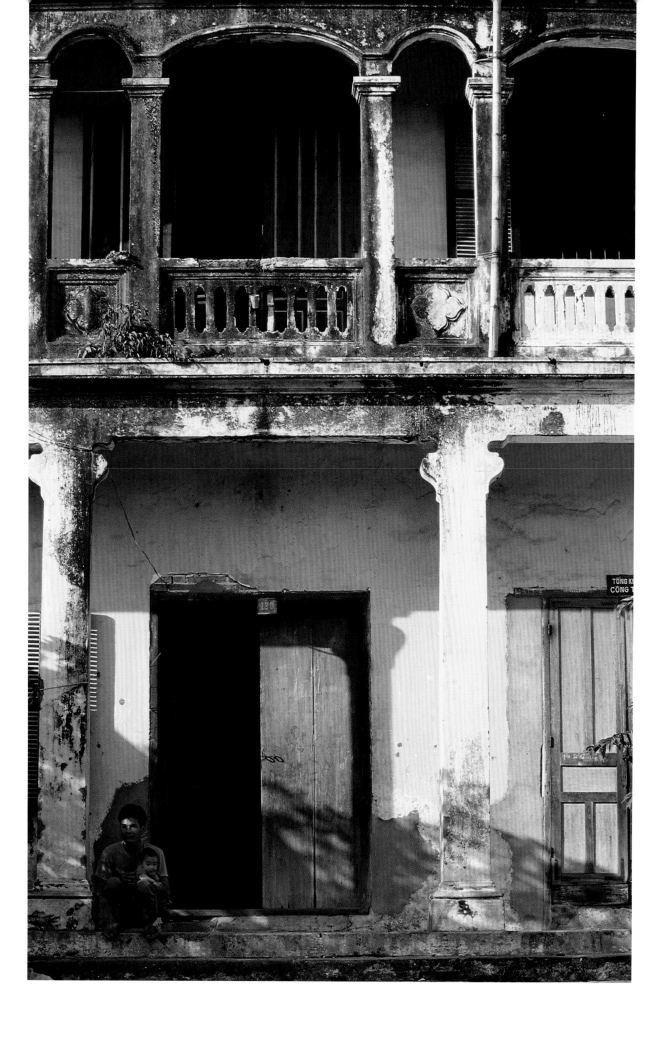

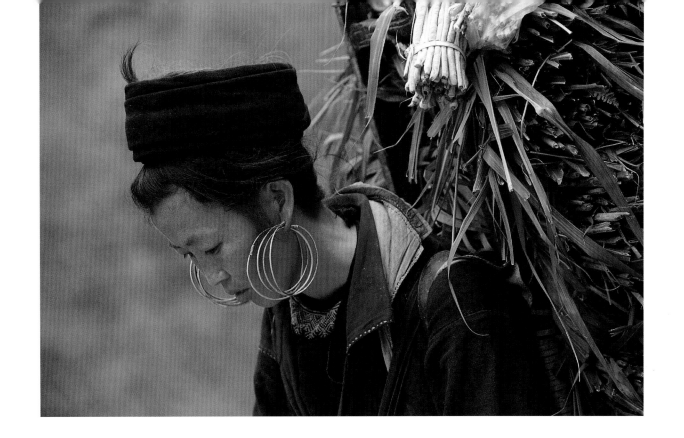

A World of Decent Dreams
VIETNAM IMAGES

PHOTOGRAPHS BY ELLEN KAPLOWITZ

TEXT BY JEFFREY HANTOVER

FOREWORD BY BERNARD KALB

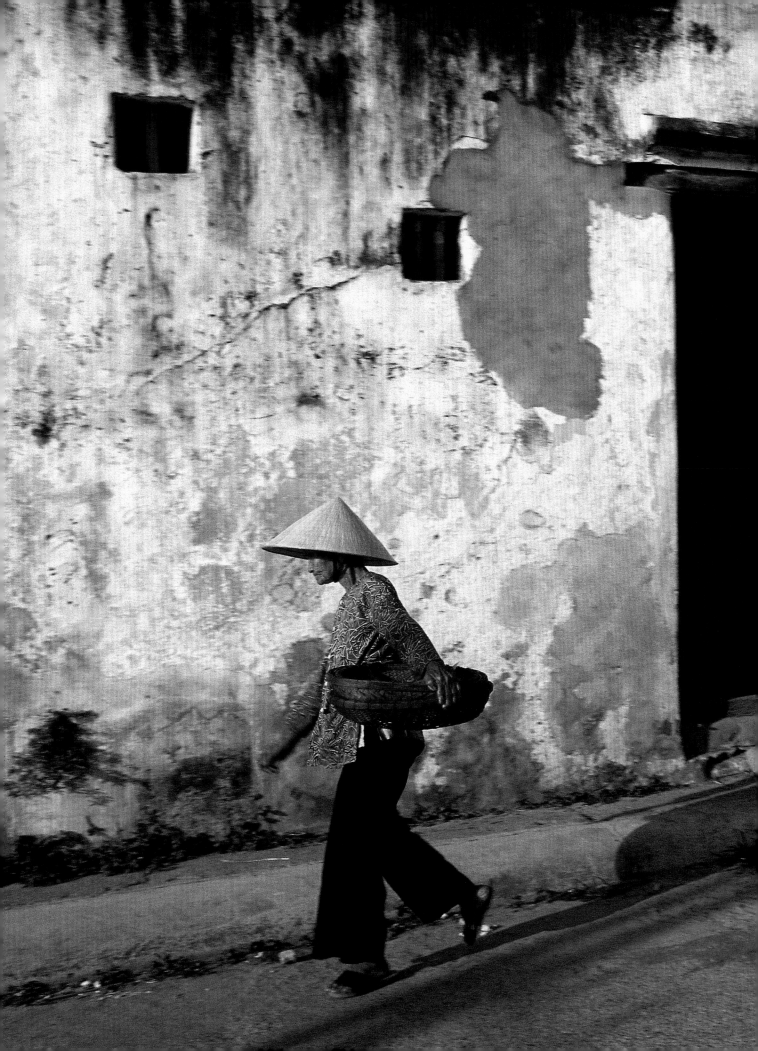

First edition, 2003

Published by Weatherhill, Inc.,
41 Monroe Turnpike,
Trumbull, CT 06611.

Printed in China.

07 06 05 04 03
5 4 3 2 1

ISBN 0-8348-0528-6

Library of Congress Cataloging-in-
Publication data available

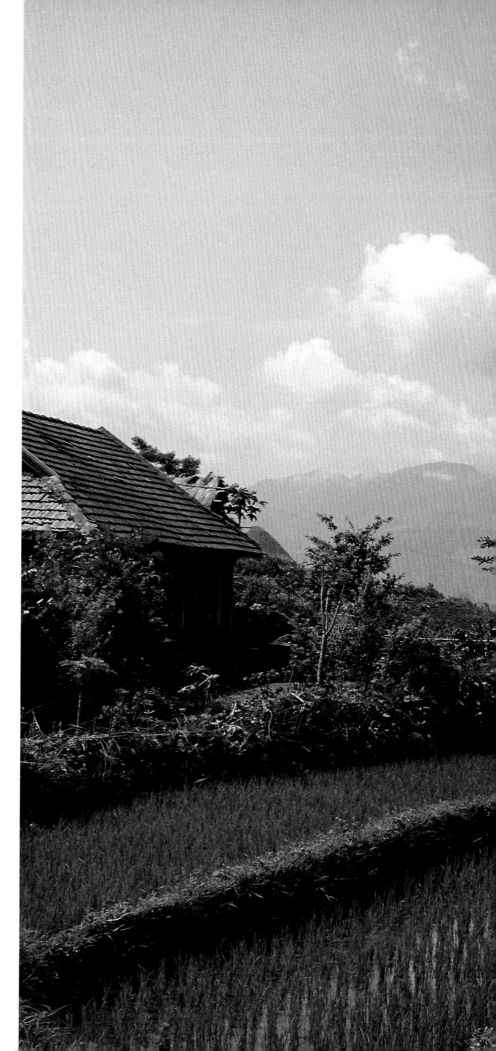

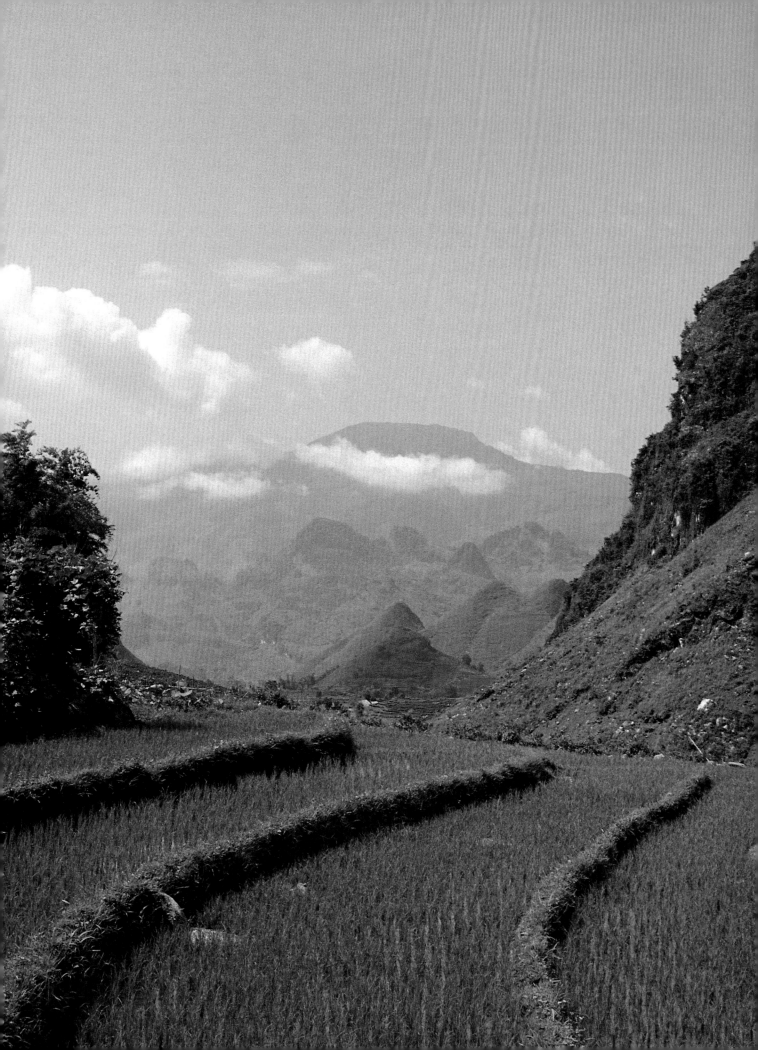

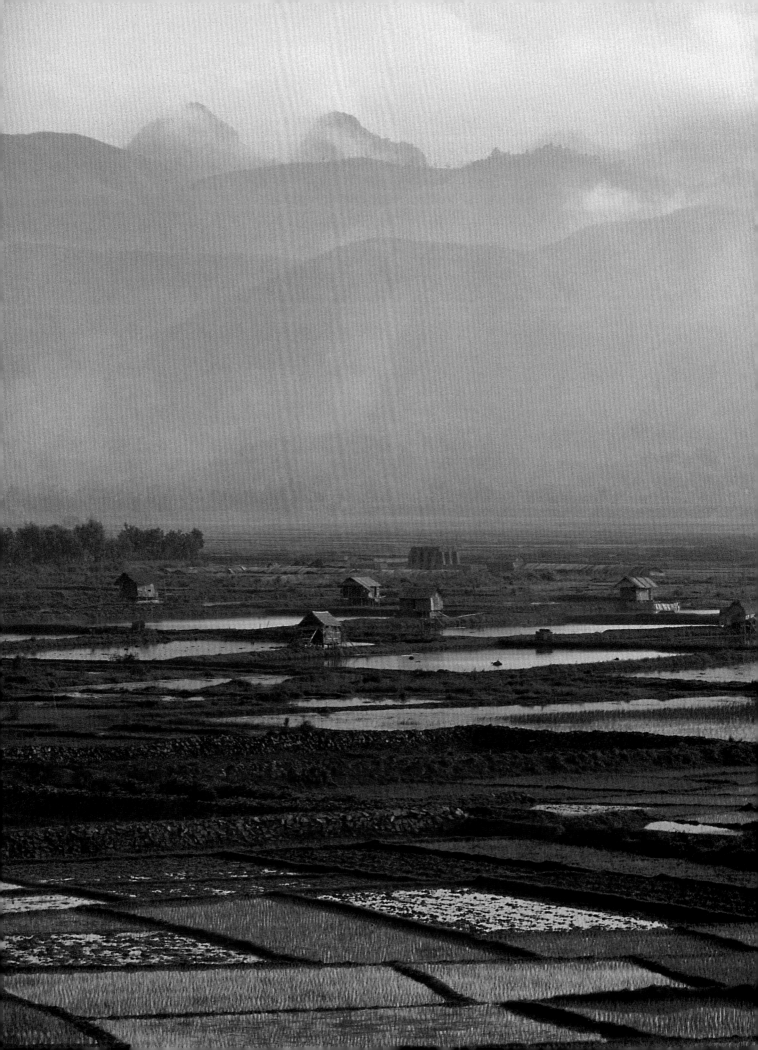

Contents

FOREWORD

It still comes as a surprise—my life being filled with so many Vietnams, a half century's worth, so that I often find myself wandering in and out of decades, remembering my earliest Saigon in 1956, my first Hanoi in 2000, the years in between—how a country can scratch its way into you and never let go. War can do that. So can war's end. So can the exhilaration, the opportunity, of peace. But mostly it is those friendships that suddenly erupt in the midst of the killing—those first Vietnamese you met all those years ago and have never lost touch with, still exchanging phone calls about our children and our lives since, and a need to know the Vietnamese on the other side of the 17th parallel, the ones you'd not been able to meet during the war. Links to the past, links to the future, personal, national. Even now, on seeing a map of Asia, my eye rushes to that corner that once was a blank spot in my mind—America's too—only to become a bloody scar memorialized on the Mall in Washington.

Astonishing, isn't it? Vietnam, about which we once knew nothing, crashing the party so to speak, ending up as a memorial—right there with monuments to Washington and Lincoln and Jefferson and FDR, all within sight of each other, on the most hallowed few acres in America. But the US involvement was geopolitical, South Viet Nam seen as a strategic anti-Communist symbol that must not be lost to America's Cold War adversaries; mine was that of a reporter, close-up, on the ground, trying to learn as much as possible as fast as possible, sharing *nuoc mam* with Viet Nam. And these superb photographs by Ellen Kaplowitz and knowledgeable text by Jeffrey Hantover have rekindled memories of some of my own encounters with a country now forever linked to American history.

I'm looking at a slightly battered press credential—" Mr. Kalb Bernard" and "New York Times" typed on it—with a ribbon of scarlet and gold, the national colors of the old Saigon regime; it's dated "26-10-1956." That got me past the police lines that day, and I witnessed the inauguration of the US-supported Ngo Dinh Diem as

President of South Viet Nam. I had no idea I was also witnessing the inauguration of America's ultimate defeat in Viet Nam.

Year after year, through the late sixties when "quagmire" began hitting the headlines and Washington nervously rushed in troops by the thousands, I'd fly down to Saigon from my base in Hong Kong to catch up on what had changed since my last visit a month earlier; and there were always changes, always more deadly—militarily, politically, in terms of morale. The only winner was the war; it was conquering the country. South Viet Nam itself seemed to be missing in action, and reporters hitched chopper rides to the boonies to drop in on the war and see what happened that day before hitching another ride back to Saigon in plenty of time for dinner at Givral or Bodard or any of the other popular bistros, always wondering what it must be like on the other side.

It's only been since the end of the war, on April 30, 1975, that we've been able to visit a Vietnam reunified. Flying into Hanoi and wandering around town on that first visit of mine had more than a touch of the surreal. No open hostility. Hardly anything about the US role in the war. Instead, "Hello, America!" *This*, Hanoi? I'd read about the friendly welcomes to foreigners but here I was, face to face with Communist Viet Nam. Yet if the Vietnamese I met were thinking future tense, I found that I couldn't completely shake off old war images; suddenly the past seized the present, and the street scene in front of me, of lunchtime men and women, transformed for an instant into a rice paddy with black-pajama guerrillas firing AK-47s. Now, a quarter of a century after the shooting stopped, those old memories were fighting against the easy hellos of Hanoi.

The Vietnamese I now encounter on visits to Vietnam—again in 2001 and 2002—are eager to join the drama of the twenty-first century, although one young Vietnamese told me his family still sets a bowl of rice on the dinner table for an uncle who never came home from the war, and I saw school kids bussed to the Army Museum to view, among other of Vietnam's war trophies, the wreckage of downed US warplanes. Even so, what is ahead—the future—is where the passion is.

Ho Chi Minh City—my old Saigon—is a dynamo of commercial energy; Hanoi is more patrician, does things less frenetically. Both are flooded with youth, eager to make up for lost decades. The most obvious symbol of economic progress is in the streets: automobiles replacing motorbikes replacing pedal bikes—but millions and millions of Vietnamese still depend upon biking to get around; it's as though Vietnam were a civilization on two wheels. University students are furiously studying English even though dissent in any language is not exactly encouraged. The speed of modernization is in the powerful hands of the Politburo and, while the skyline of the two big cities has leapt off the ground with scattered new construction, it's still decades too early to say *au revoir* to the nostalgic charm of Hanoi's Old Quarter. The countryside is where most of the Vietnamese live—in hamlets, villages, and small cities, on a per-capita income of about a dollar a day—and it too is changing, but slowly, very slowly.

That is where Ellen Kaplowitz turns her camera loose; she visits not only the big cities but also those out of the way places that have never even turned up on a map of the country. The closest these images get to the year of the calendar on your wall is the inclusion of some *motor*bikes, a glimpse of *neon*, a bridal *gown*; otherwise you're back in Viet Nam of a century ago, even earlier. Locked in time, remote, not worth a mention in the guide books, these places, caught unposed, impromptu, by Ellen's evocative lens give us Vietnam's everyday face: country and people, rice fields and mountains, crowds and close-ups. These photographs say this is the way it was before; this is the way it is now. Vietnam *sans guerre:* the war an interruption. Jeffrey's text is a pleasure, at once historical and immediate, so that centuries of Vietnam spill out of these pages. The resulting book is altogether a sophisticated overview of the Vietnamese—their history, culture, even their "dreams." Photographs and text reinforce each other; suddenly, Vietnam is in your hands, not half a world away.

—Bernard Kalb

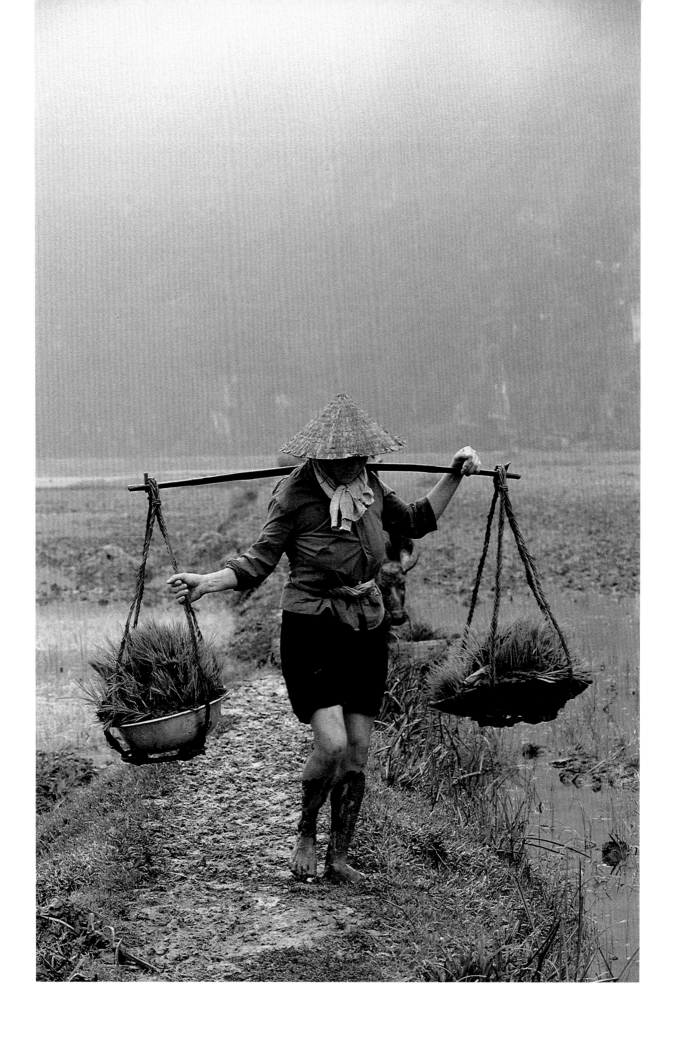

PREFACE

It is 5:15 p.m. and I am riding from the Hanoi airport to the city. Velvet green everywhere. The sun is a ball of fire reflected in the water of rice fields. Farmers swing pails of water; boys play soccer. Chickens in bamboo cages cluck on the back of motorbikes. Girls riding bicycles wear *ao dais*, hats and long gloves, handkerchiefs cover all but their eyes. Gravestones stand in the paddies. A Coca-Cola truck lumbers in front of me. Kumquat trees on the back of motorbikes are a sign of Tet, the Vietnamese New Year. 5:25 p.m. The sun is very close to the horizon; it's so beautiful. I remember past trips here. Nothing changes. Everything changes.

Yet there is a constant factor of life in Vietnam that winds through the rivers, grows in the rice paddies, and blows in the high mountain winds. It is what has given structure, strength, and longevity to this country and culture. It is perhaps best expressed in *Paradise of the Blind* by Duong Thu Huong:

> *There are always those who are conscientious and loving,*
> *who worship what they do. Devotion like this is impossible*
> *to explain. No matter, for it was this love that assured the*
> *survival of an entire way of life.*

Vietnam is a place of beauty. Photographing there is to experience this in many ways. It goes beyond the visual. I hope through this book others will share what I have been fortunate to see, feel, and taste. Maybe then, the word Vietnam will not automatically be associated in Western minds with the word war.

There are many people I would like to thank not only for making this book a reality, but for being supportive and appreciative of my work. They have encouraged me to try and reach my potential both in photography and in life. This book would not have come to fruition without Ray Furse, editorial director of Weatherhill, Inc., who believed in my work and shared my vision. Jeffrey Hantover, author of the text, understood from the beginning my feelings for

Vietnam. His selection of poetry and prose spans eight hundred years and yet relates cogently to present day images, truly reflecting the spirit of a country that has survived for centuries because its roots are in the land, family, and community. I was thrilled that Liz Trovato was the designer of this book. Not only is her sense of color and design extraordinary, but her efforts to combine images with text in order to give the truest sense of Vietnam were exceptional. Bernard Kalb, a journalist known throughout the world for his writings during and after the Vietnam War, agreed to write the foreword. As someone who has experienced all the many stages of Vietnam's current history, he brings depth and importance to this book.

Thanks also to Heather Peters and David Feingold for taking me on my first trip to Vietnam; Laurel Kendall, Ann Fitzgerald, and Maron Waxman of the American Museum of Natural History, for including me in their Vietnam exhibition and encouraging me to do this book; Fredo Binh for creating my adventure in northern Vietnam; Suzanne Lecht, for sharing her love of Vietnam, Josh Levine, editor of the *Vietnam Business Journal*, for choosing my images; Ray Carbone, for exhibiting my work and telling me where to get the best *op thuoc bac*; my Vietnam friends, Trinh Xuan Dao, Do Dong Hai, and Pat Rafael, for the motorbike rides and great restaurants; Judy and Carl Schlosberg, for their constant support; Cynthia Rosenfeld, for her generosity; Kylie Wright, Pedro Ceballos, and Esteban Mauchi of Laumont Lab for the most beautiful prints; Mahmud Rounak of Midtown Lab; Stephen McGuinness, for introducing me to Jeff; my brother David for walking a seven-year-old Ellen to the American Museum of Natural History; David Kaplowitz, for being an honest critic and my best friend. Daniel Kaplowitz, your memory is part of my spirit because you taught me to seek the adventurous possibilities in life by freeing myself from the known. And a special thanks to the people of Vietnam, who allowed me as a stranger to walk into their homes and lives.

INTRODUCTION

The extraordinariness of the ordinary: for a people who have lived under the heavy cloak of "History" for centuries, to live in an ordinary country in ordinary times is a blessing. To call Ellen Kaplowitz's photographs "images of the ordinary" is a relief for a people anxious to live in the present and high praise for a photographer not compelled to impose her narrative on their lives. Vietnam has fought for a thousand years the imposition of the narratives of others.

Of course it is naïve to think any country can live outside its own history. As James Baldwin has written, we carry our history within us: "history is literally present in all that we do." The demographic, ecological, and economic consequences of Vietnam's recent history is there to be seen: circular paddy fields made from bomb craters, rusted monuments of downed American fighter jets, Amerasians hawking tourist T-shirts in the center of Ho Chi Minh City, Zippo lighters (real and fake) embossed with the Marine insignia and etched with a soldier's name for sale in the antique stores on Dong Khoi Street. Images of the "American War" are there to confirm the expected, especially for many Americans for whom Vietnam and war are synonymous.

The unexpected that Vietnam offers is not the transcendent beauty of monument—no Great Wall, no Angkor, or even grand vistas—but the celebration of the ordinary. Perhaps the future to which the youth of Vietnam are speeding toward in this book's final image will break down the shared pleasures of the ordinary. But for now, it is the pleasures of lives lived among family and community, on the unchanging land and in the changing social landscape, that arrest the eye and all the senses of a visitor.

When these images of contemporary Vietnam are accented by poetry and prose stretching back eight hundred years, we enter a strange time warp where dates don't matter, where the past is the continuous present. A poet musing on a fifteenth-century landscape could be composing on a laptop computer. It is not that the country

has and is not changing. A walk through the center of Ho Chi Minh City on Sunday night, the flash of neon, the guttural growl of motorcycles would disabuse even the most blinkered visitor of the changes the country is undergoing. But there is an essence beneath the change, a cultural DNA that exists, out of which comes a present related to but not a clone of the past. A love of place, a love of "mountain and stream" that is Vietnam, is not a recent nostalgia fueled by late twentieth-century urbanization. And peace is not a recent dream: Nguyen Binh Khiem wrote in the sixteenth century:

The rich eat three full meals, the poor two small bowls,
But peace is what matters.

Ho Xuan Huong, the nineteenth-century poet of witty wordplay and veiled and not-so-veiled eroticism, "drunk with rivers and hills," her backpack, "breathing moonlight" and sagging with poems called her readers to:

Look, and love everyone.
Whoever sees this landscape is stunned.

She was right: those who look with open eyes ready to love will be stunned by the simple beauty of the ordinary.

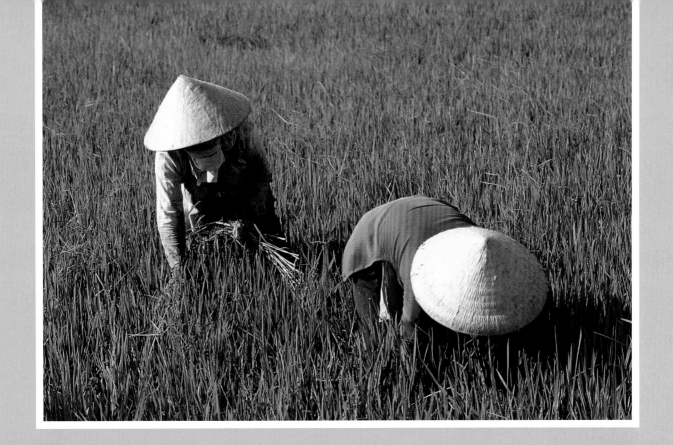

"A life at one with nature, flowing on
as slowly months and years or seasons flow,
a clean plain world of toil with decent dreams."

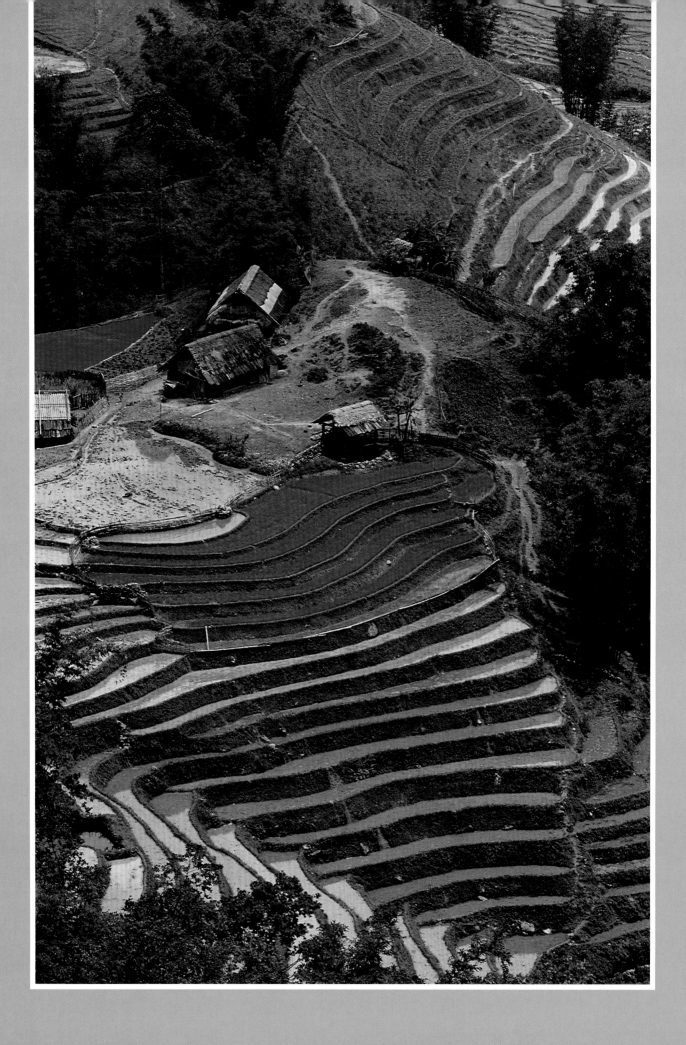

I

A CLEAN, PLAIN WORLD OF TOIL

You can immerse yourself in numbers—metric tons, square miles, percentages rise and fall. You can let dates and facts be your compass. But unless you attend to the more elusive and impressionistic, the poems and proverbs, the fleeting images, the object or person in the corner of the frame, you can't know Vietnam. You can't know Vietnam unless you leave Hanoi and Ho Chi Minh City and head to where three quarters of the people live—to the heart, and soul, of the country—the village.

Iconic images announce Vietnam as clear as the Eiffel Tower and the sidewalk cafe announces Paris: women in conical hats bent knee-deep in rice paddies or walking along muddy dikes with baskets slung on poles across their shoulders, filled with clumps of green rice shoots ready to transplant, or a young boy sitting atop a glistening water buffalo. The village in the Red River Delta in the North or the Mekong Delta in the South, "a clean, plain world of toil with decent dreams / nursed in the shadow of those tall bamboos," is not a fading object of urban nostalgia. Its images are familiar to us because Vietnam remains, despite increased urbanization fueled by economic reform, a predominantly rural country. For the present the village continues to provide the vast majority of the population a necessary sense of community and a social anchor in a changing world.

The economy may be diversifying and agricultural production declining as a percentage of the country's gross national product, but in the countryside rice remains king. Almost two-thirds of the cultivated land in Vietnam is devoted to rice, and in a major survey done a decade ago, seventy percent of all households grew at least some rice. *Doi moi* ("renovation," the shift from a planned to mixed market economy) in the countryside ended the exclusive powers of cooperatives, allocated land to individual peasant households and by acknowledging "long-

lasting existence and positive effects of individual and private economy" put individual households on an equal footing with state and collective agricultural units. Full-scale family farming led to an explosion of productive energy. In 1989, one year after the famous government decree (Resolution 10, "Renovation in Agricultural Management") the country produced three million more metric tons than the year before the change. Vietnam became and remains the third largest exporter of rice in the world behind the U.S. and Thailand, and, importantly for future development, rice production is outpacing population growth.

Yet the village is much more than a demographic fact of Vietnamese life and rice production more than a source of national economic pride and a foreign income earner. The village is a cultural fact, the dominant social and cultural unit that has shaped the country's character. More than rice is grown in the almost seven million acres of the Red River and Mekong deltas: the personality of a people has and is nurtured in these paddy fields.

From a prison cell in 1942 Ho Chi Minh rhapsodized about the peasants midway through the autumn harvest:

> *Everywhere peasants' faces wear smiles of gladness,*
> *And the rice fields resound with songs of happiness.*
>
> —FROM "COUNTRY SCENE"

From jail any life outside looks good, but rice is a demanding master. Seeing the paddies of Vietnam in the mid-1920s spoiled one American travel writer's taste for rice. In *New Journeys in Old Asia*, Helen Churchill Candee (an adventurous survivor of the Titanic) found rice a "tyrant water-plant" that demanded "those who raise it become amphibious, if not altogether aquatic." Rice required "an incessant attention which is only appropriate to loved relatives in times of illness." The folk poem, "A Farmer's Calendar" (see p. 20) echoes in more detail the demanding work of the Vietnamese peasant: attending to three crops a year, bent over in muddy water, transplanting approximately 1600 bundles of seedlings per hectare weighing over four tons, moving quickly to give the young plants a head start over the weeds—picturesque only from a distance.

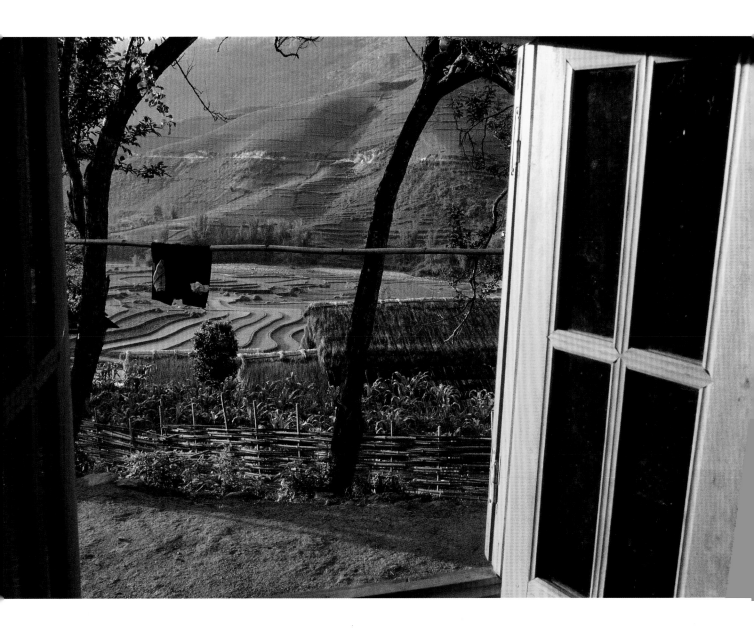

To the wood seeking shelter a bird flies, forlorn.
Leisurely a lone cloud floats across the expanse of heaven.
In yonder mountain hamlet a girl is grinding corn.
The grain ground, a hot fire glows red in the oven.

—"DUSK." HO CHI MINH, 1890–1969

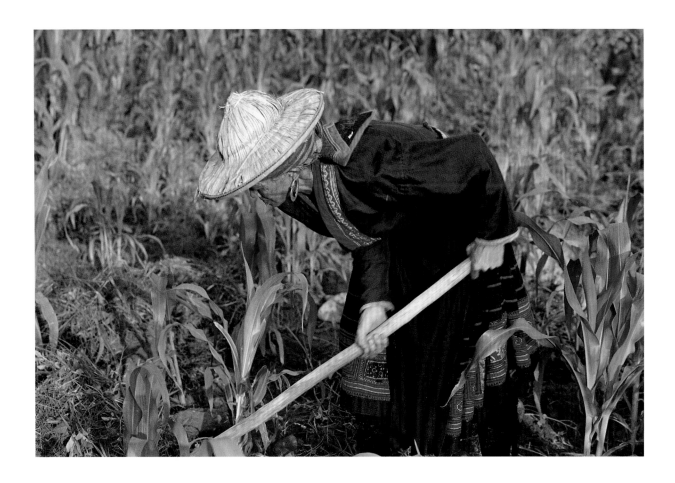

Screened by bamboos, the village did not stir,
yet something brewed and smoldered, live, inside.
It had the farmers' simple thatch-roofed huts;
it had those people who'd brave rain and sun,
all forces quiet but persistent, tough,
those buffalo, shy and gentle, also fierce,
a life at one with nature, flowing on
as slowly months and years or seasons flow,
a clean, plain world of toil with decent dreams
nursed in the shadow of those tall bamboos,
with joys from caring for the green rice shoots
while gladly feet trampled mud and hands touched soil.

—FROM *The Bamboo Hedgerow*. NAM XUYEN, 1909–

The demands of the seasons forged a bond between villagers and between them and the land, and from that bond grew a sense of national identity. The novelist Duong Thu Huong (see p.*) captures this almost instinctual, primeval oneness with the land and the forces of nature. The villagers could at Tet, she writes, plunge their hands into the mud to "sense the earth's cooling or warming" and in the summer "listen to the way the wind whistled through their straw roofs to divine what calamities or blessings heaven had in store for them."

While the Vietnamese family stretches across time, the family's identity is tied to the land and that means not just their fields, their vegetable garden, their bamboo grove and fruit trees but the village in its common physical being, its history and its gods. You still can see among the rice fields the graves of ancestors buried in the land they too worked. There is in Vietnam a sacral bond between the living and the dead and between the living and the land. (In a land dispute between two villages in April, 2002, one village dug up the graves on the area in question—a symbolic severing of the other's claim). When starting and completing a new house, the Vietnamese made offerings to their ancestors and to the God of the Soil. At completion, roasted rice mixed with water was sprinkled at the four corners of the house so that the earth could "heal its scars."

Identities are most often shaped in contrast if not conflict with others—us v. them. In Vietnam "them" has been the forces of nature and man. The traditional Vietnamese village was not a classless Eden and we shouldn't downplay its social differentiation, its divisions of class, age, and gender. But keeping the forces of nature at bay and repelling the foreign forces of man bound the villagers in common enterprise. Building and maintaining the dikes and irrigation systems protected common fields, pagoda and *dinh* (village communal house) shared by all as well as individual plots. The gates of the village and the guards who manned them at night protected all. Marriage custom protected the village's integrity as it was "Better to marry your villager, who might be lowly like a dog, than a person of high social status, who is from outside your village." The communal calendar was dense with celebrations at the *dinh* to propitiate

and honor the village's tutelary god: every other week celebrations were held to mark the anniversaries of certain natural phenomena, phases in rice growing, fictive events in the biography of the deity, movements of the moon, plus holidays to celebrate the seasons and honor the dead. Communal land, "fields of deity" were set aside to support all of the community's ritual feasts and offerings.

There is the tendency to see the history of a nation through the prism of its urban centers and the seat of its political power. Not so in the Vietnam, where the center of economic and cultural activity was the village, not the cities or royal court. From the ninth to the nineteenth century, Vietnam engaged in minimal foreign trade: there was only one port for foreign traders and the royal administration was the sole financial beneficiary of the trade. Until the twentieth century, no Vietnamese was allowed to go to neighboring countries to trade. Without foreign trade, a class of urban traders did not develop, nor did cities become economic markets but remained administrative and military centers. Again, not to downplay class divisions in the traditional Vietnamese village, but there did not exist in Vietnam either a large landowning class (as in the colonial Americas) or a large merchant class engaged in foreign trade.

Vietnam was an agricultural country where rich and poor earned their living from agricultural activities supplemented by handicrafts and small-scale domestic trade. Vietnamese peasant families have and continue to carry out sideline activities between the rice seasons; more so in the past than today peasant families were self-sufficient, making baskets, soya bean sauce, shrimp paste, and rice alcohol for their own use and to earn money. Certain villages became famous for certain skills, such as Dong Ho for papermaking, Dai Bai for bronze work, and others for ceramics, mats, copperware, or stone carving.

In the mythic tale of Giong the boy warrior who saved the country from General Stone-Spirit and his soldiers, the boy demands the King build him an iron horse with a living heart. In other countries, the King would have drafted iron masters from the palace forges, but in Vietnam the masters of the craft are summoned from the villages. Handicrafts were specialized by village and women forbidden from

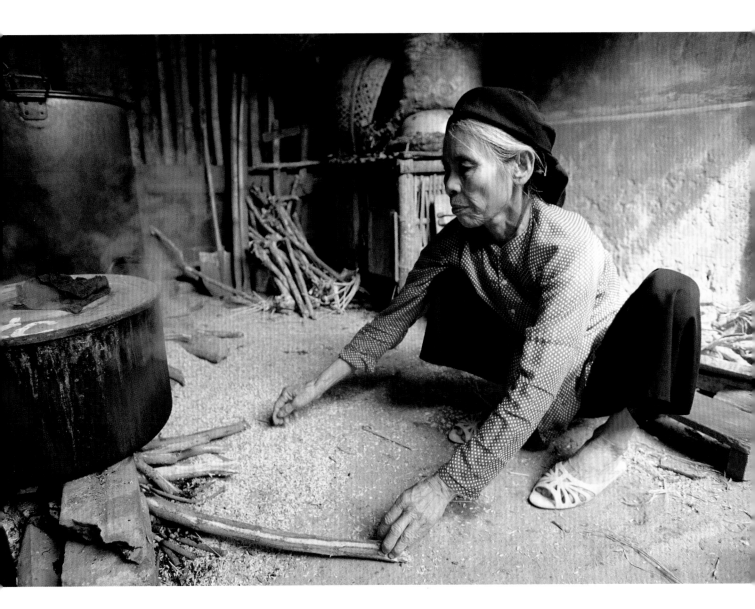

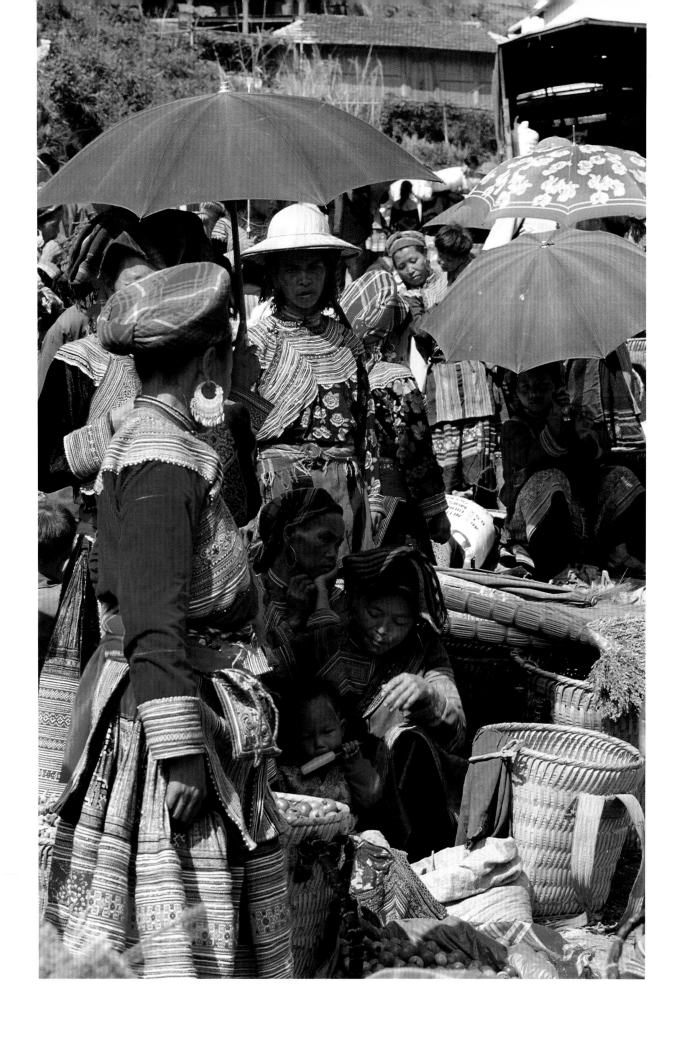

marrying outside the village lest the mysteries of the trade were comprised and the village's monopoly lost. But handicrafts were not separate from agriculture: they were family crafts village-based. The division of labor took place within the family and not on a larger organized scale in the village; households engaged in handicrafts still had their own kitchen garden and fishpond. They too clung to the peasant dream of self-sufficiency—"A brick house, jackfruit trees, a paved courtyard, a fish pond, and a kitchen-garden." Secondary activities while providing subsistence for individual families retarded the development of an organized handicraft industry and in turn an independent class of traders.

If the economy was a village economy, so too was Vietnamese culture a village culture, in which contributions of village-based scholars of peasant stock trumped the achievements of the royal court. Literati from the villages remained as school teachers rather than going to urban academies and cutting themselves off from the peasants. In the village, they executed calligraphy to commemorate births and deaths for their fellow villagers. The finest extant artwork from the pre-colonial period comes from anonymous artisans for pagoda, temple, and *dinh* and not from the court at the royal capital of Hue.

Two sides of the proverbial Vietnamese coin—"The Laws of the Emperor are less than the customs of the village" and "It is better to be the head of a chicken than the tail of an elephant"—spoke to the world as it was. Social, cultural and political power and prestige lay within the village and it was better to stay there as mandarin, literati, or respected elder of a well-to-do lineage.

The village's cultural power as home to respected values and artistic images may have been strengthened rather than weakened by the wars against the French and the Americans. The teachers and students of Hanoi's Ecole des Beaux Arts evacuated the city to join the Viet Minh in the mountainous northern provinces of the Viet Bac. Here peasants were their artistic models and comrades in arms. They held exhibitions among the stilts of mountain houses, in underground bunkers and in village *dinh* where troops were billeted. They

saw, in the words of one artist, "our ancestors' artistic legacy" and carried back these images and aesthetics with them as they navigated the political minefields on the road to artistic Modernism. In the "American War," more than just artists evacuated for safety to the countryside as the population of Hanoi dropped from around a million to less than 200,000. The urbanities from Hanoi and Haiphong experienced first hand both the privations and the communal pleasures of the village.

Village women bent over in work—in the rice paddies, in the stern of a boat, under the weight of kindling, rice seedlings, and produce for the market. Ellen Kaplowitz had no feminist agenda: she shot what she saw and what she saw was a "clean plain world of toil," where toil bears heavier on the shoulders of women than men. Yet the realities of peasant life temper the Confucian patriarchal polarities of king and subject, father and son, and husband and wife, and give to women power and place philosophy denies.

"Man plows, wife transplants, and buffalo harrows." But a wife does more than the folk saying's allocation of labor. She tends the vegetable garden, does all the household chores, and carries out almost all of the secondary economic activities that bring cash to the family; survey data found rural men at the end of the twentieth century did two-thirds the amount of work that women did. What social science reveals today can be heard from the past in the poet's voice and the anonymous songs of the people. Ho Xuan Huong with sly humor piles up the maternal, sexual, and domestic demands, the "Rushing around all helter-skelter" that made up the condition of the early nineteenth-century woman. Her complaints were echoed pointedly by the words of a folk song directed at a lazy husband: "You dress in your best gowns and loaf around / While I have to soak in sweat working in the paddy." The man had the help of the water buffalo but women alone bore the arduous work of transplantation because of its supposed affinity to childbearing.

In "Testing the Confucian Ideal" (see p. 60) the wife is saved just before the boat. It is difficult imagining even the most chauvinist American husband saving the President (whatever his political

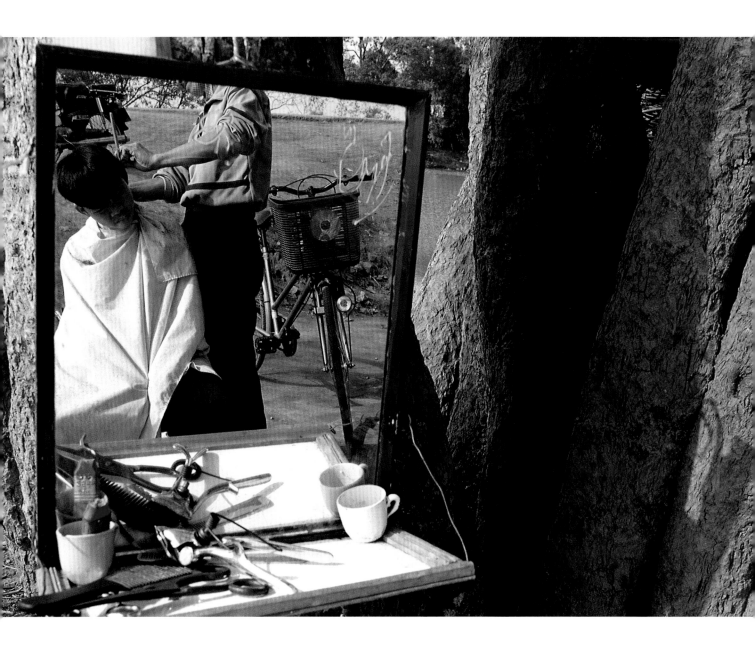

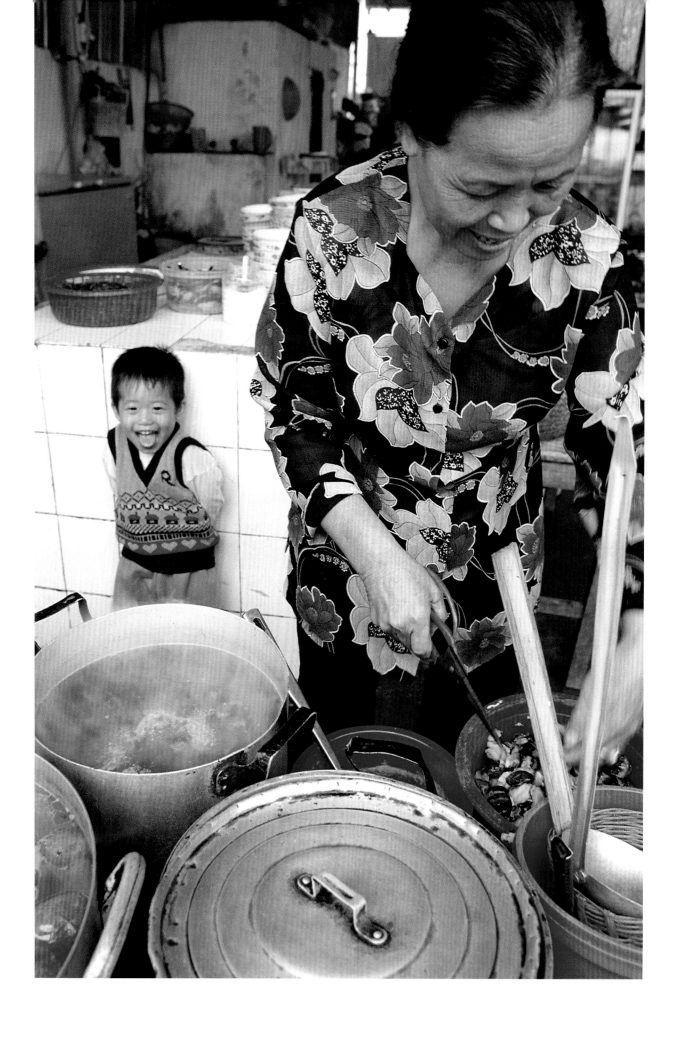

party) and even his parents over his wife, whom at least he choose (his parents he only inherited). While the proverb "However wise a woman is, she is still a woman; however foolish a man is, he is a man" announces a public truth about deference and gender relations in the ideal philosophical realm, the world of real relations and feelings paints a more intimate and equitable picture.

A visitor to Ben Thanh market in Ho Chi Minh City or Dong Ba market at Hue will see women traders on their haunches counting out wads of *dong* thick as dictionaries. Few men are there buying and selling. Again, a folk saying gets at a social truth: "Three women and a duck make a market." In rural areas, especially in the North, small trade lay in the hands of women. Women brought cash to the families and with it a voice in the running of the domestic economy. Husbands called their wives "General of the Interior," for it is they who "held the key to the cash box" and decided the allocation of rice within the family. Men could see, especially among the poorer peasants, the invaluable role their wives played in wet rice cultivation—without a water buffalo, women and children pulled the hoe—as well as the extra money they brought in.

Cooperation and dependence bred intimacy under the veil of Confucian patriarchy. Because it runs against the grain of Confucian pronouncement, there is something even more touching about the expression of companionship in some folk poems:

> *In plenty or in want, there will still be you and me,*
> *always the two us.*
> *Isn't that better than always prospering alone?*
>
> —FROM "A FARMER'S CALENDAR"

And to say "Husband and wife know their bodies' smell" is to observe a truth beyond the senses about two persons wed by parental arrangement but brought together by the common struggle to survive.

Survival marks the life of the peasant woman, the village, and the very nation. The character of all three, especially as perceived by the Vietnamese themselves, is no better and more movingly embodied

than by Kieu, the heroine of the long, early nineteenth-century narrative poem by Nguyen Du, *The Tale of Kieu.* Taught in schools, parts learned rote by almost every Vietnamese, Kieu has in the words of one translator a "pervasive popularity, little short of adulatory worship, among both scholars and illiterates and in all spheres of life". Du's poem, based on a Qing dynasty prose novel about historical figures from sixteenth-century Ming China, is, as one scholar writes, a preeminent example of the Vietnamese ability to absorb "Chinese learning so completely that its Chinese origins became irrelevant."

Kieu, her Chinese origins left behind, became the embodiment of the Vietnamese woman and the nation itself. A chaste daughter, who sacrifices herself to save her imprisoned father, she undergoes years of trial and despoliation: the "scholar" to whom she sells herself as concubine turns out to be a pimp who sells her to a brothel. She is a betrayed by a scoundrel, enslaved by the jealous wife of a weak-willed lover, and suffers the death of a powerful protector and lover before being finally united with the lover of her youth. But like the lotus in a pond, "Always near mud, it never smells of mud", Kieu though soiled is not muddied, her soul remains pure.

Kieu endures the depredations of nature, man, and fate—like the people who have embraced her, like the life and traditions of the village that have sustained them.

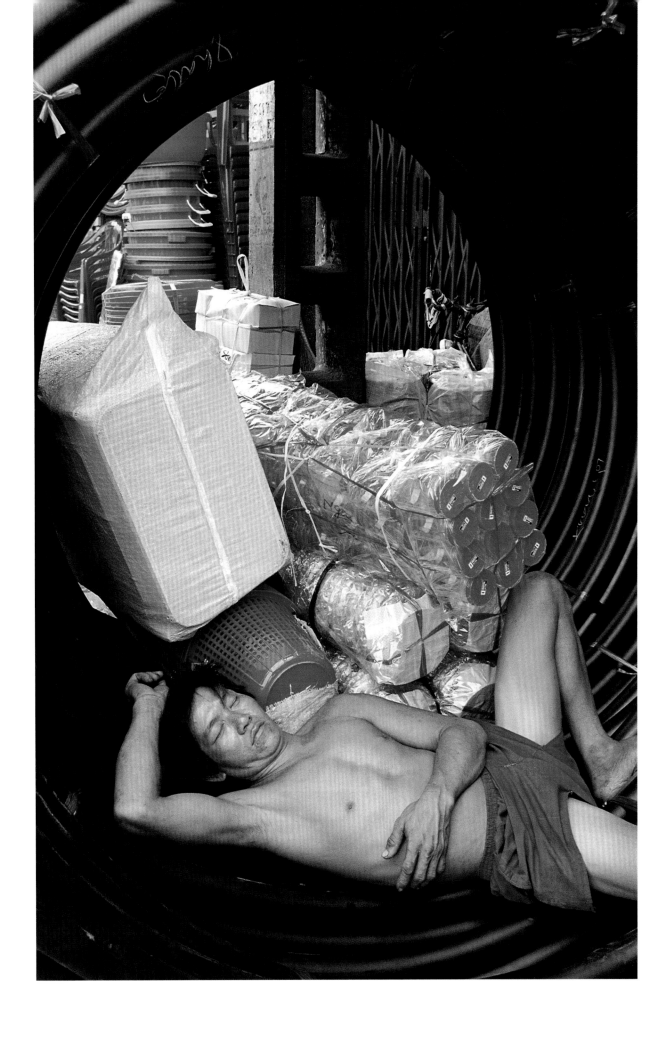

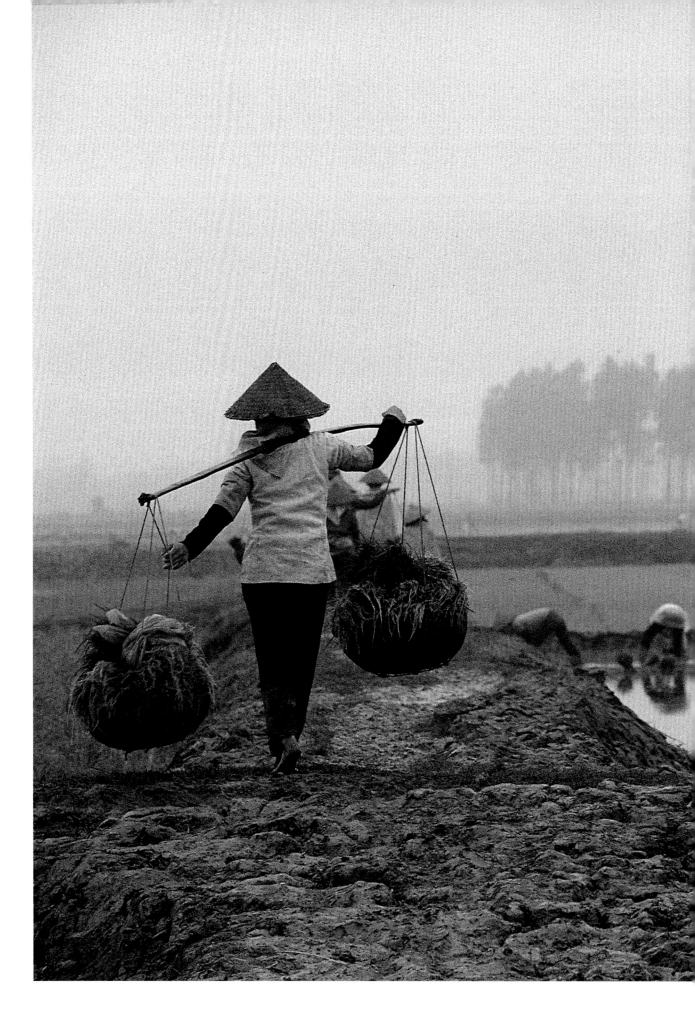

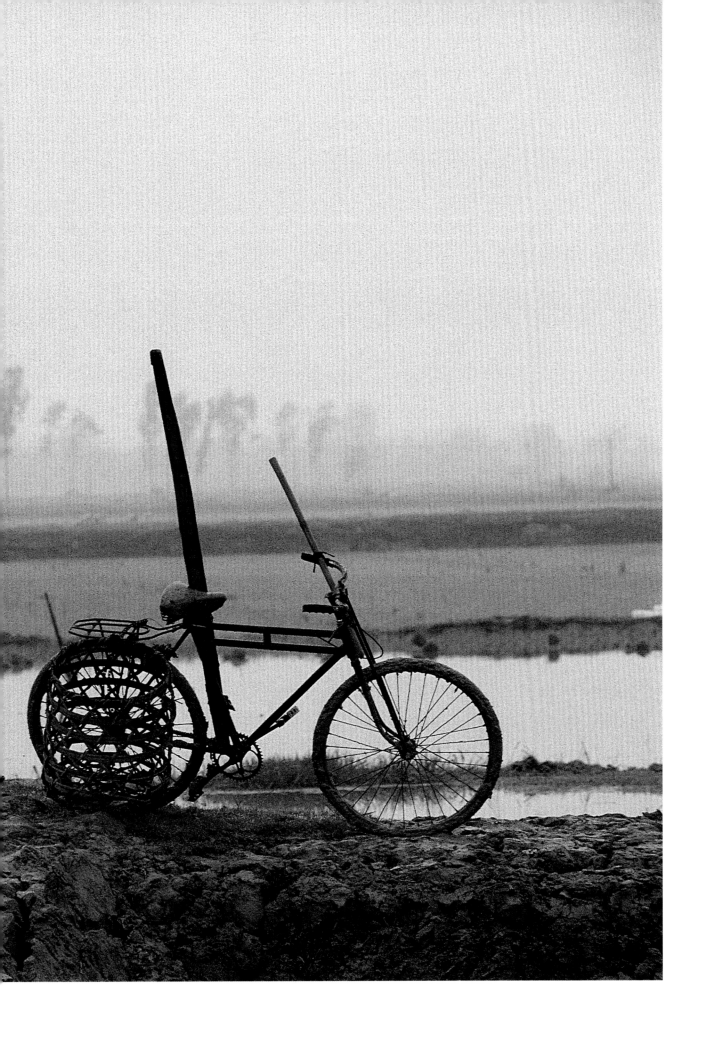

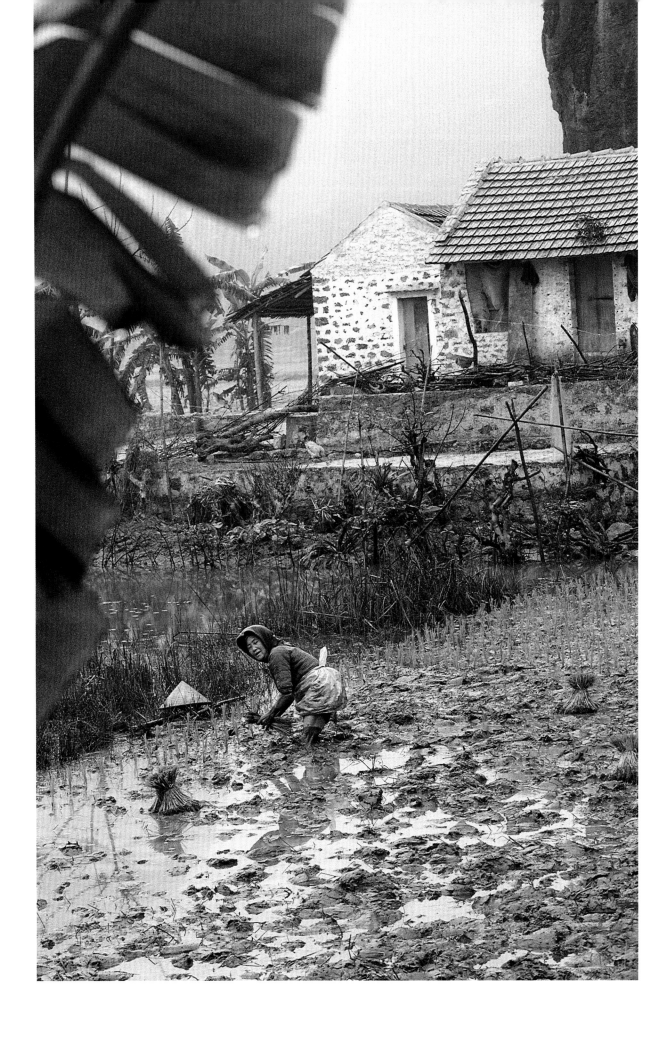

On clear August nights, the rhythm of pestles pounding young rice rose from every courtyard in every village. The shrill jeer of women's laughter was enough to shatter these millions of white flowers. As the intoxicating fragrance of cactus floated over the gardens, the villagers studied the moon: What did it mean, this red halo, this silvery sparkle of clouds biting into the intense blue of the sky? In winter, in the deep chill of the night, they could wake in an instant, tear themselves from the warmth of their beds, and run to the cowshed to light a fire or drag a bushel of straw to the buffalo. There are always those who are conscientious and loving, who worship what they do. Devotion like this is impossible to explain. No matter, for it was this love that assured the survival of an entire way of life.

—FROM *Paradise of the Blind.* DUONG THU HUONG, 1947–

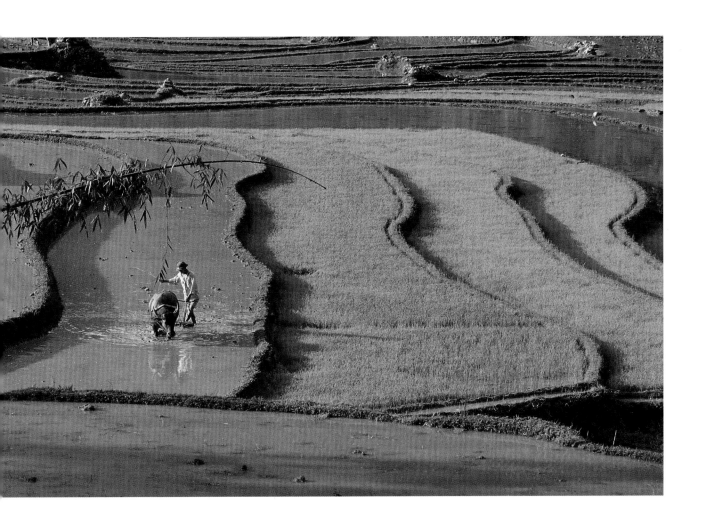

The twelfth moon for potato growing,
the first for beans, the second for eggplant.
In the third, we break the land
to plant rice in the fourth while the rains are strong.
The man ploughs, the woman plants,
and in the fifth: the harvest and the goods are good —
an acre yields five full baskets this year.
I grind and pound the paddy, strew husks to cover the manure,
and feed the hogs with bran.
Next year, if the land is extravagant,
I shall pay the taxes for you.
In plenty or in want, there will still be you and me,
and the two of us.
Isn't that better than always prospering, alone?

—"A Farmer's Calendar," folk poem

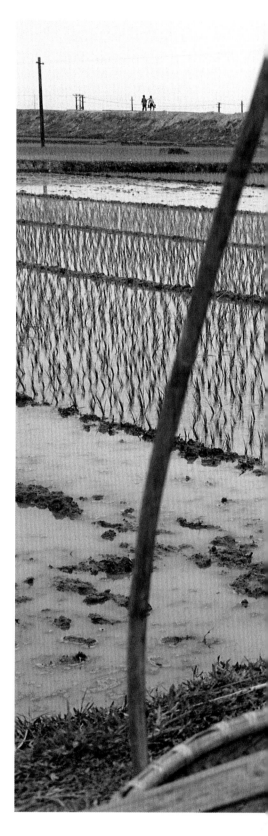

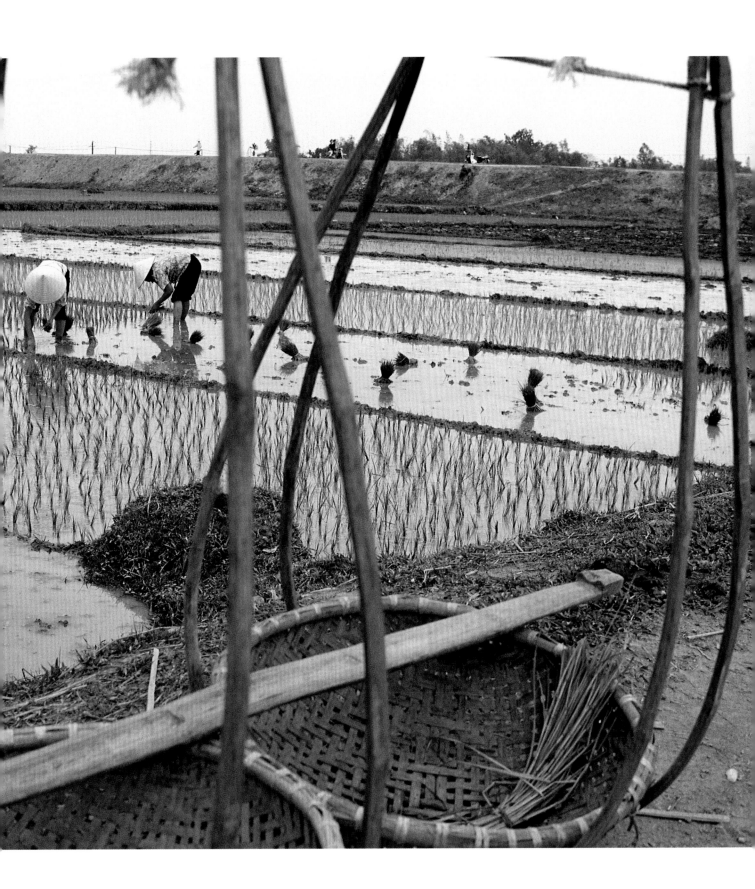

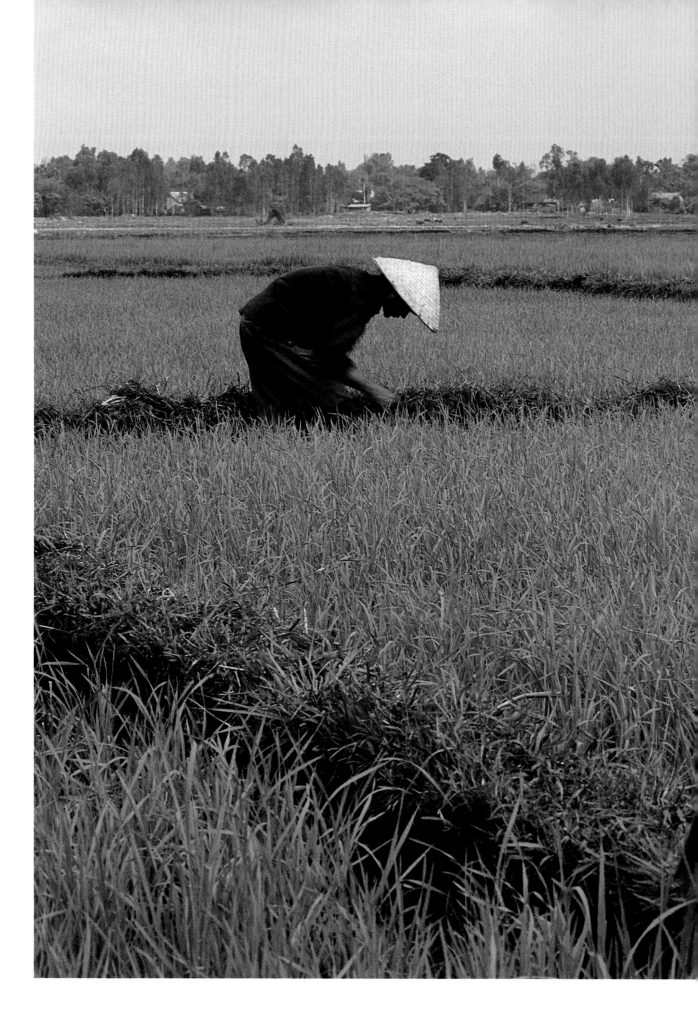

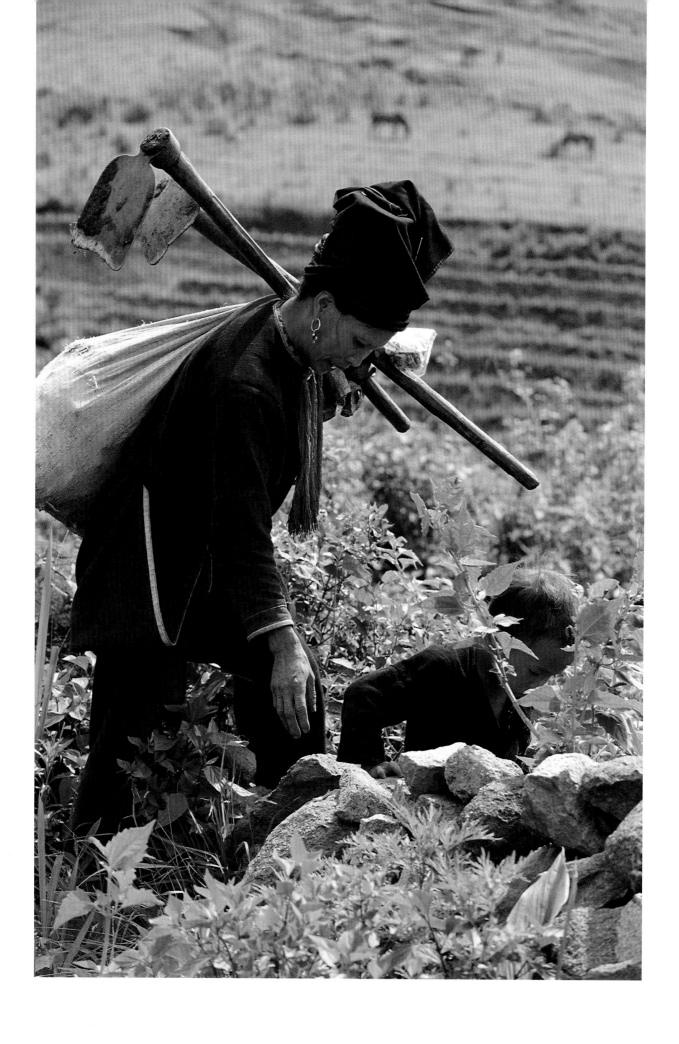

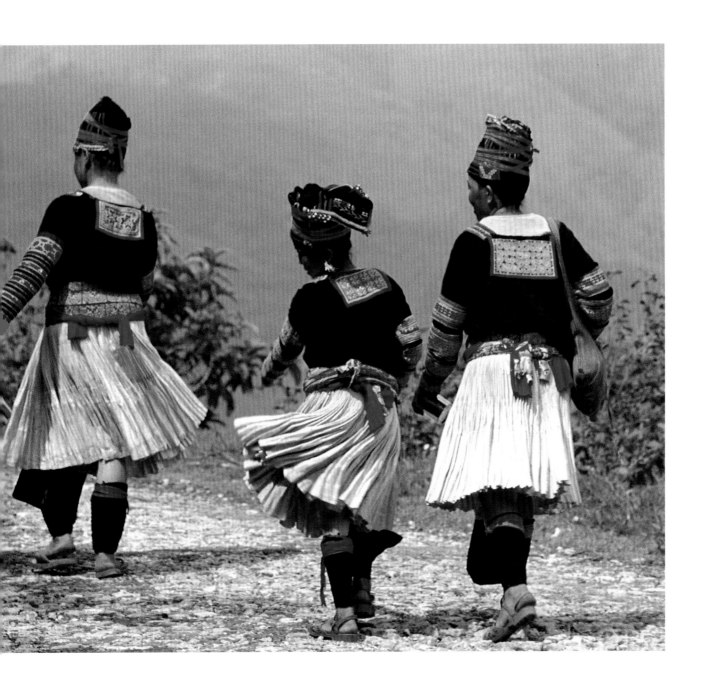

I will choose a place where the snakes feel safe.
All day I will love that remote country.
At times I will climb the peak of its lonely mountain
to stay and whistle until the sky grows cold.

— "THE IDEAL RETREAT." KHONG LO, D. 1119

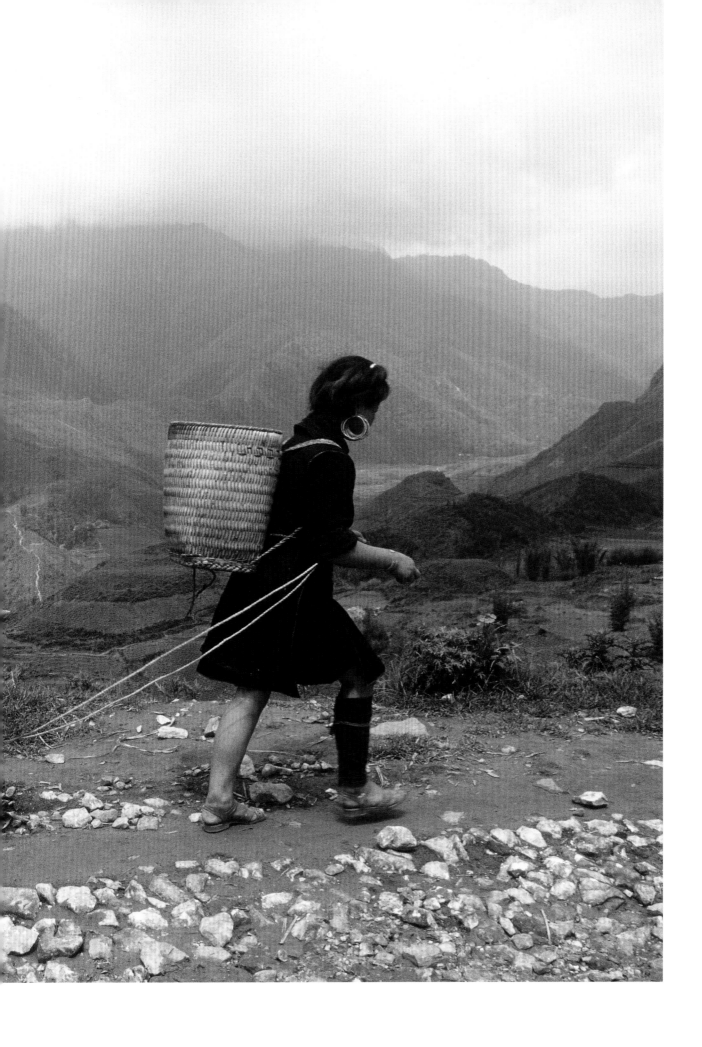

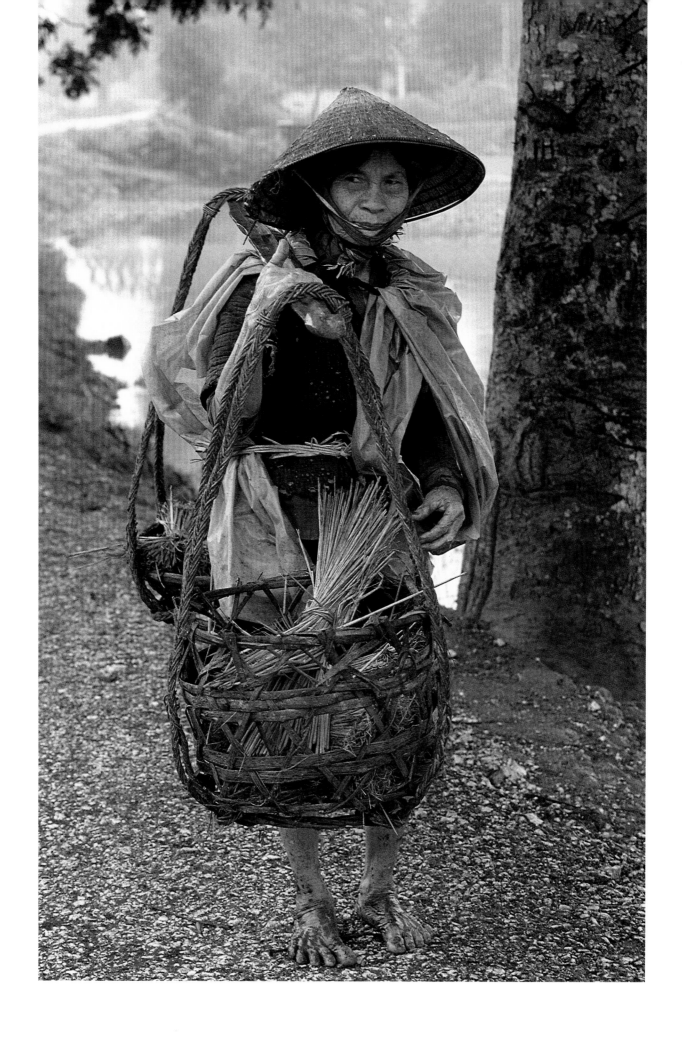

I share the happiness of village folks
when they bring in good crops, their cares and woes
when harvests fail. I even feel the thrills
of country boys and girls at their love trysts.

So gloom and tedium haunt my life no more—
in my poor village, well content, I stay.
With rapture I absorb through all my pores
aromas exhaled from the fields, the earth.

—FROM "THE COUNTRY ROAD." TE HANH, 1921–

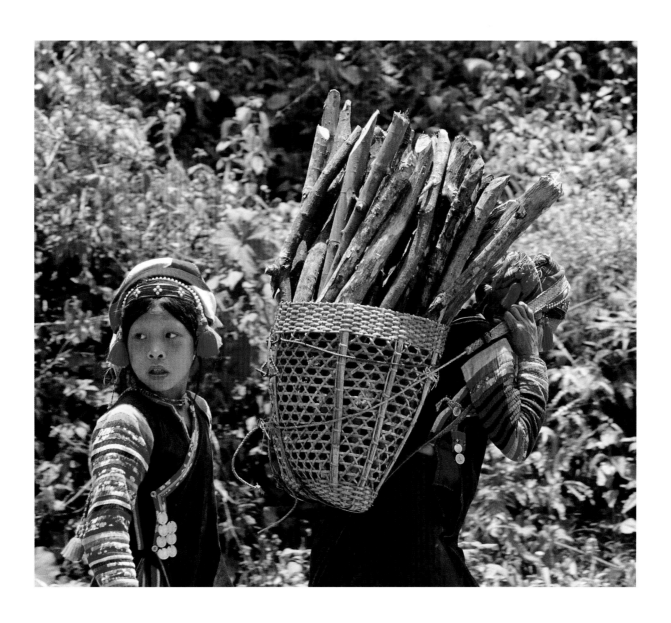

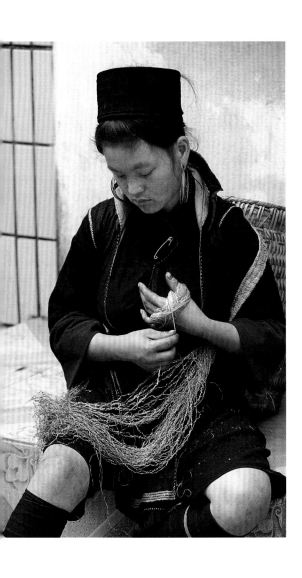
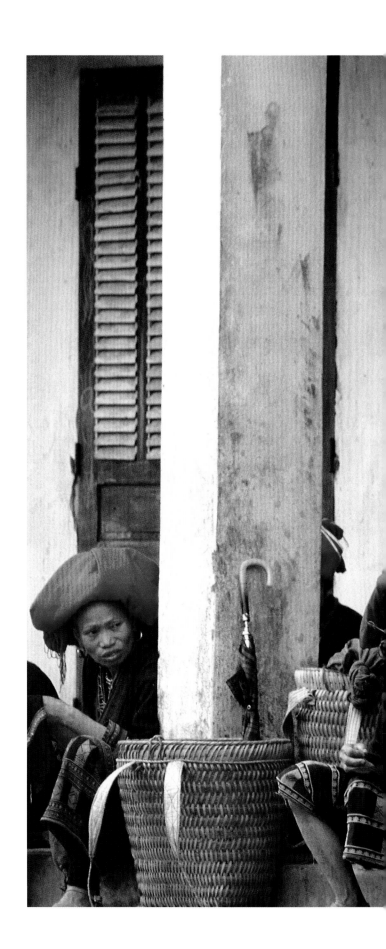

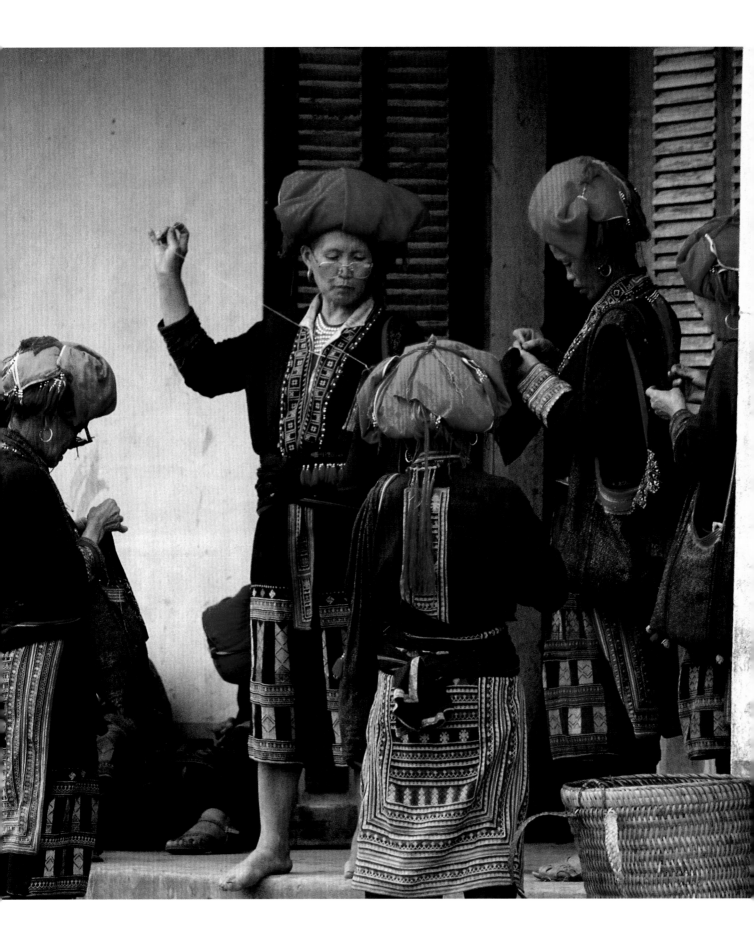

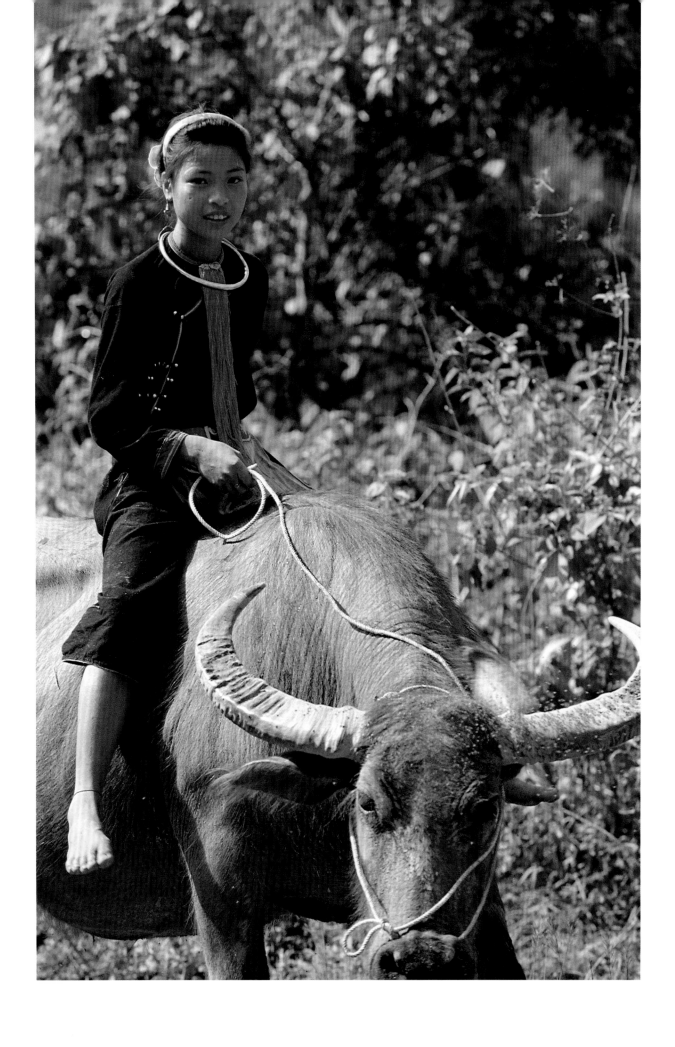

The sun is setting – clouds still glow with red.
Storks in white flocks fly over far-off fields.
A whistle-kite plays music with the wind
while sings a lass who picks mulberry leaves.

In the rice field, stalks sag with golden ears –
young lads in joyous teams all reap the grain.
Meanwhile, an old man under his cone hat
sits smoking, puff by puff, at the far end.

Along the dike wave wind-borne tufts of hair:
small children, busy chasing after kites,
leave buffalo in peace there on the grass –
eyes dream and gaze at ripples of the breeze.

— "Harvesting at sunset." Anh Tho, 1919–

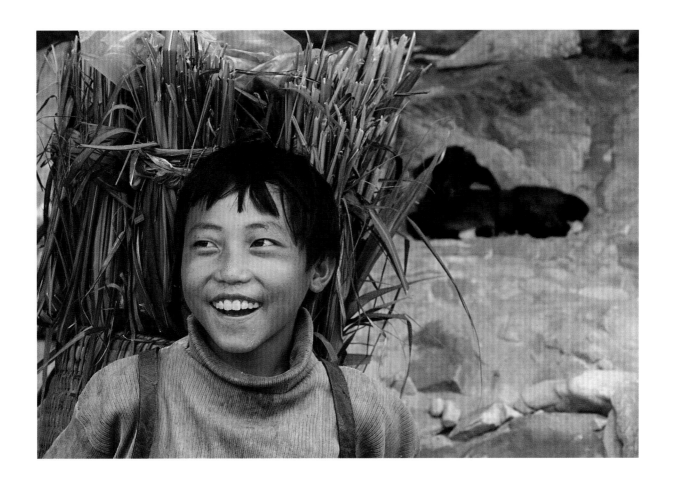

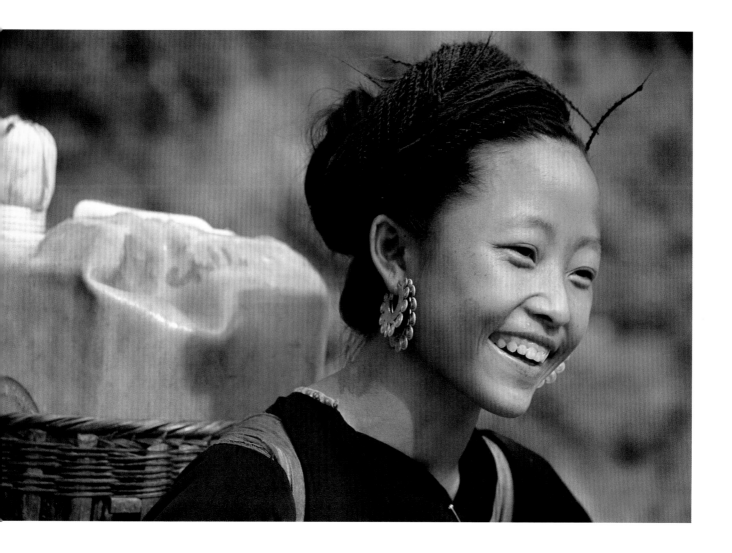

House of bamboo, eaves with plum trees—days pass
Vain tattle flees the world of mists and clouds.
A bit of rice to eat with salt and greens,
Some clothes to wear, but no brocade or silk.
The pond's kept limpid—mirror for the moon,
The soil's plowed open—seeding bed of flowers.
When chilly night inspires the fitting mood,
You sing aloud some magic lines of song.

—"HOUSE OF BAMBOO, EAVES WITH PLUM TREES—DAYS PASS."
NGUYEN TRAI, 1380–1442

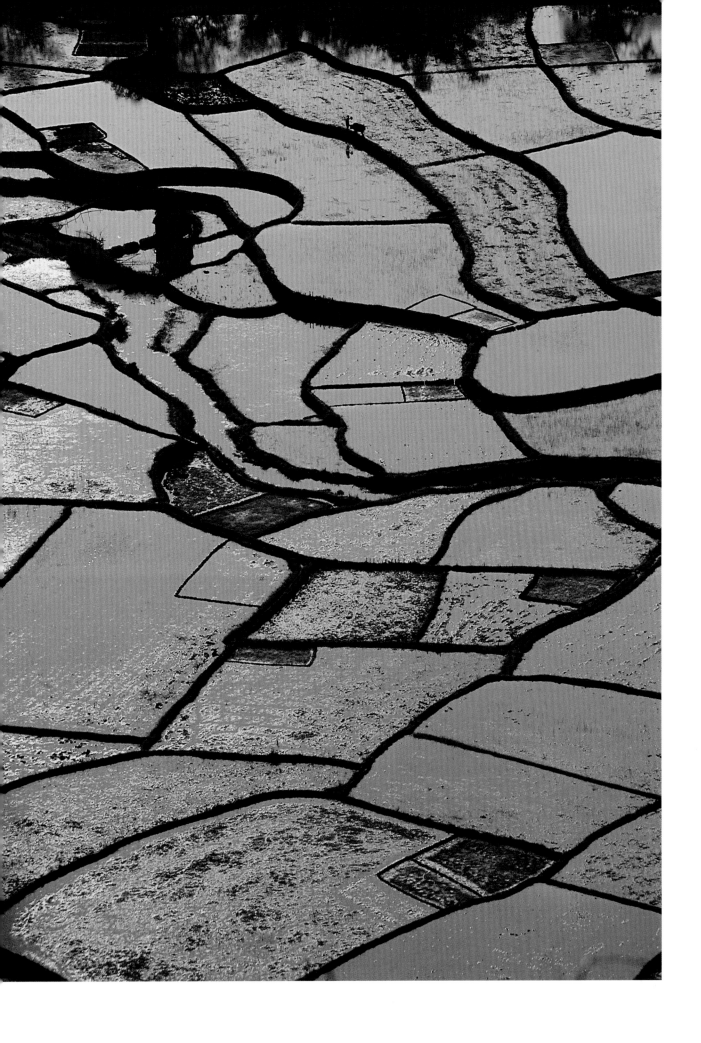

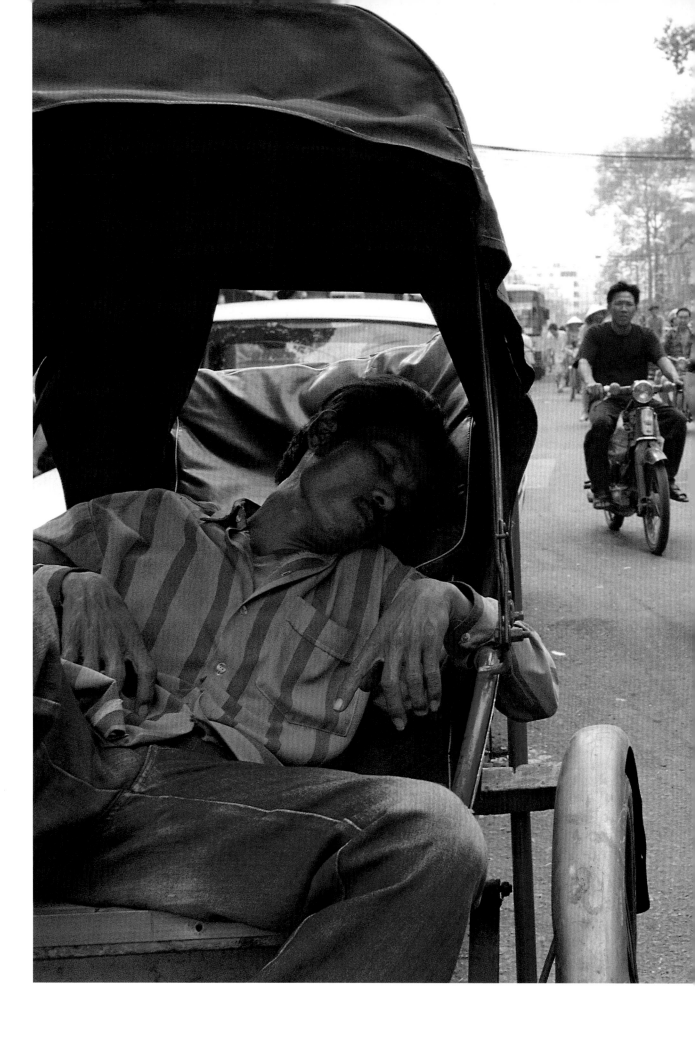

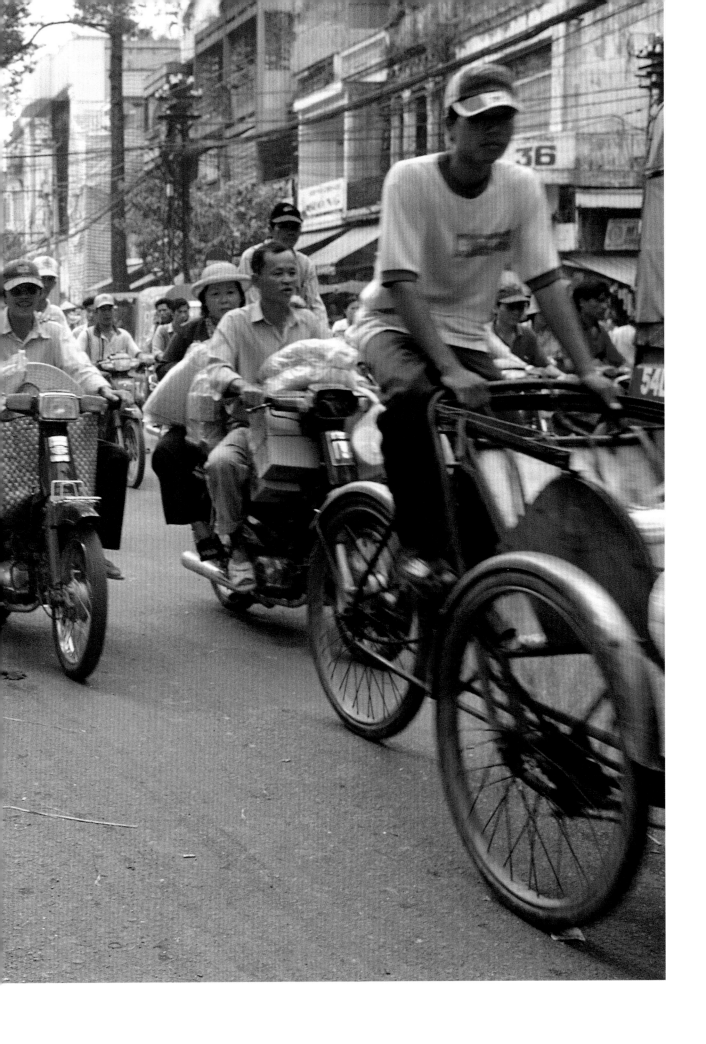

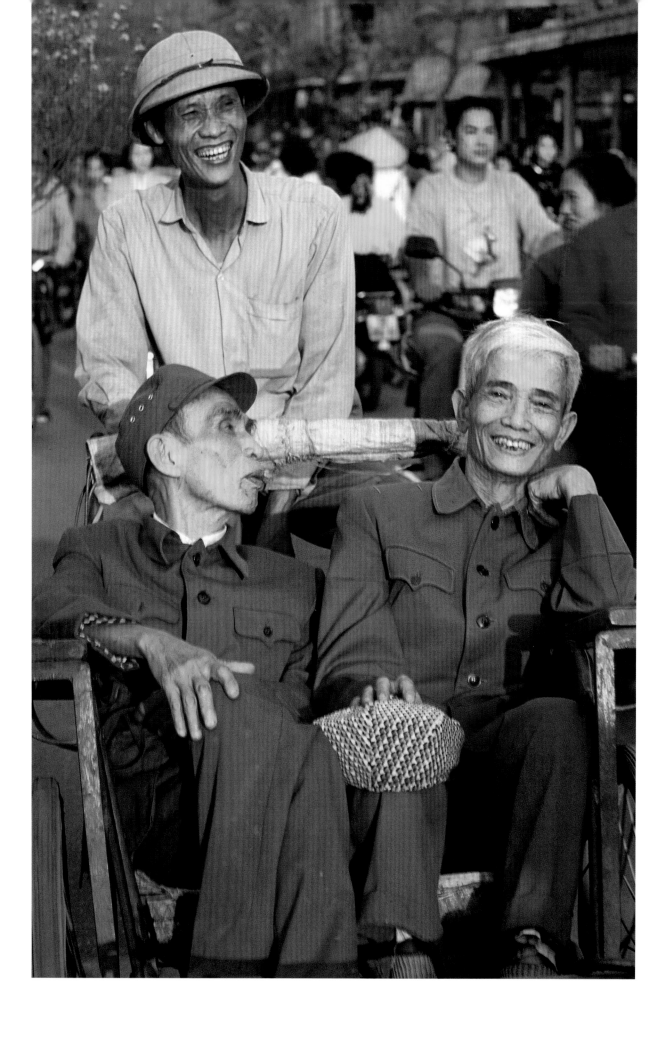

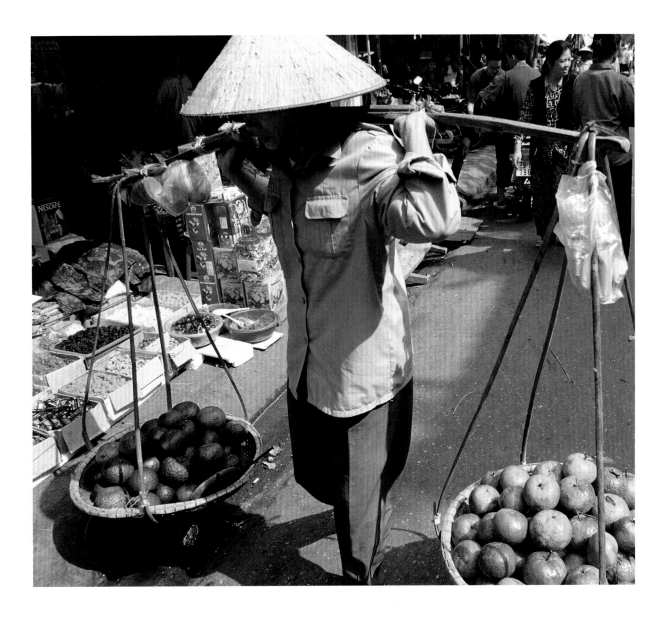

The ricksha man does quite a simple job;
he who can hardly walk pulls him who can.
He'll fake the slave for now and bide his time:
he may yet throw the bigwig who sits there.
He fights his way through streets against the cars;
the wind blows dust and smudges up his face.
Both he who pulls and he who's pulled are men:
between the two the difference lies in luck.

—"THE RICKSHA MAN." PHAN VAN HY, 20TH CENTURY

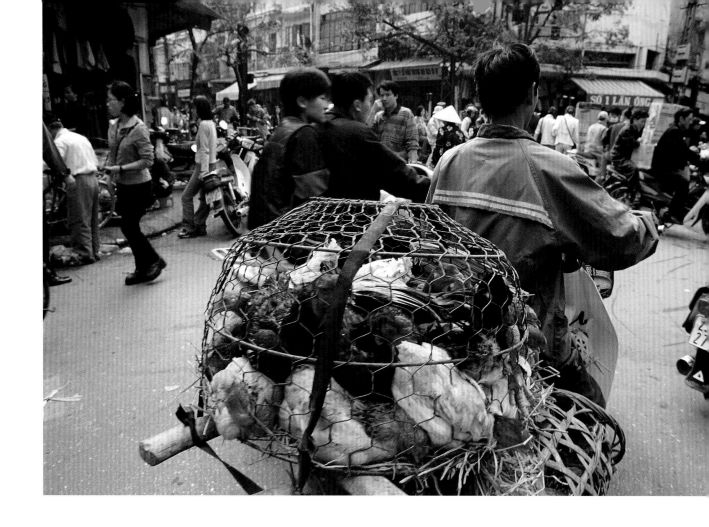

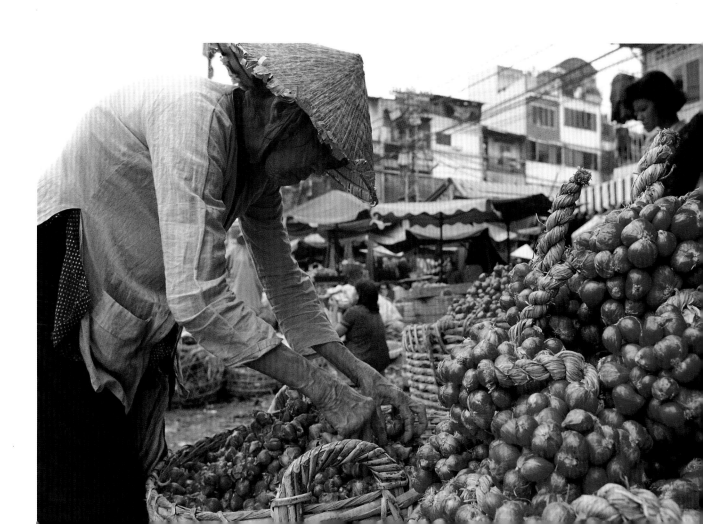

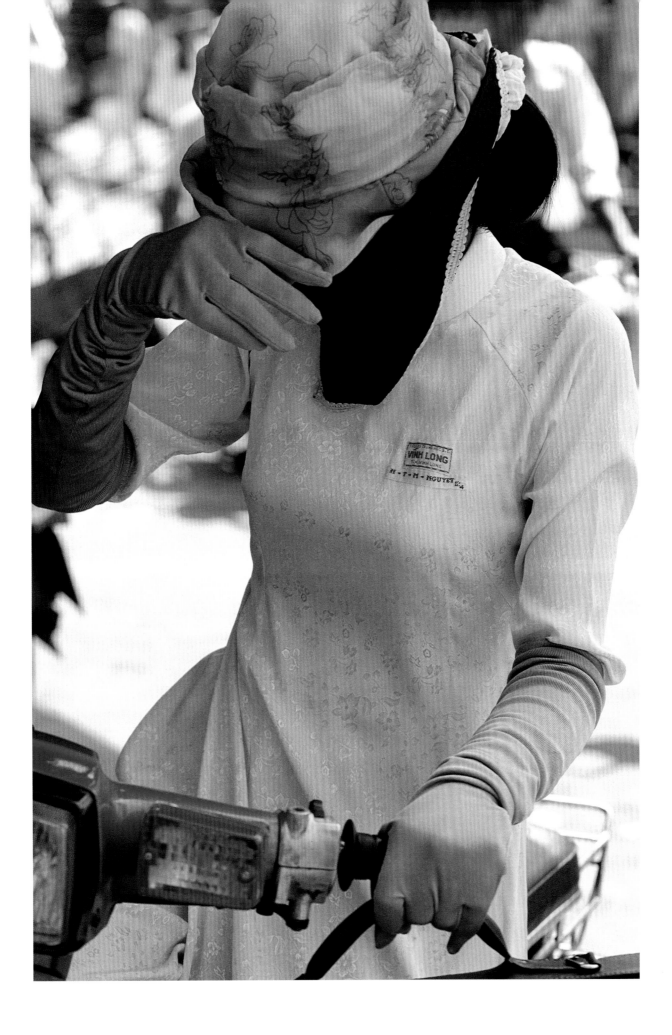

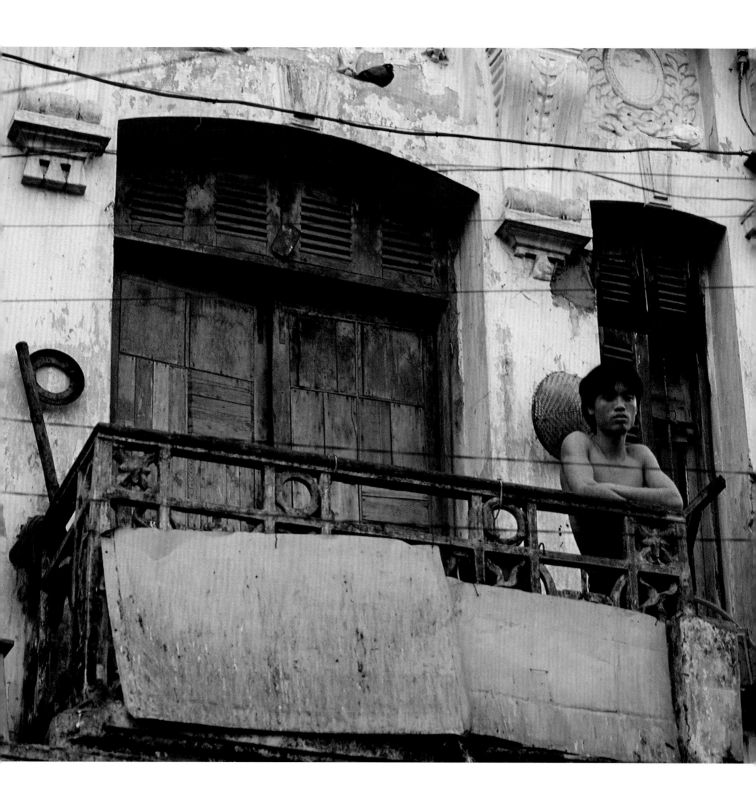

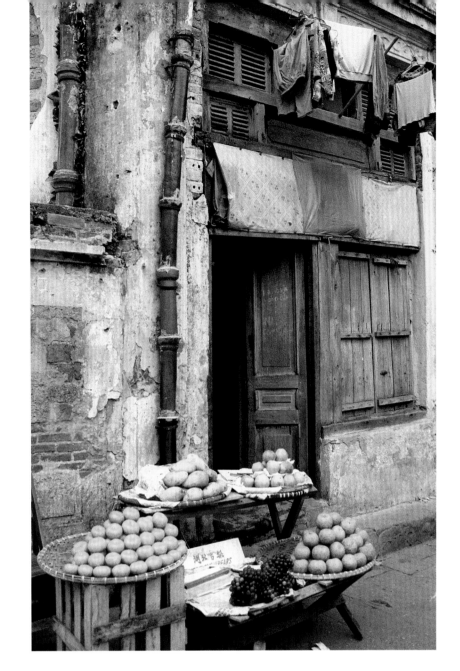

Why did the Maker stage such drama here?
Since then, how many stars have spun and fled!
Old horse and carriage paths – faint autumn grass.
Once-splendid towers and mansions – setting sun.
Rocks stand stock-still, unawed by time and
change.
Waters like rippling, grieved at ebb and flow.
From age to age, a mirror of things past:
the scene from here can break the viewer's heart.

—"Remembering the past in the City of Soaring Dragons."
(Lady) Thanh Quan, 19th century

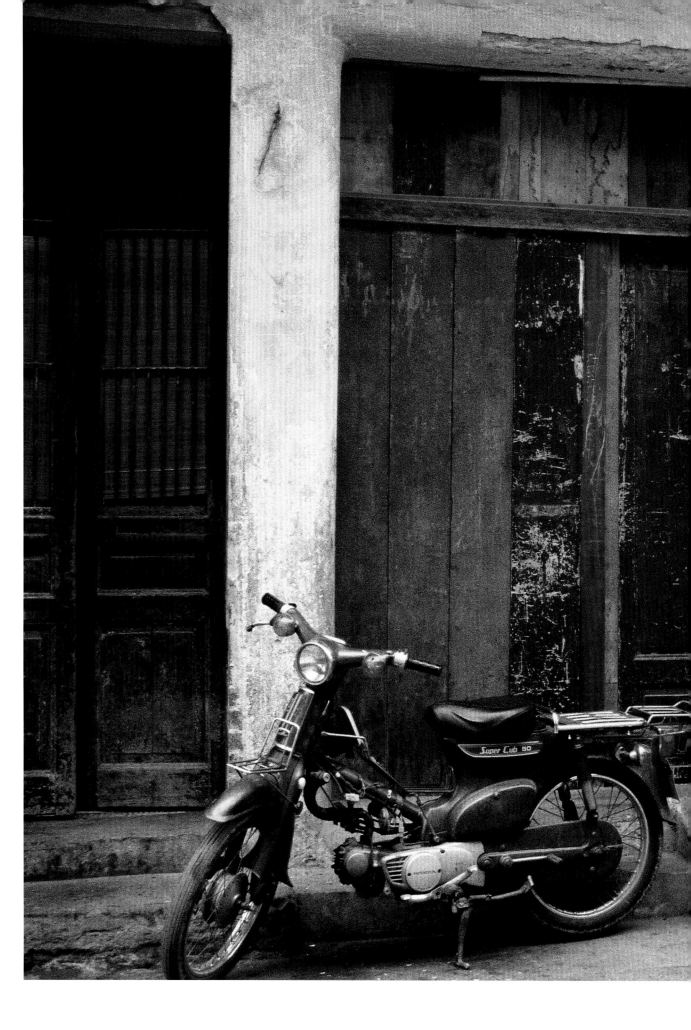

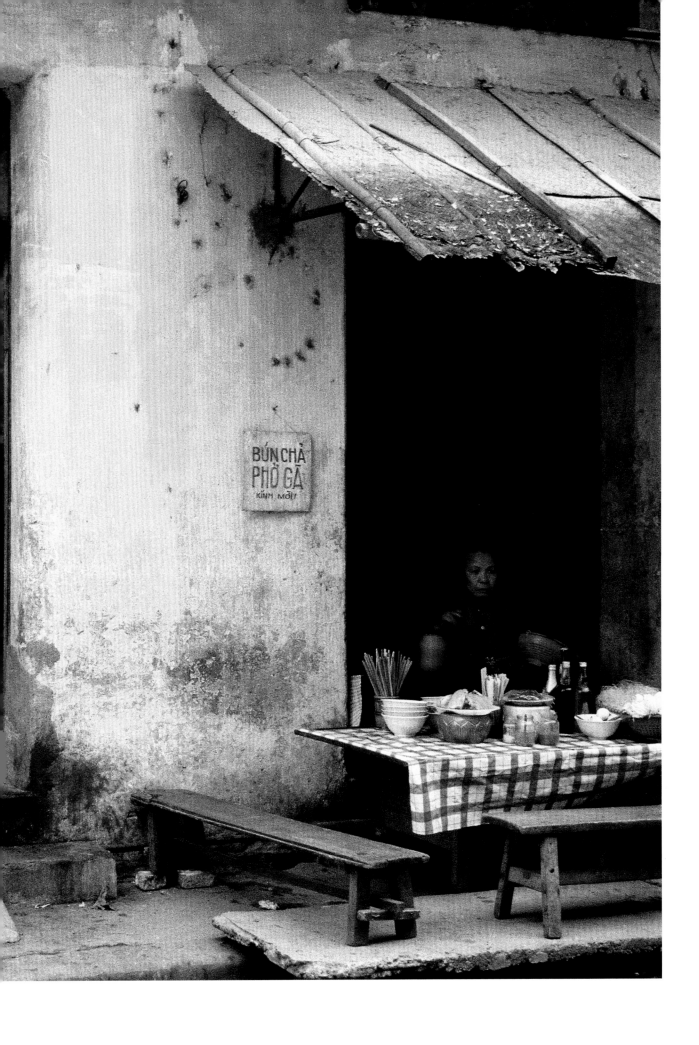

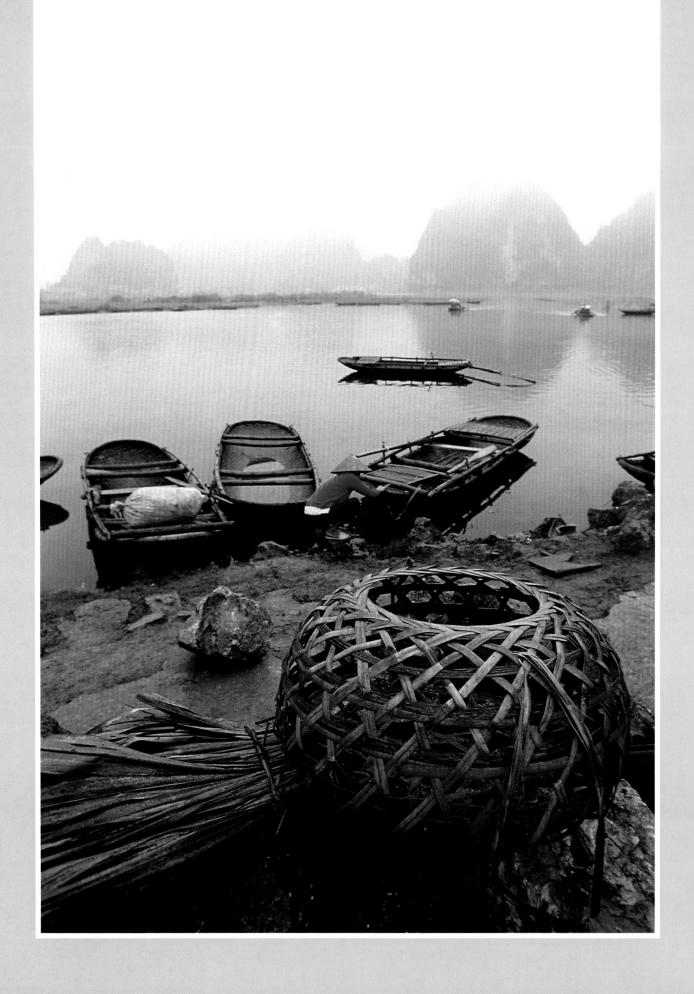

II

Fish Shine

in the Current

"Mountains and streams" (*nuoc non*), the literary stand-in for the nation, captures in shorthand the mythic origins of the Vietnamese people—the people of the land and the people of the water, the people of the North and the people of the delta in the South—united by blood, separated by custom and disposition, descendants of Au Co, the female mountain spirit, and Lac Long Quan, the water dragon.

Au Co laid a sac of one hundred eggs from which hatched one hundred humans. Lac Long Quan had been given Lac Viet, or Vietnam, by his father before his marriage, but Au Co grew unhappy in the underwater imperial palace and longed for the mountains. In one of the mythic world's more amicable no-fault divorces, Lac Long Quan realized that he and his wife were of different habits and dispositions, and had to live apart. One half of the children stayed with him in his underwater palace while the remaining fifty went with their mother to live in the mountains.

The descendants of the fifty who stayed with Lac Long Quan have long since multiplied beyond the confines of their underwater home, and now can be found in the millions in the Red River Delta, along the Perfume River in center of the country and most especially in the two thousand miles of waterways in the Mekong Delta. The miles of delta waterways almost equal the twenty six hundred miles of the river itself as it surges from China through Myanmar, Laos, Thailand, and Cambodia. The Mekong enters Vietnam as two channels and though it empties into the South China Sea through seven branches (two channels having longed silted over) the river is still called Cuu Long or Nine Dragons because nine is an auspicious number. The Mekong, contraction of the Thai for "Mother of the Waters," is the twelfth longest river in the world, sixth largest by amount of water discharged

into the sea, and deposits enough silt annually to add two hundred feet of land to the Vietnamese coast. For a river of such physical and hydrodynamic magnitude and historical and geopolitical importance, Western knowledge of it has been slow to accumulate; it was not explored scientifically until a French expedition in 1866–68 mapped its course in an abortive pursuit of a navigable route to China. And it wasn't until 1994 that its source was finally located, sixteen thousand feet up in the mountains of eastern Tibet.

The French dreams for a navigable route to China were thwarted by rapids and the Khone Falls on the Cambodia-Laos border, but the drainage works and canal construction of the French brought agricultural development to the Mekong Delta, though at a high price of economic exploitation and human suffering. Fertile soil, peace and *doi moi* have made the Mekong Delta a land rich in rice, fish, and fruit. The land is intensively cultivated: orchards can be seen along riverbanks and canals, and fish farming is often combined with orchards and rice fields. But economic development in Vietnam and upriver in China (who is not a member of the Mekong River Commission, a regional body for regional development) are casting shadows across the fields and waterways of the Mekong.

Fish catches in Vietnam (and Cambodia) are dropping, salinization of the rice fields is increasing, and the possibility of irreversible environmental harm from upstream hydroelectric development is forecast. Hundreds of square miles of delta mangrove swamp have been converted into rice paddies and fish ponds, and in the "prawn rush" to profits, existing rice paddies have been converted to fish farms totally or during the dry season. More rice fields means increased irrigation drawing water from the river, and more shrimp farming means increased salinization of the combined rice and shrimp fields and the neighboring rice fields. Deforestation brings increased runoff into the Mekong and fewer trees means less decaying leaf matter providing needed nutrients for the fish.

Hovering over the self-inflicted environmental wounds of Vietnamese development in the Mekong is the potential damage whose cause lies thousands of mile upstream in China. The Chinese

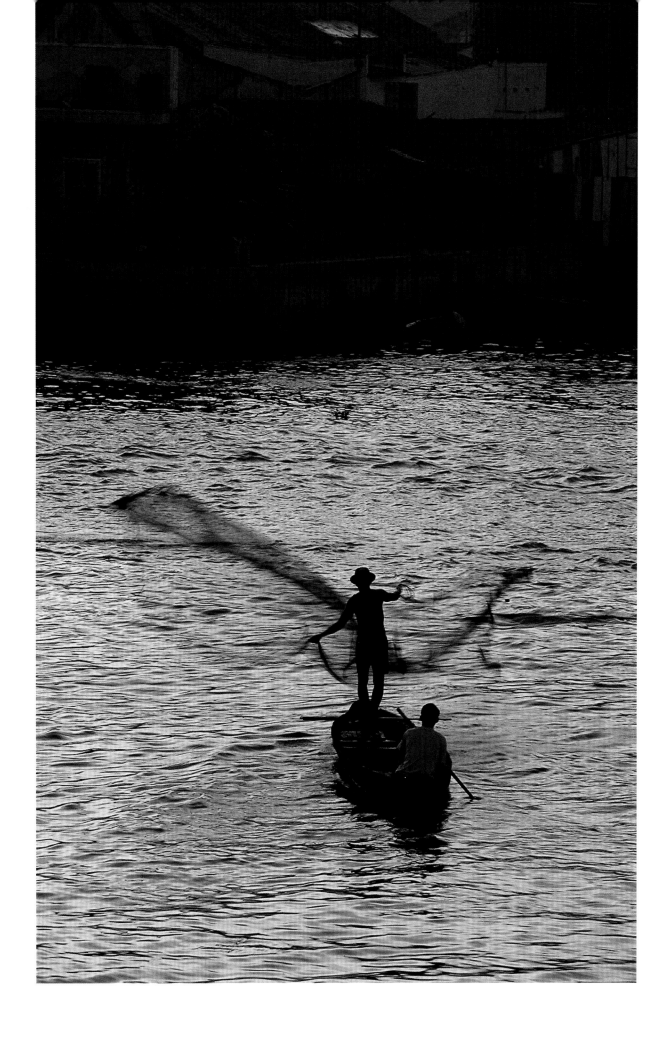

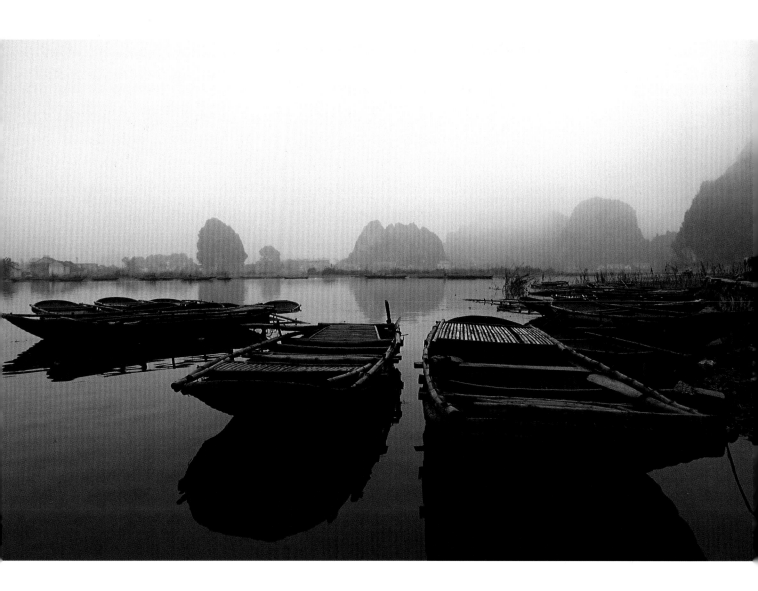

Dim starlight swept down across the surface of the water in beautiful
silver streaks. A few dozen basket-boats drifted in the perfect calm.
The sound of a few short coughs, the sharp wet gurgle of tobacco
smoke being drawn through a water-pipe, the murmur of prayers
from a bible-meeting; all of these were infinitely pleasing to my ear.
Toward morning, a ribbon of mist unfurled on the river, blurring the
boundaries between the jetty and the bank, the surface of the water
and the sky. The bottoms of the boats were full of silvery white her-
rings. The acrid smell of smoke and the fatty fragrance of roasted
fish mingled in the clean morning air.

—FROM "RUN RIVER RUN." NGUYEN HUY THIEP, 1950–

have built the only two dams across the Mekong, have five under construction and seven more in advanced stages of planning. Besides generating hydroelectric power for Kunming and other cities, the Chinese argue that the dams will even out the river's flow during the wet and dry seasons. Because only twenty percent of the river's volume comes from China, the Chinese believe there is no cause for concern on the part of countries downstream. Yet the Laotians are worried about lower dry-season water levels and their own plans to harness and sell hydroelectric power to their neighbors, and the Cambodians are intensely concerned about the impact on the fish in the Great Lake and the Tonle Sap River, which supply sixty percent of the country's annual protein intake. The Vietnamese fear the dams will reduce fish migration and reproduction and will cause changes in the temperature, quality, and seasonal levels of the water—all of which could negatively affect agriculture along the river. Despite Chinese claims to the contrary, Milton Osborne, probably the most knowledgeable scholar on the Mekong's history and strategic importance, concludes that it is "not alarmist" to believe that the Chinese plans will bring in future major, irreversible environmental problems for Vietnam and other downstream countries. One can only hope that images of the vibrant life along the Mekong will not in the coming years be a historical record of a life irretrievably lost.

The hard realities of geography, climate, political history, and economic development have given substance to the mythic origins of the nation's North-South differences. Or perhaps the myth evolved to explain cultural differences rooted in centuries-old ways of life conditioned in part by ecological differences. Whatever the circuitous paths of causation, North and South Vietnam existed as different social and cultural regions well before the partition of 1954. The South was more Buddhist, less Confucian—the first Confucian temple was not opened in the South until 1697. North and South had their own political institutions and history of absorption into a unified Vietnam under the Nguyen Dynasty, established in Hue in 1802. The North, with a longer history of exposure to Chinese cultural

influences, resisted more vigorously the Sinification favored by the Nguyen; women continued to wear skirts, not the Chinese inspired custom of tunics and trousers, and Northerners even continued to use copper coins from the Ly Dynasty (1592–1788). Local resistance to French rule continued longer in the North than the South.

The Vietnamese themselves have been quick to attribute, and exaggerate, differences in habit, manners, and temperament to divisions in geography. Le Ly Hayslip, author of *When Heaven and Earth Changed Places*, writes that because her home village near Danang was midway between North and South, the villagers shared characteristics of both: "We were more serious than many in the warmer South, but not so stern as people in the North." Climate seems to have an insidious influence on character, whether it be in Europe or Vietnam. From Hanoi or Brussels, those in Saigon or Sicily are supposedly morally looser, lazier, and more emotional. Talk to a painter from Hanoi and he will claim for himself and his northern peers a seriousness, profundity, and spirituality lacking in the South, whose artistic productions suffer from superficiality, commercialism, and melodrama. North-South differences tinged with a sense of moral superiority extend even into gastronomic sniping. Northerners may admit that Southern mangoes and rambutans are larger, but theirs are sweeter. Southerners mock Northerners' love of "Northern cow," while Northerners dismiss Southern attempts at cooking dog as bland and uninspired. And the North, birthplace of the national dish, *pho*, claim their version of this soup noodle captures its true essence while the Southern use of mung bean sprouts is an act of culinary desecration.

How to say it without giving the reader the wrong idea, but the photographs in this section smell. No, that is not an aesthetic judgment; and you don't scratch them and take a whiff. Look at them and you can smell the river in the morning sunlight, the damp mud, the fish drying on the river banks, the thick, mingled smells of decay and life, of the river as home. After oil and gas and rice, fish is Vietnam's third largest export: in 1999, almost 1.8 million tons of fish, crustaceans, and mollusks were exported, exceeding fish rich

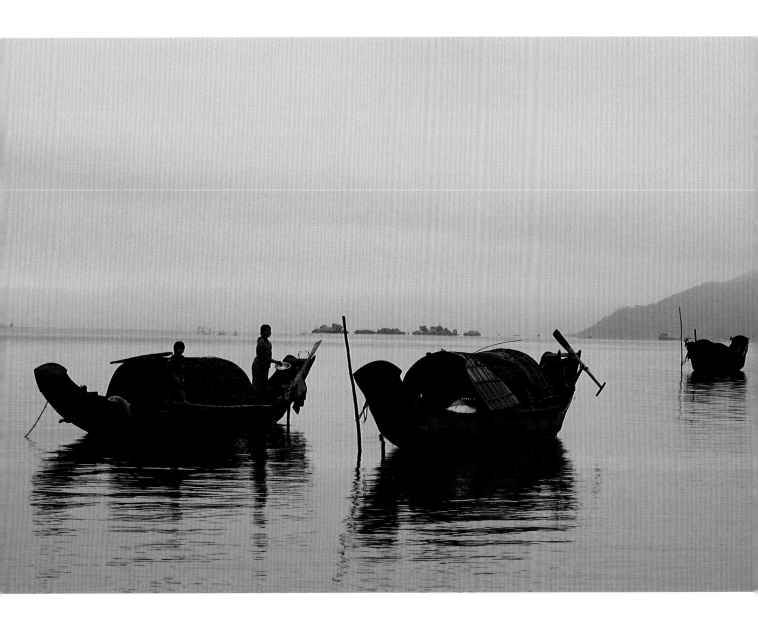

The Saigon River slides past the Old Market,
its broad waters thick with silt. There,
the rice shoots gather a fragrance,
the fragrance of my country home,
recalling my mother's home, arousing deep love.

—"The Saigon River," folk poem

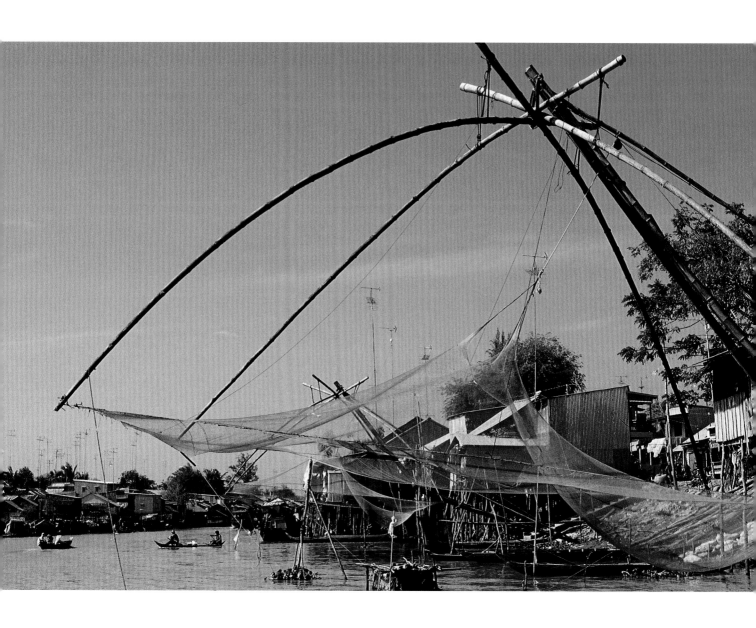

countries like Canada and Spain. Along its almost two thousand miles of coastline and thousands of miles of rivers, canals, lakes, and family ponds live some two thousand species of shrimps, crabs, and fish; in the Mekong River alone, the third most biologically diverse river in the world, there are some twelve hundred species. From the Mekong it is estimated that the actual tonnage is two to three times the amount officially reported, as most fish are locally consumed, made into the fermented fish sauce called *nuoc mam* and other products that can be stored without refrigeration.

What olive oil is to Mediterranean Europe cooking, salt to the West, and soy sauce to China, *nuoc mam* is to Vietnam, North and South. Somewhere in the images of floating food-sellers or the humblest house boat is this liquid staple that the perceptive writer on Vietnamese food Annabel Jackson says simply, "defines the flavors of Vietnamese food." Only after having rice and fish sauce can a Vietnamese say he has eaten.

Vietnam resisted China on the battlefield and in the kitchen. Its cuisine is not a wan copy of its northern neighbor: food is simmered, cooked only sparingly in oil; cornstarch or other thickening agents are little used; and fresh, uncooked vegetables are a mainstay. For the Chinese, dressed salad from the West or the Vietnamese do-it-yourself wrappings with Thai basil, *rau ram* (Vietnamese coriander), saw leaves, *la lot* leaves (pepper leaves), cilantro, and mint are culinary exotica best left untouched. The natural flavors of pureed shrimp patted tight around sugar cane and grilled, Vietnamese spring rolls, and grilled beef in *la lot* leaves are accented when dipped into fermented fish sauce. No Vietnamese table is without *nuoc mam* and *nuoc mam cham*, a sauce to whose base of *nuoc cham* is added lime juice, distilled white rice vinegar, sugar, fresh chilies, and garlic.

Like wine, *nuoc cham* is aged; like olive oil, it goes through several distillings or drainings, the first prized over those that follow. The best *nuoc chom* comes from the island of Phu Quoc in the Gulf of Thailand, where annually during fishing season silvery, almost translucent anchovies are layered with salt in large wooden barrels.

After three months the mixture produces a liquid which is poured back into the barrel, and after six months a clear amber liquid is distilled. This first draining, relatively expensive, is reserved for table use; the second and third drainings of lower cost and quality are used for general purpose cooking. For some passionate students of this pillar of the Vietnamese table, source, age, color and taste may not be enough to distinguish the best. In the 1950s a provincial Vietnamese governor showed travel writer Norman Lewis the best test: "Taking a grain of cooked rice, he deposited it on the golden surface, where it remained supported by the tension."

If *nuoc mam* brings out the empiricist in the Vietnamese, *pho* brings out the poet. To describe it as beef noodle soup is to acknowledge the limitation of language, as if it were sufficient to call the Pieta of Michelangelo a stone carving. Nguyen Tuan, one the country's preeminent writers of the twentieth-century, wrote a classic essay on its preparation, comparable perhaps to Chekhov writing on borscht. Expatriates are haunted by the special *pho* aroma, with its faint hint of cinnamon, or grow misty eyed hearing in their mind the rat-ta-tat of the soup seller's wooden sticks, seeing side-street *pho* shops with their small, low, wooden benches set in front of a steaming pot surrounded by bowls of beef, noodles, chilies, basil, and mint. Its origins are murky and the subject of much contention — descendant of the Mongolian hot pot, an import brought back from Yuannan by Vietnamese nationalists who fled the French at the end of the nineteenth century, or an early 1900s solution to excess beef left over at Tet are some of its creation theories. Clearer is what once was primarily a Northern dish became with the exodus in 1954 of a million Northerners to the South and abroad a universal Vietnamese dish; from the side streets of Hanoi to the floating soup sellers of the Mekong, the day begins with *pho*.

If *pho* marks the day's beginning for many, then the glutinous rice cakes of *banh giay* and *banh chung* mark the beginning of the year for all. Like many foods that mark special holidays—moon cakes for the Chinese Moon Festival or matzoh for the Jewish holiday of Passover—the story of the origin of the dish may be more intriguing

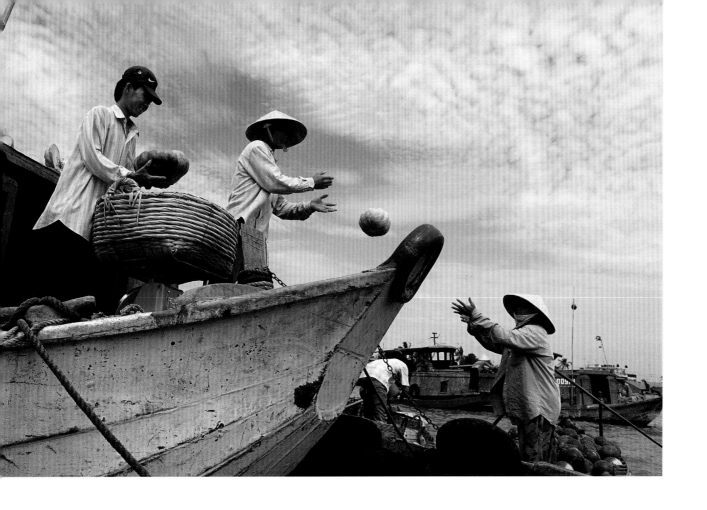

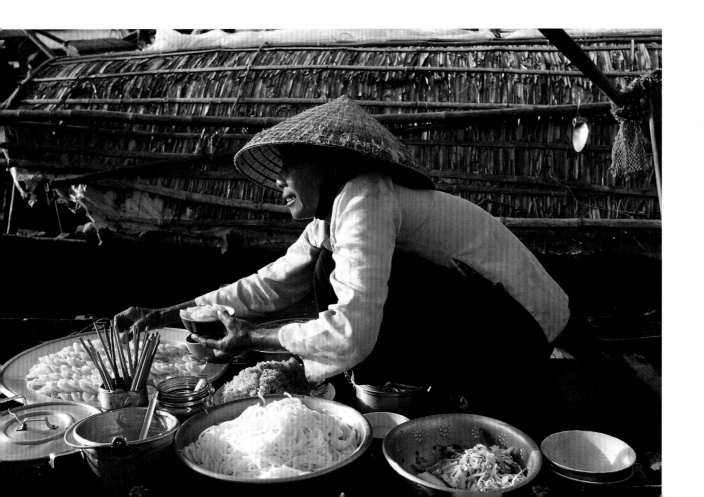

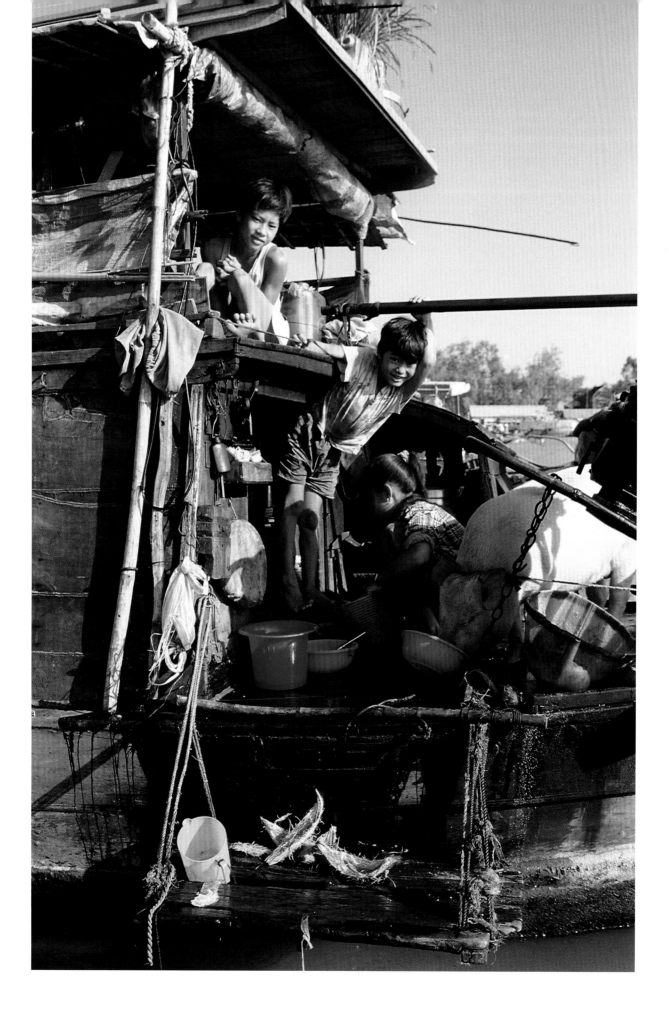

than its taste and more revealing as cultural commentary. In the mythic past, King Hung Vuong the Sixth of the Hung Bang Dynasty having repelled the nation's enemies and brought peace, decided to relinquish his crown to one of his twenty-two worthy sons. Unable to choose among his heirs and believing they could learn much from traveling, he decided to give his throne to the son who brought to him a recipe for a dish he had not eaten and would most enjoy. Lang Lieu, sixteenth in rank, motherless from an early age and especially caring of his father, choose to stay back and look after his father. With no one to advise him, he despaired of finding a worthy dish until a genie came to him in a dream and told him what to prepare. Both cakes were made of rice, symbol of the earth's abundance. *Banh giay* was "round as the sky" under which all human beings lived, and *banh chung* stuffed with bean paste and minced meat was "square as the earth" on which all humans lived. Exotic dishes from the four corners of the earth did not satisfy the king, and when told of the genie and how the rice cakes were made, he realized Lang Lieu would not lack for divine inspiration. The crown was given to the young prince and the recipe to the Vietnamese people.

These Tet dishes, food for stomach and mind, reinforce in their symbolism the key cultural constructs of filial piety, the primacy of one's native ground, the power of guardian spirits, the communal and equalitarian nature of Vietnamese life. At the table, differences disappear temporarily. "Heaven punishes, heaven reprimands. But heaven does none of this when people are eating." Fate's decrees and societal dictates and divisions are suspended. In America, when people go out to eat, they each order separate dishes: "family style" is something special, whereas in Vietnam it is the norm. Rice, *nuoc mam* and *pho* unify on national scale as the common bowl and plate do in the home.

From creation myth to the commonest meal on river junk or in mountain hut, unity is found and celebrated beneath surface differences. In Vu Tu Nam's poem "Mountain, River," the mountain sees its image reflected in the river. River, sky and mountain in the purity of their blueness are one.

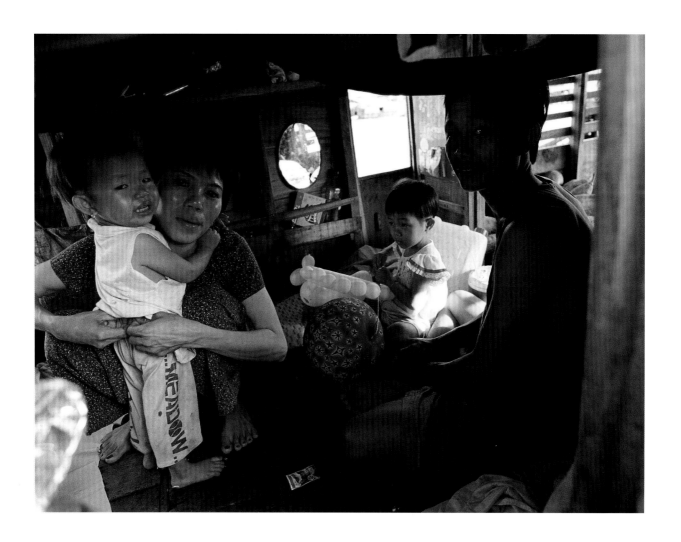

She: King. Father. Mother. Husband. Wife.
 Sat down in one boat; met a storm and sank.
 Dearest, I want to know whom you would save?

He: Standing before Heaven, I cannot lie.
 I would carry my King on my head,
 father and mother on my shoulders.
 And say to you, dear wife, 'Swim here;
 I will carry you on my back
 and with my hands save the boat.'

 —"TESTING THE CONFUCIAN IDEAL," FOLK POEM

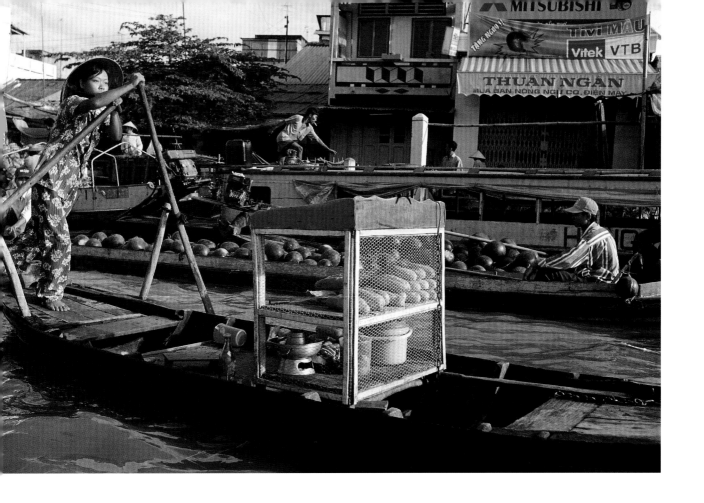

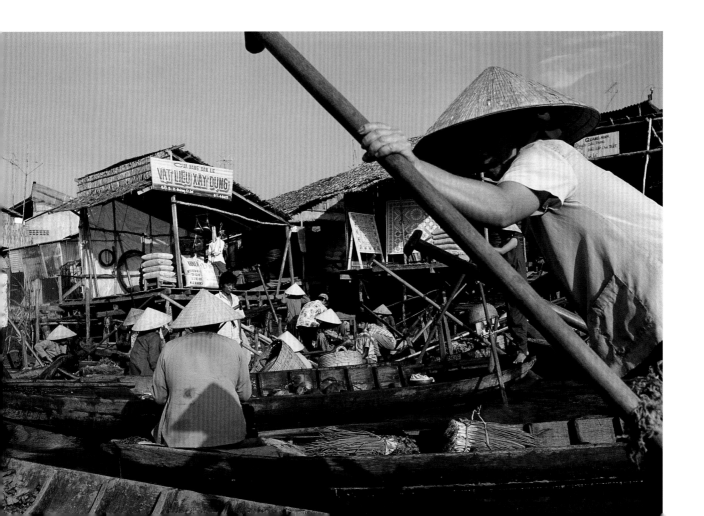

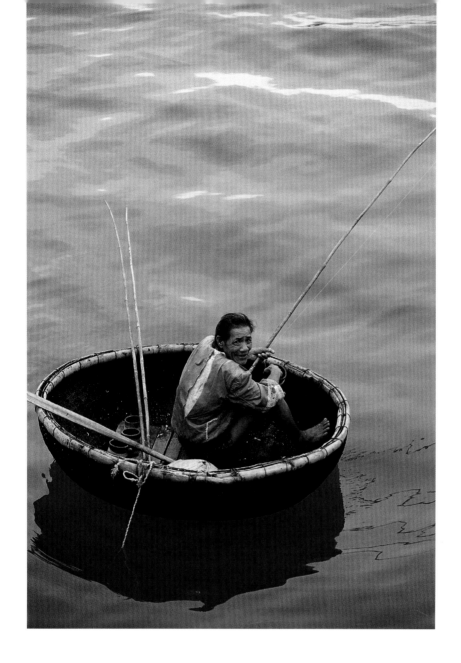

A small boat on the immense sea: who is it?
All he owns are a straw hat and raincoat.
Nobody but gulls to visit him by the sandbar.
But in the autumn the fish are fat and good.
Idling, he may play his flute to the wind
Or get drunk and come home under the moon, a lone sail.
He might be living in the ancient tale of the peach spring.
What does he care what goes on in the world.

— "To An Old Fisherman." Nguyen Binh Khiem, 1491–1585

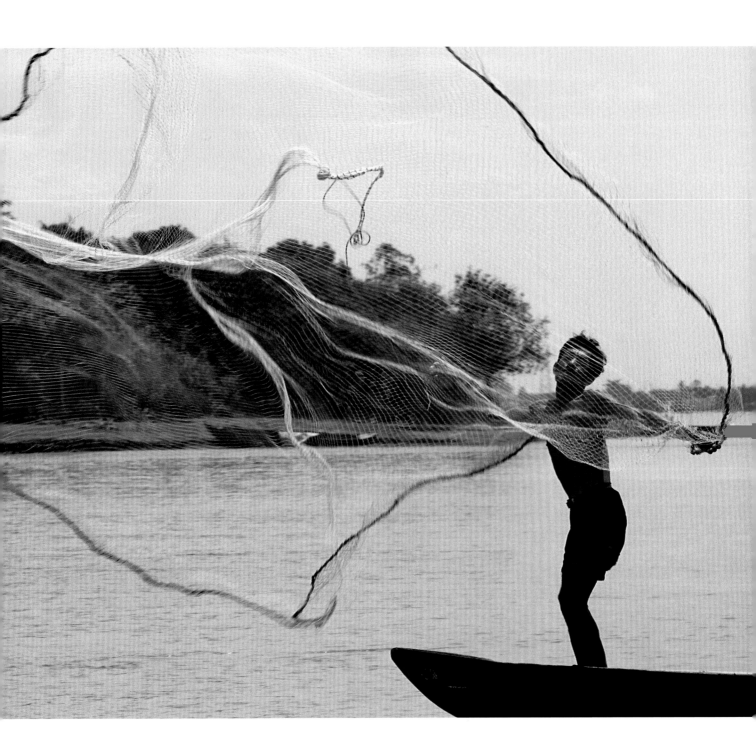

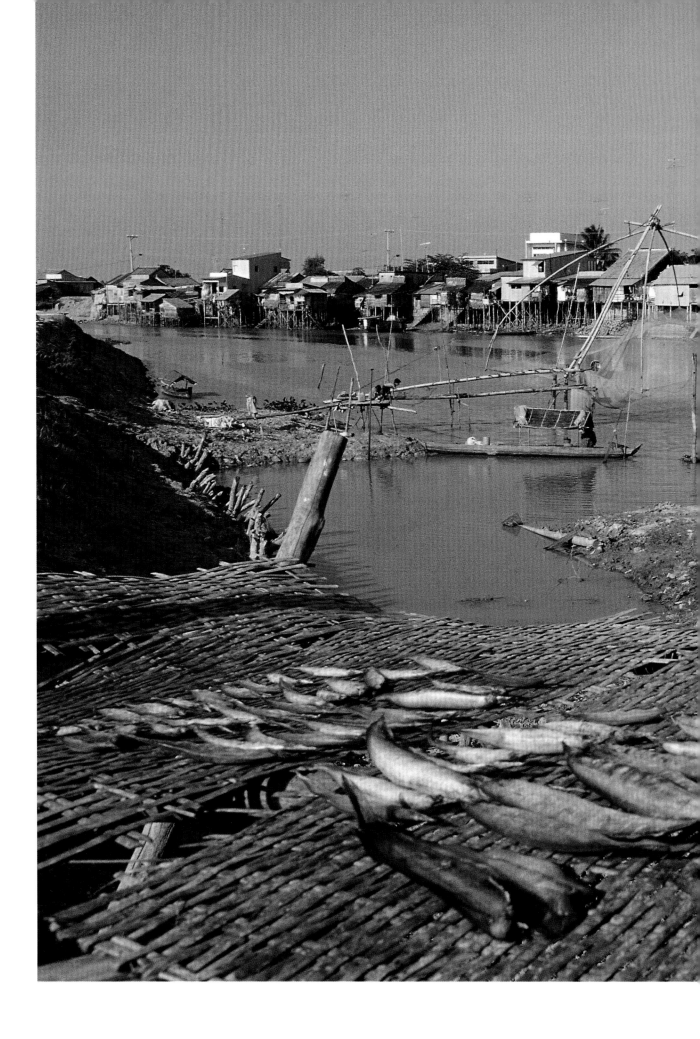

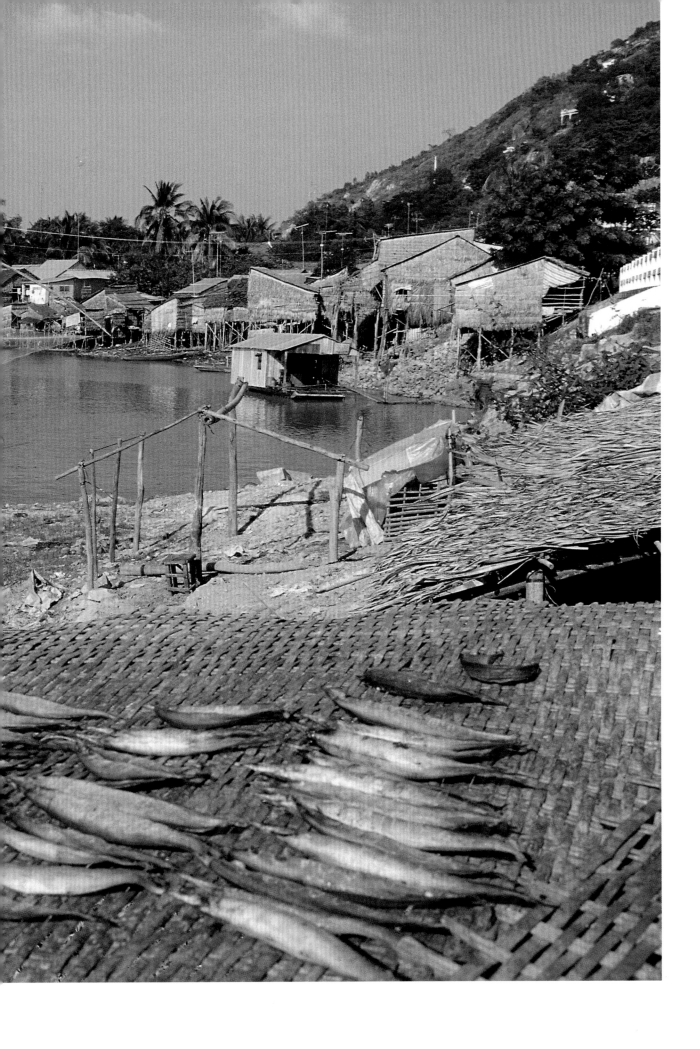

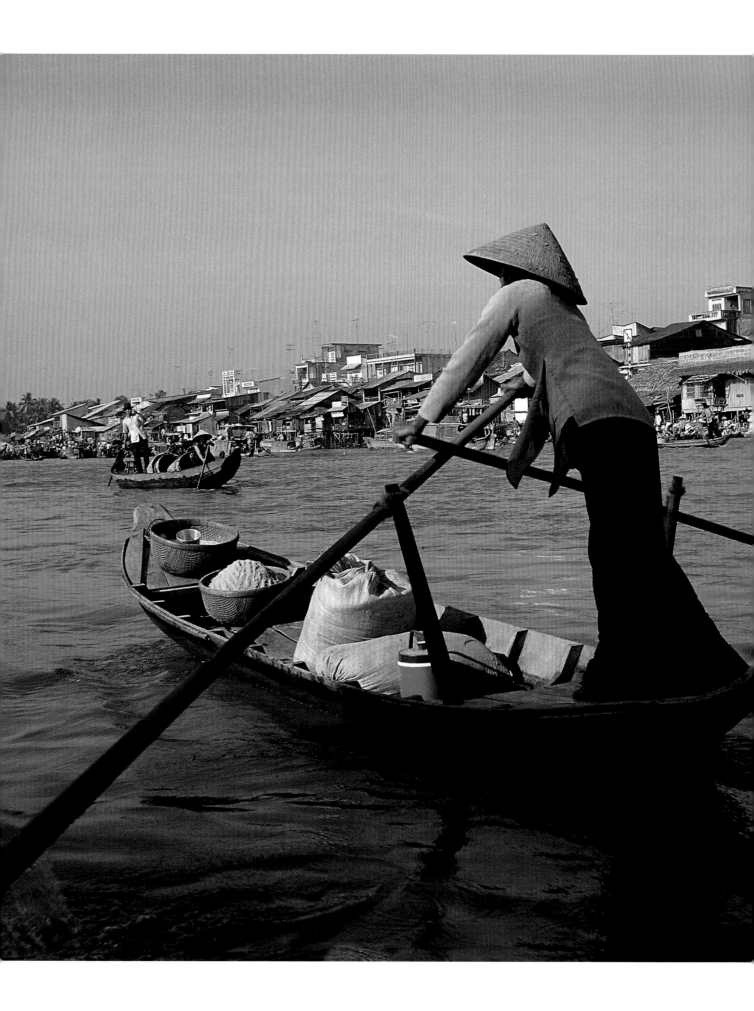

A *bobbing boat behind the phoenix trees:*
a lovely Kim Luong girl was rowing it.
I went aboard—she did not know,
but poets, seeing Beauty, must give chase.

Reaching the pier, the girl rowed back;
she swung the oar, and water splashed.
I gazed and gazed upon her oar
as it was churning up the clear blue stream.

But do you know, O Beauty, do you know
your oar's still stirring ripples in my heart?

—"BEAUTY AND THE POET." NAM TRAN, 1907–67

My mother's village shrouded in a blue mist,
my heart—the leaky spot where she slept at night,
in sorrow, I long for my mother—the days long ago,
that pasty rice she chewed for us,
 the fish her tongue deboned…

 —FROM "A SONG FOR MOTHER." NGUYEN DUY, 1948

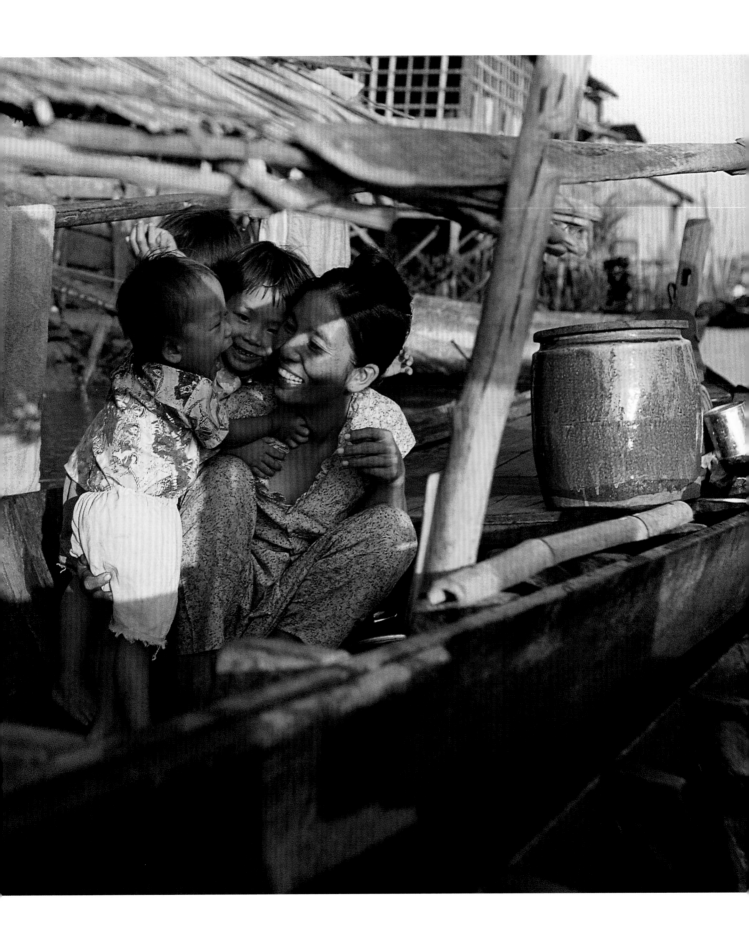

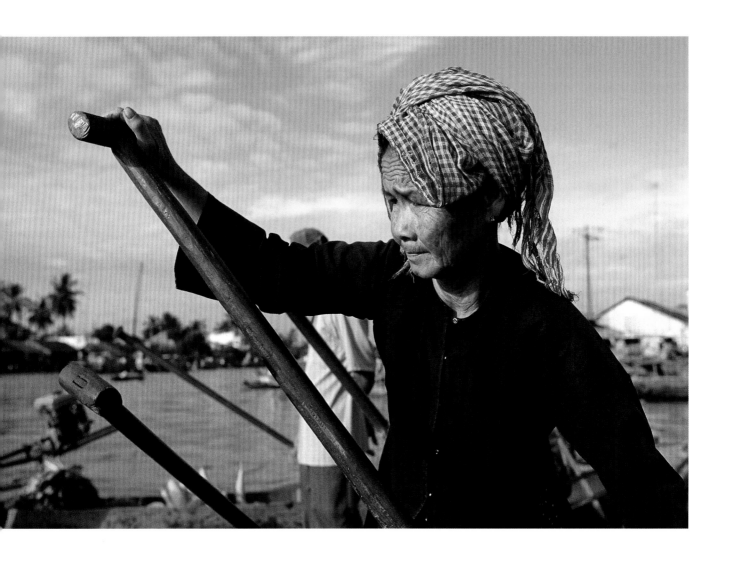

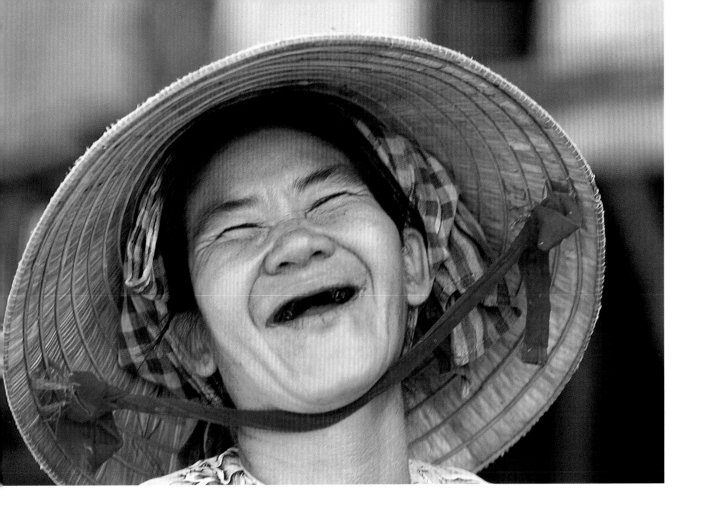

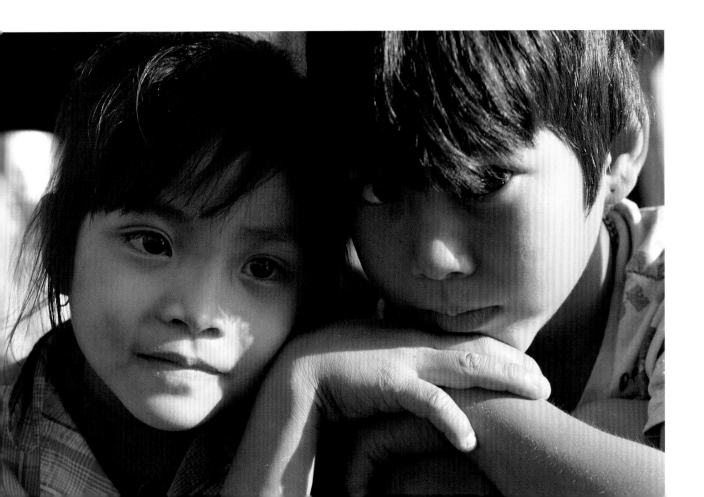

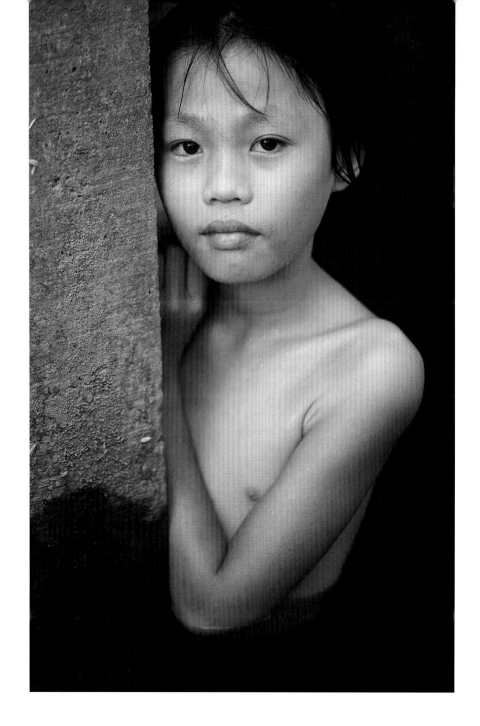

Seven, eight low-lying houses by the river
In autumn: shadows lengthening,
Crowded boats moored near the willow hedge
Or gliding by the flower pool.
Birds trailing bits of cloud perch like toys on the trees.
Fish shine in the current, bite at the surface sheen.
A leisurely rower waits for the moon,
Lifts his voice, sings out the Ts'ang River Song.

—"FROM EIGHT VIEWS OF HSIAO HSIANG."
UNATTRIBUTED, 15TH CENTURY.

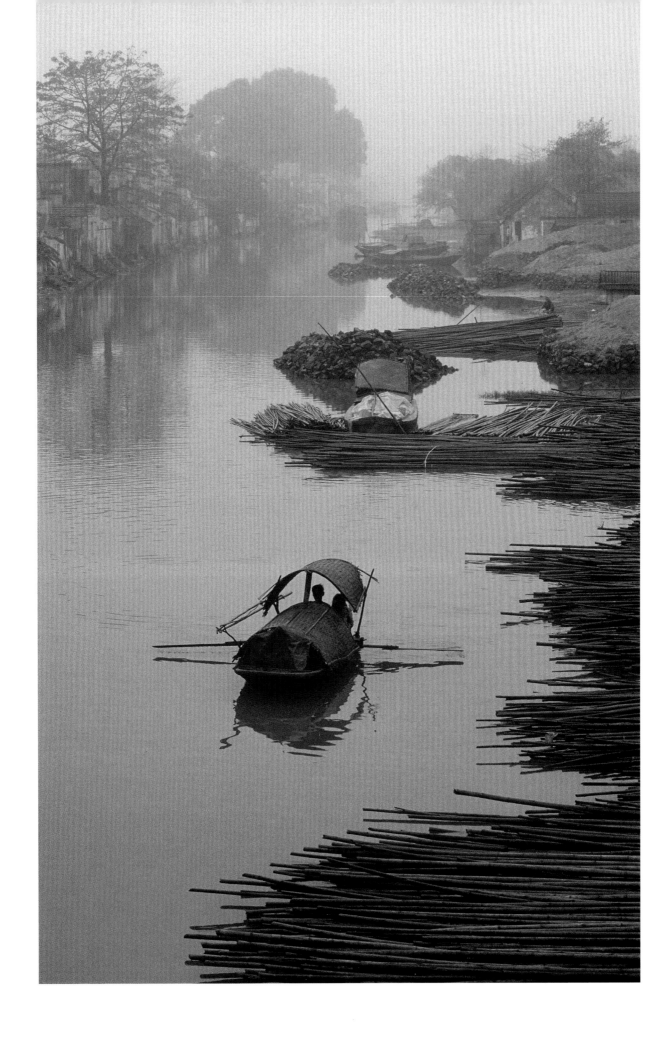

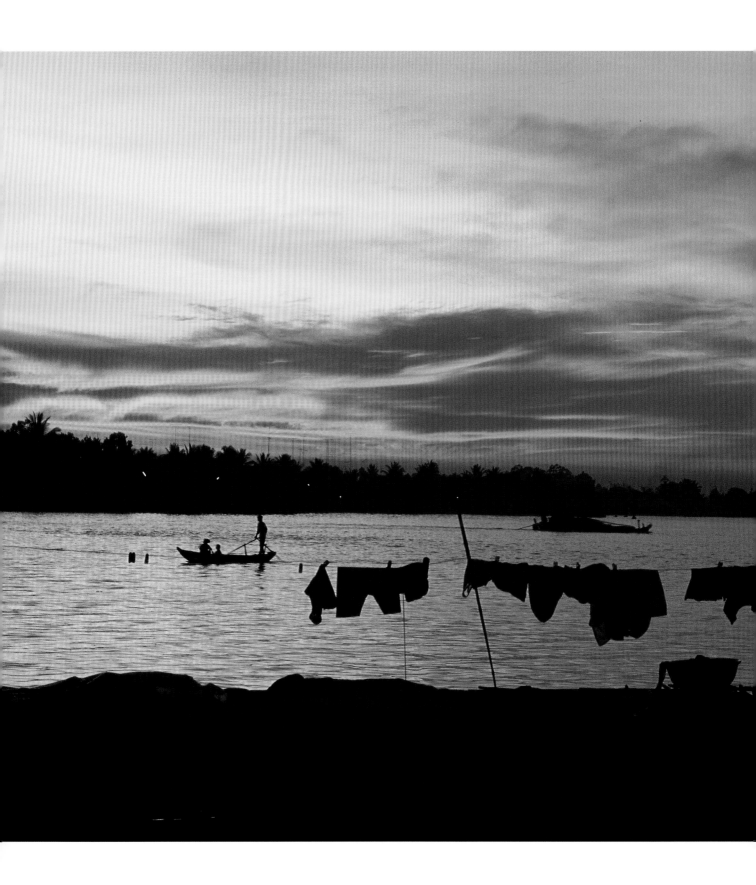

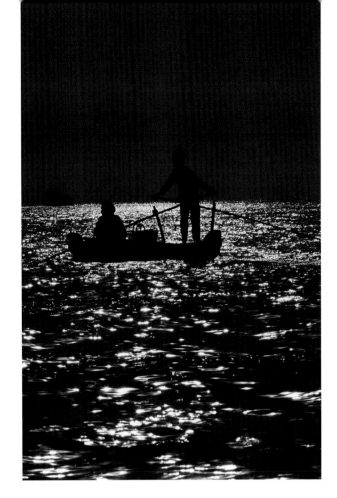

How many thousands of years
 have you been there?
Why sometimes slender, sometimes full?

How old is the White Rabbit?
How many children belong to the Moon-Girl?

Why do you circle the purple loneliness of night
and seldom blush before the sun?

Weary, past midnight, who are you searching for?
Are you in love with these rivers and hills?

 —"QUESTIONS FOR THE MOON."
 HO XUAN HUONG, 19TH CENTURY

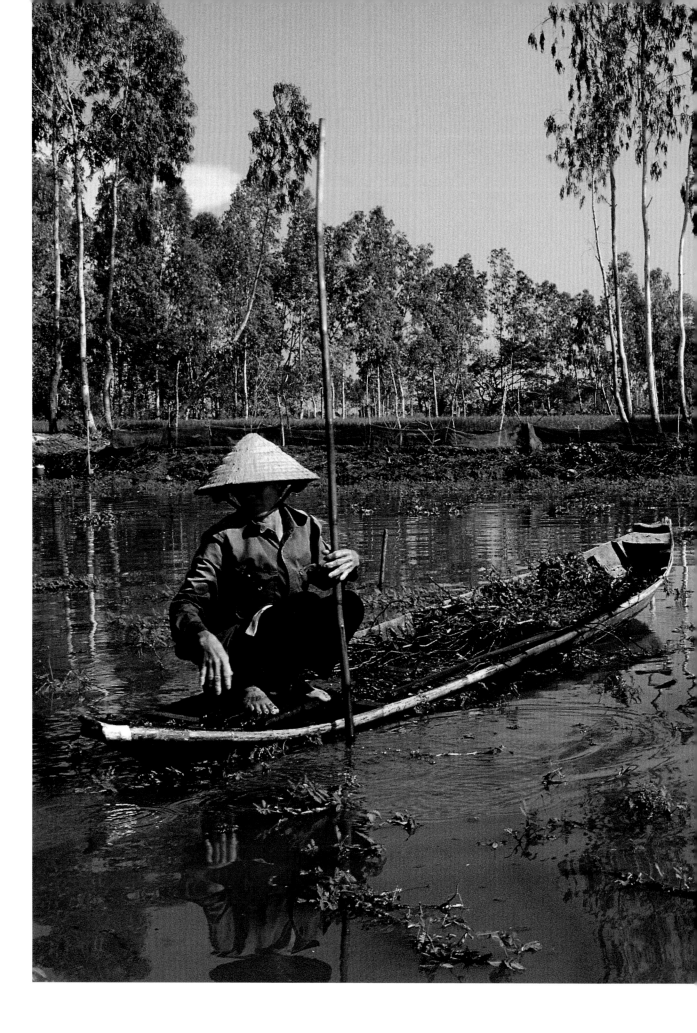

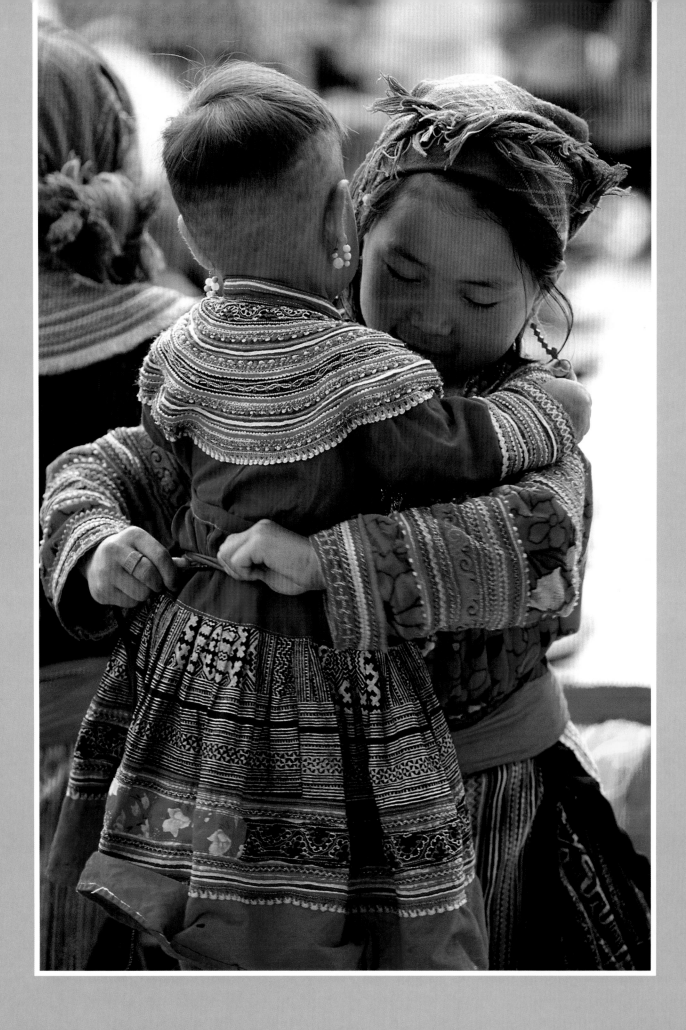

III

LOYALTY, PIETY, LOVE

In 1989, after *Gone With the Wind* had been shown on television in Vietnam for the first time, a woman, echoed by her female companions, told an American reporter that Rhett Butler would come back to Scarlet. "Surely he'll come back to this fine woman who cares so much about the farm of her ancestors, about her family. These are the things that count—sooner or later he must realize that." A Vietnamese Rhett would come back. A Vietnamese Rhett would not have left in the first place.

Whether in the village home of a farmer or in the city apartment of an urbane, well-traveled artist, you will find in the main room an ancestral altar and on it a faded black and white picture of a dead father or grandfather, joss sticks upright in an incense burner, a pair of candles, a vase of flowers. The dead are an everyday presence in the lives of the Vietnamese. Not just one small boy in a Hollywood movie "can see dead people" but everyone sees and honors them in Vietnam. In Vietnam the bonds between the living and the dead, between a mother and her son who will bear the primary ritual responsibilities of ancestor worship, have greater value than the bonds of husband and wife. State and Communist Party efforts have failed to suppress "superstitious" beliefs, and the last decade has seen a revival of communal and family ritual. Vietnam's experience gives lie to any simplistic theoretical dichotomy between modernity and tradition in which more of one means less of the other: Internet cafes, karaoke players and the material fruits of globalization coexist with centuries-old traditions of ancestral loyalty and piety.

The words of the Vietnamese folk song—"Men have ancestors, just as trees have roots and rivers have sources"—express more than a biological truism. It is a deeply held belief that infuses Vietnamese cultural thought and action. Because it is believed that the dead look after the living, it is the responsibility of the living to ritually look after the dead. At funerals and death anniversaries, Tet (Vietnamese lunar New Year), Wandering Souls Days, and many family events and rememberances—

birthdays, marriages and anniversaries and graduations—ancestors are consulted and venerated. It is a sin of filial omission to let a tomb fall into neglect. And if at death, there are no descendants to perform the required rituals, to burn paper in the shape of objects needed in the afterlife—today U.S. dollars and motorcycles are as critical as clothes—the dead are left to eternally wander as beggars in the World of Shadows. The State can provide a safety net of social services for living in times of hardship and old age, but only children can be the safety net for the dead. Only they, and not some impersonal organ of the State, can offer the personal prayers and ritual attention needed to comfort their ancestors. Even to a secular Westerner, who at first glance might view ancestor worship as a quaint hold-over from a "backward" age, there is something moving and profound in the belief that only human beings know who their ancestors are and ancestor worship is what distinguishes human beings from other animals.

In most agrarian societies, sons are valued more than daughters. Sons provide an extra pair of strong hands, will not some day move off to work in the fields of their in-laws, and will be there to look after their parents in old age. In Vietnam, while the economic motive is at play, what propels the desire to have a son is that it is a son who must perform the rites and rituals of ancestor worship. At least one son must walk before the coffin in the funeral procession (otherwise the second son of the closest male relative must perform the responsibilities of the "first son"). As the Confucian saying makes clear: "If you have a son, you can say you have a descendant. But you cannot say so if you have even ten daughters." Despite their high level of education and participation in the labor force, Vietnamese women exhibit a strong preference for sons. Some couples are willing to pay stiff fines (in some provinces as high as 800 kilos of rice) to have another child beyond the government limit of two when the first two are daughters. Some men withdraw from the Communist Party to handle the conflict between policy and progeny or take a concubine to bear a son.

From the ground of mutual obligations between the living and the dead springs a thick growth of relationships among the living: women valued more as mothers than as wives, the parent-child bond

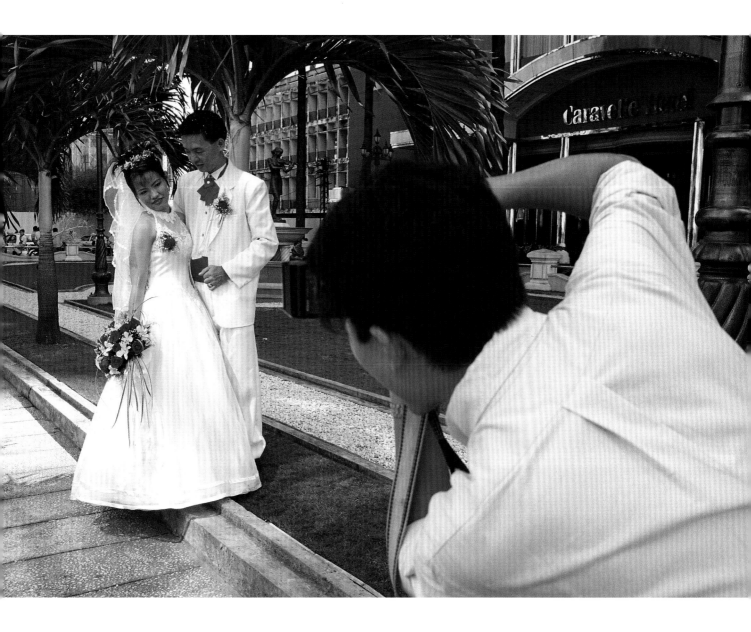

You try to run, but I won't let you.
Grasping your dress, I inscribe a poem
 of three words: loyalty, piety, love.
We'll leave loyalty to Father,
We'll give piety to Mother.
And love? That's ours!

—"A MESSAGE." FOLK POEM

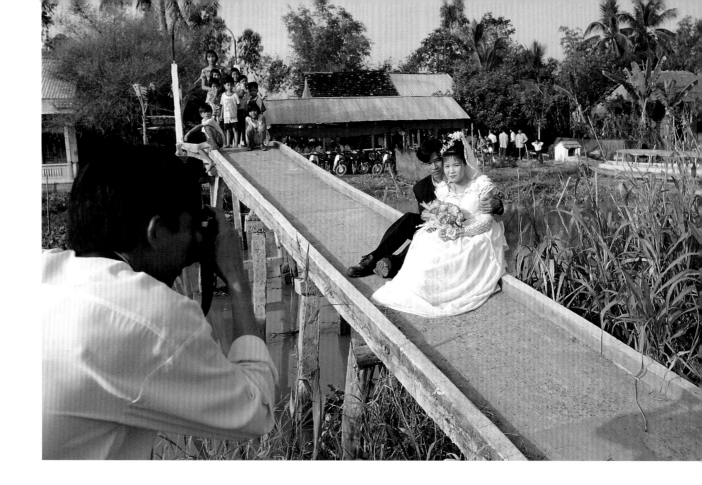

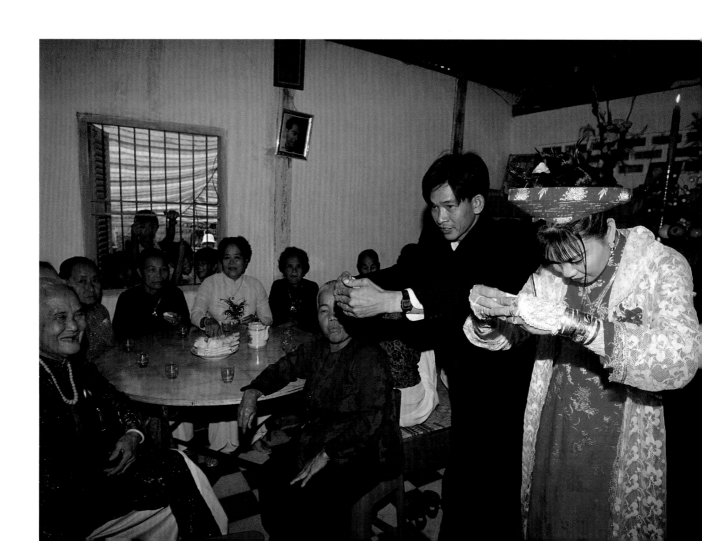

having priority over the marriage bond and the primacy of the family over the individual. "It is because a man wants to have children that he takes a wife." A Vietnamese man has traditionally married not to wed a wife but have a mother to continue the lineage. After marriage, Vietnamese do not postpone having children—developing intimate bonds of marriage is sacrificed to the demands of serving the lineage. Maybe in time, especially for urban youth, the notions of romantic love and the attraction of material wealth will erode the call of ancestors but for now Vietnamese find the voluntary childlessness of young Western couples unthinkable.

The young bride is told in the many osmotic ways culture works what her place is in the Vietnamese family of the living and the dead. A bride may no longer bow as with their husband before the ancestral altar, a pre-1945 practice condemned by the Communists, but she does pay her respects and offer tea to the grandparents and parents of the groom. She knows that the wedding procession is spoken of as "welcoming a daughter-in-law" not a wife. In her new family where the eldest son still lives with his parents, she is first a daughter-in-law, second a mother, and lastly a wife. American stand-up comics would have plenty of fodder for their routines in Vietnam where one scholar has observed that nowhere in the world's folk literature are there more sayings about mothers-in-law and the enmity bred between a young wife and her husband's mother. Under traditional Vietnamese law, a wife's neglect of her husband's mother was grounds for divorce. Still today she will hear the oft-repeated saying that a man can always get another wife but he can only have one mother. The children come quickly after marriage, the child sleeps with the mother, and the grown son evinces what appears to the armchair psychoanalyst a particularly strong tie with his mother. Childhood memories are memories of one's mother. As one contemporary poet writes, "a mother's lullabies never die."

The young bride has a special reproductive obligation to serve the interests of the family: her individuality, like that of all members of the family, is subordinated to the collective interests of the family. "Individual excellence is not as good as group success" or "Better for

the whole group to die than for one person to survive". The admonitions of these Vietnamese proverbs strike an uneasy note with Westerners, especially Americans, raised in more individualistic cultures where the family supports, often sacrifices, for the individual. Not to say that the Vietnamese do not make sacrifices for their children nor take pride in their accomplishments. In America, parents often live vicariously through the achievements of their children and this success is taken as a sign of their own parental self-worth. But in Vietnam, these sacrifices are ultimately for the group—the parents sacrifice for the child who will in turn literally make sacrifices for them in front of the ancestral altar.

Listen to a Vietnamese child and watch the family at a meal—it is clear that the family is the dominant and defining unit and not the individual. When speaking to parents or grandparents, a child rarely refers to him or herself as "I" but rather as "your child" or "your grandchild." Language emphasizes that the person is defined in relation to others in the family and does not stand alone in naked individuality. Join a Vietnamese family in their home for a meal and see the true expression of "family style"— common bowls and platters of food from which each person eats. The individual is nourished by the group.

The family extending back through time and the rituals that sustain it not only have survived the Communist campaigns and the encroachments of secular modernity but are flourishing— look at the images of shops full of Tet gifts and decorations and streets full of costumed celebrants, look at the elaborate funerals with family members in mourning white. After unification, the government instituted a campaign to wipe out "superstitious" beliefs and simplify rituals. To make the "New Man," the government published "Conventions of the New Way of Life," with detailed instructions on the organization of funerals, weddings, death anniversaries, and other family and communal celebrations. In banning lavish feasts that had bankrupted some families in pre-Communist Vietnam, the government hoped to reshape village culture and social arrangements and deny traditional elites the opportunity to maintain their social position through conspicuous consumption.

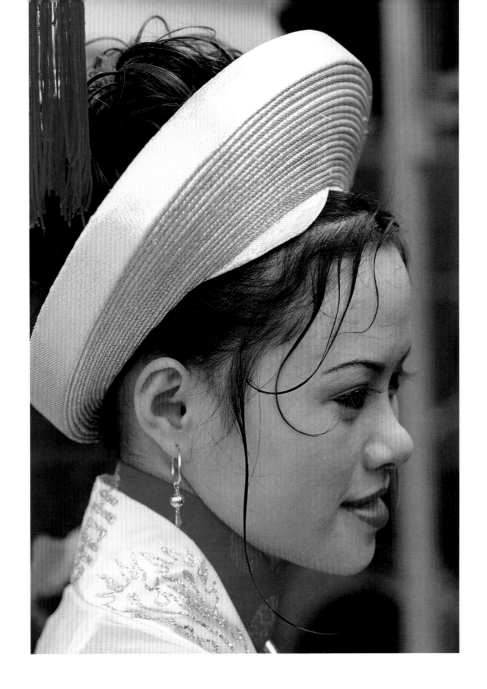

When I was a fifteen-year-old bride
My husband refused to lie with me.
By the time I was eighteen or twenty,
I'd creep to the floor to get some rest,
but he'd drag me back to the bed, shouting
"I love you!" and "I love you!" still.
Our bed has only three legs, the fourth
is broken. If you go to our village, please
tell Mother and Father not to worry.
My husband's behaving normally now.

— "MY HUSBAND IS NORMAL," FOLK POEM

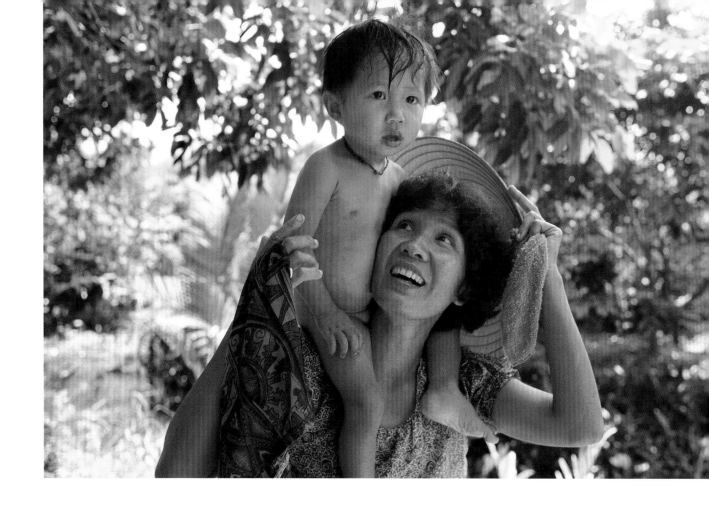
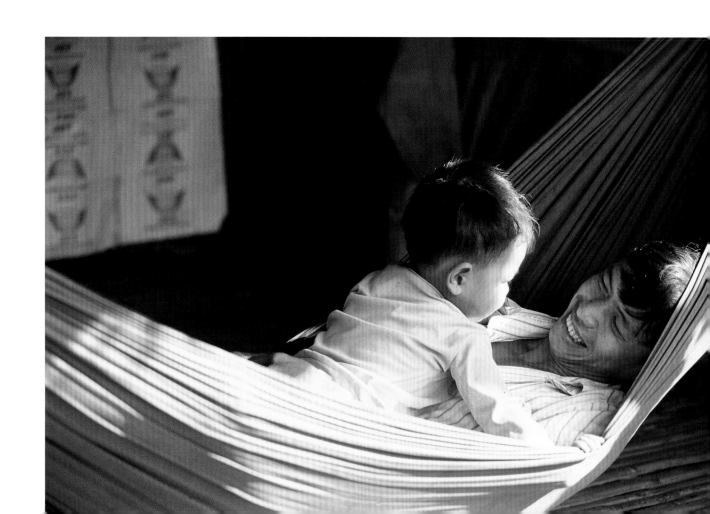

The *dinh*, with its altar for the village guardian diety, has been for centuries the center of village communal life. The fortunes of the village depended, it was believed, on the proper performance of rituals for the village's spiritual guardians, just as ritual performance by family members ensured the family's fortune. But during and after the war, *dinhs* were desecrated and used for less spiritual purposes — temporary storage for rice, hospitals, shelters for urban evacuees, Party headquarters and "cultural houses" whose discussions and festivals served political purposes such as spurring on peasants under collectivization to meet production targets.

But a funny thing happened along the road to the "New Way of Life": the people themselves decided to take a detour and return to old paths. In some villages, women and the elderly saved *dinh* statuary, gongs, and incense burners. Women traditionally had been banned from the *dinh* and held less power even in the village under communism; having less to lose, they defied the dictates of ritual reform and in secret ceremonies at night called upon ancestral and guardian spirits for their blessings. Some villages saved their shrines and statuary of village deities from destruction by adding Ho Chi Minh to the traditional pantheon of guardian spirits. Traditional wine was poured into new socialist bottles as the Party recognized that tradition could promote social order. The meritorious deeds of guardian deities, some like craft ancestors, real, and others mythical, were enlisted as examples of socialist valor and virtue.

Doi moi has brought wealth and increased economic differences to the village. As the Party loosened its control or attempts to control social life, the new socialist man and woman did not emerge but rather the old traditionalist reappeared decked out in a shiny new set of clothes. People now spend more money on more family and communal rituals. The celebration of death anniversaries has become more popular. Families use traditional life cycle events — birthdays, weddings, marriage anniversaries and funerals — and other special happenings like building a house or sending off and welcoming home a son after a long trip as opportunities to pay ritual respects to their ancestors, seek their advice, and elaborately display their own

wealth and social standing. The number of food trays a family provides the wedding guests is a sign of the family's status and connections. Old elites may have been eradicated but new ones—Party leaders among them—have taken to celebratory banquets with an Olympic competitive spirit.

Dinh, pagodas, churches, spirit shrines and other public sacred spaces have been restored. The *dinh* has reemerged as a center of spiritual celebration and is now a more democratic place, open to women's groups as well as men's. Offerings of incense, sticky rice cakes, and red wrapped rice powder cones along with fruit and cooked chickens are available in the numerous stalls in the village and brought to the *dinh* and pagoda as offerings. In true affirmation of Veblen's theory of conspicuous consumption, "a small piece in the middle of the village is worth more than a full meal in the corner of the kitchen."

Behind the facade of a new socialist culture, the old heart of village spirits and family ancestors beats. Maybe people are reaching out for something unchanging in a world of change or they recognize that ancestors and village deities still provide protection in a world where nature remains fickle and human beings mercurial and rapacious—or maybe the answer lies a bit in both. Perhaps, it pays to hedge your secular bets with a bow to the spiritual. As did one former landless peasant who marked on the ceiling of his new home, "Owing to ancestors, the new house is constructed; thanks to the Party and Uncle [Ho], the present conditions are achieved."

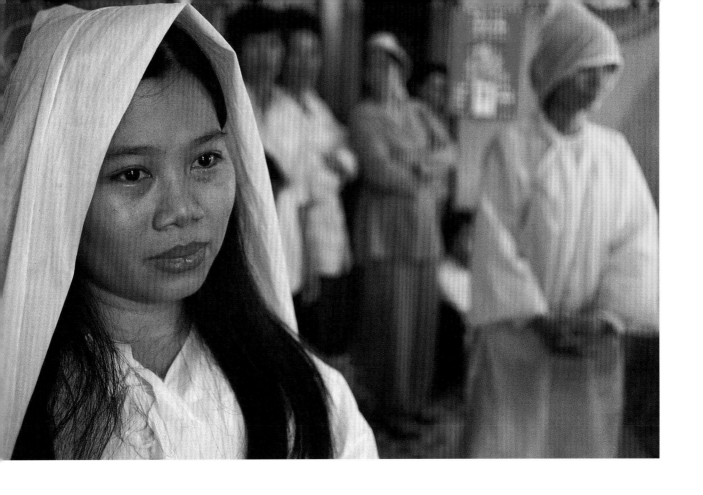

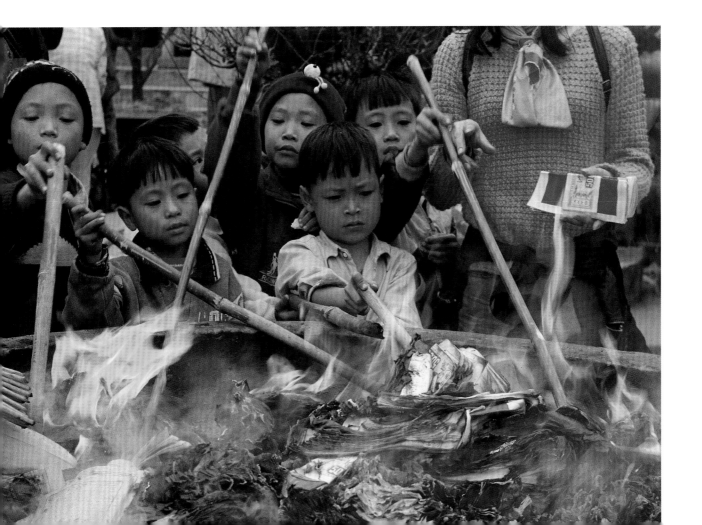

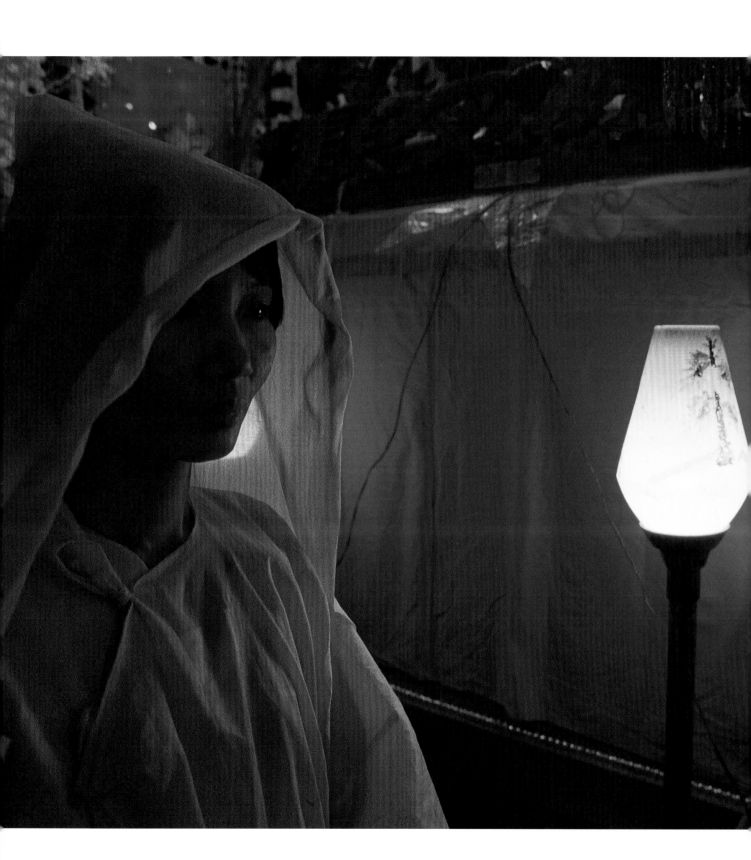

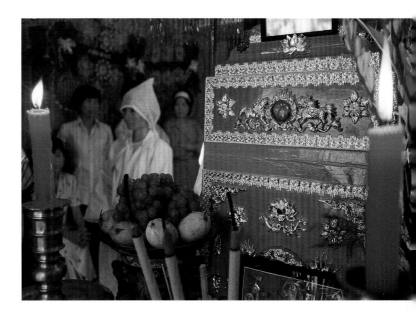

Aunt Tam's grave was the only one covered with flowers. The others were decorated with just a few incense sticks, already bent over by the wind. Nuggets made of gold leaf—the fake currency offered to the dead for their voyage through the next world—rotted where they had been scattered between the tombs. For my aunt's funeral, we had also burned gold-leaf nuggets and the "hell money" made of paper. The villagers urged me to do this, saying, "She lived magnificently, so she must die in style." They praised my piety and the splendor of the burial. I listened, satisfied. Now, I stood alone before this grave strewn with white flowers."

—FROM *Paradise of the Blind*. DUONG THU HUONG, 1947–

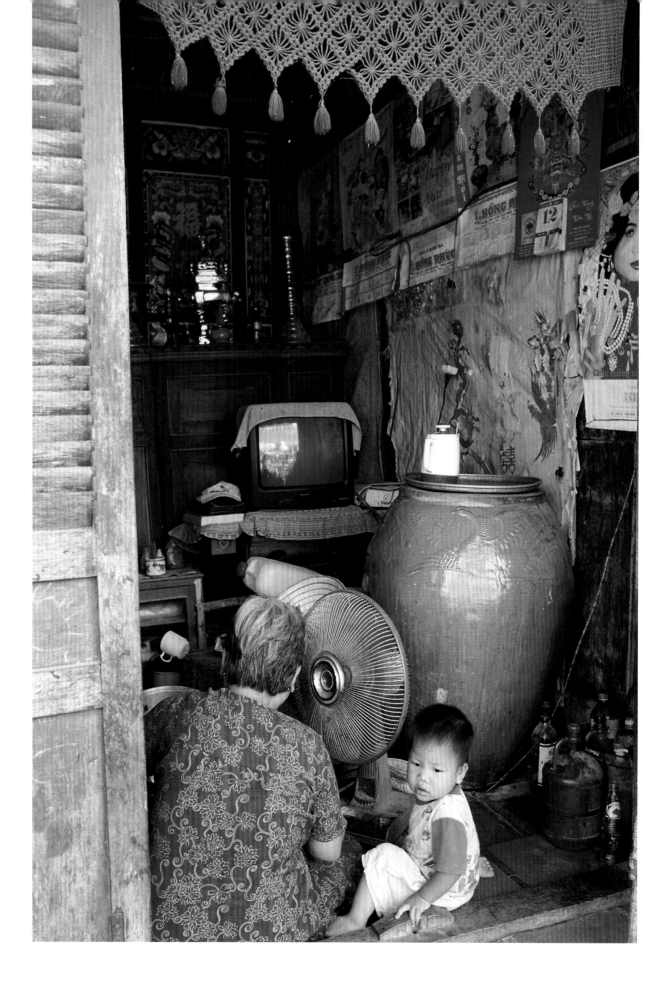

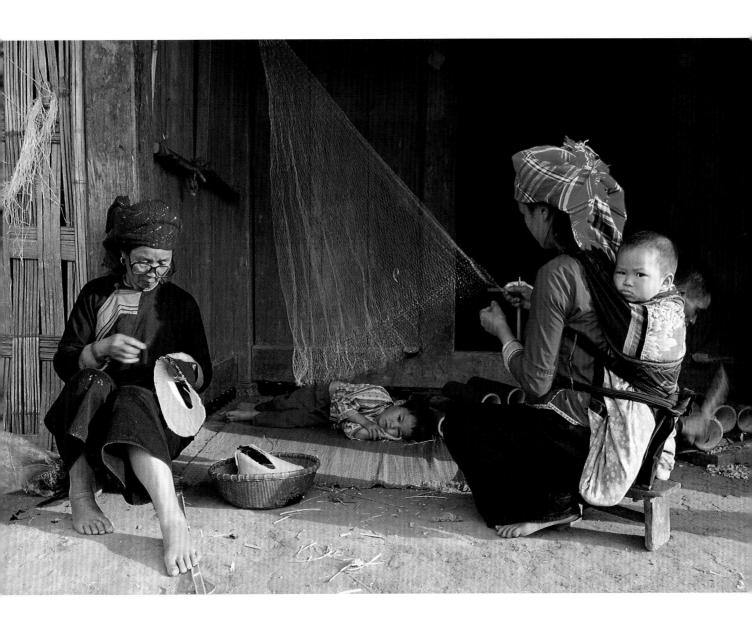

Sisters, do you know how it is? On one hand,
the bawling baby; on the other, your husband

sliding onto your stomach,
his little son still howling at your side.

Yet everything must be put in order.
Rushing around all helter-skelter.

Husband and child, what obligations!
Sisters, do you know how it is?

—"The Condition of Women."
Ho Xuan Huong, 19th century

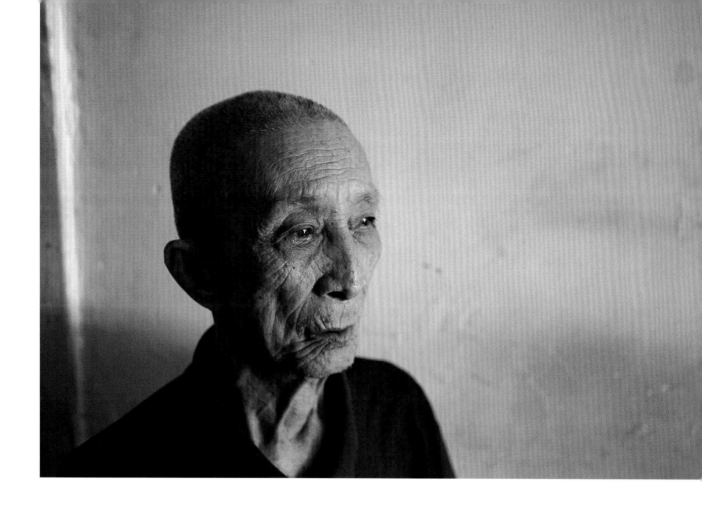

My hair has thinned, my teeth have worn away.
I've left the household to my children's care.
A chessboard and wine cups among bamboos;
A bunch of twigs, a fish pole in the hills.
Leisure enhanced by pleasure brings sheer joy.
Rice flavored with sea salt tastes good and fresh.
At ninety, I would say it's late in spring.
Let this spring go—another spring will come.

—"My Hair Has Thinned, My Teeth Have Worn Away."
Nguyen Binh Khiem, 1491–1585

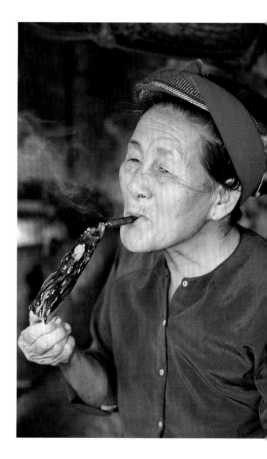

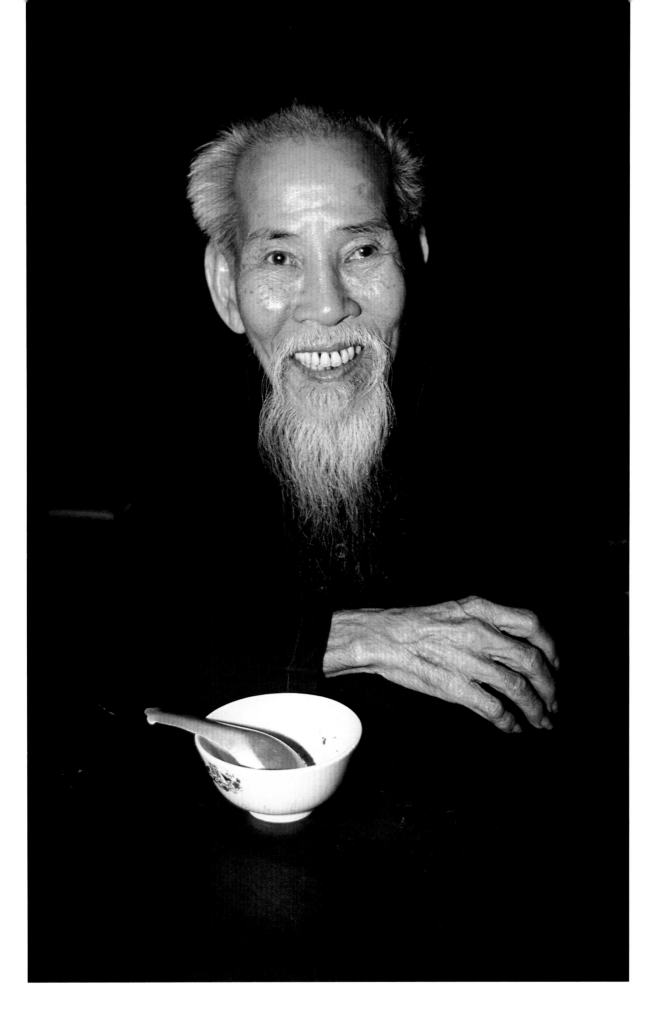

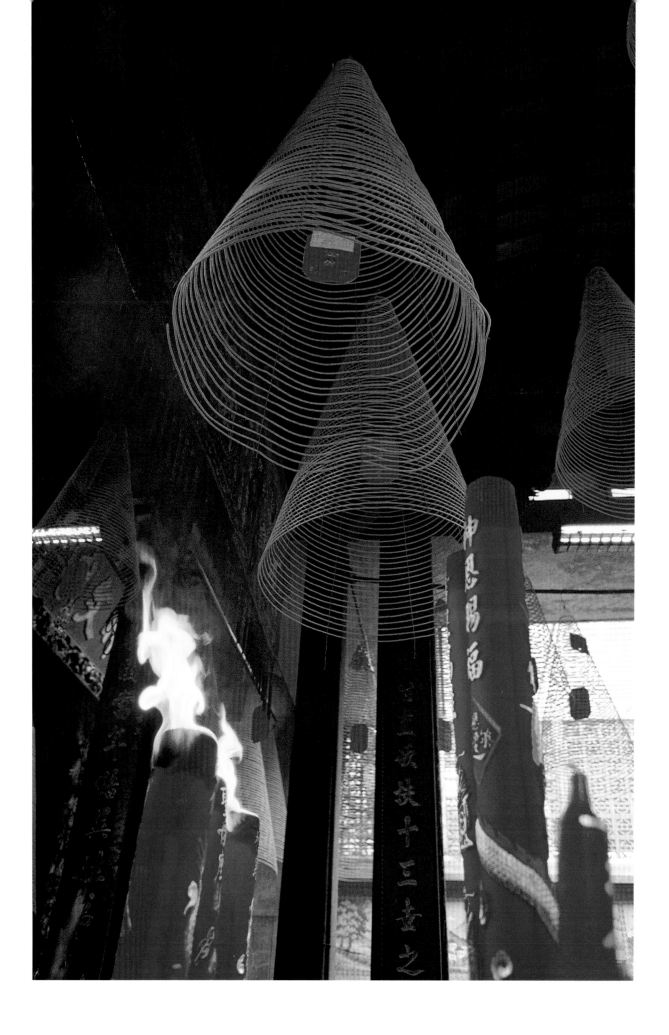

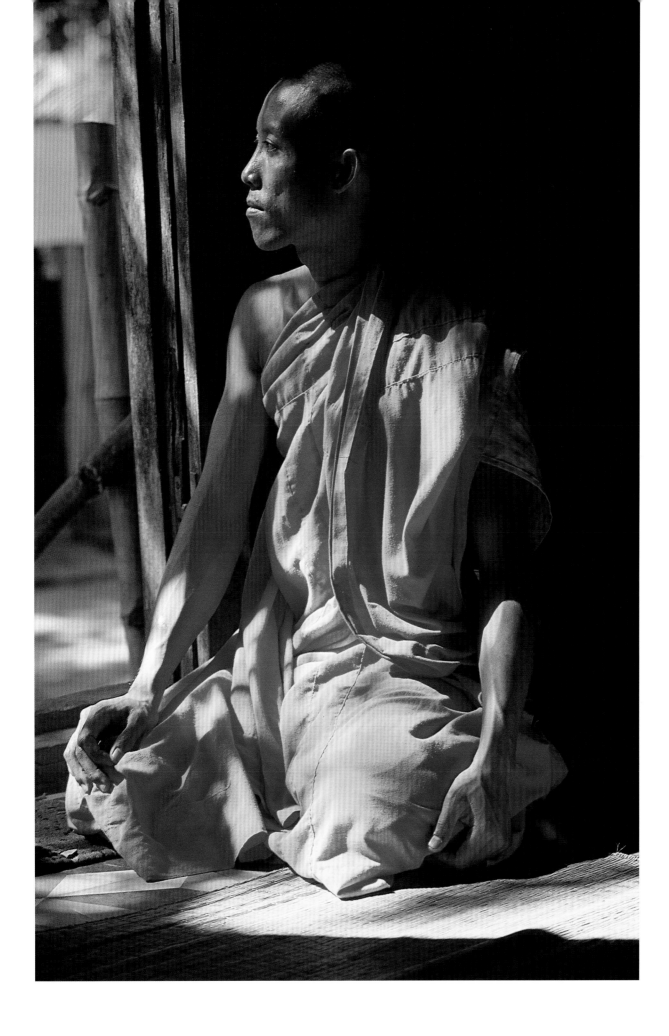

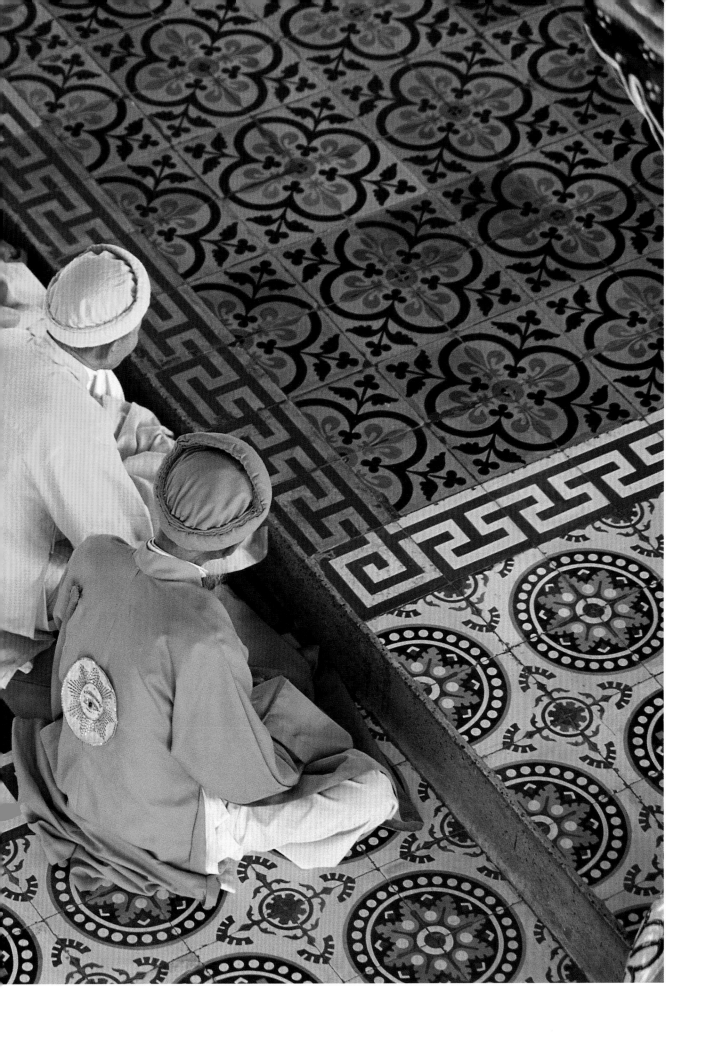

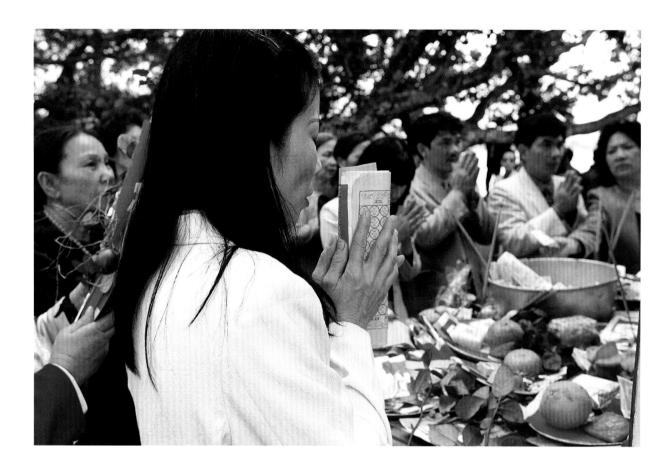

Tet comes but once a year,
please accept this drink I hold up to you, dear wife.

You smile, you like the wine already, even before you taste it,
what's sweet will rise; what's bitter will sink.

Our feet have worn away so many roads,
all year round we've worked, hoping for a day of spring.

Dear wife, our heads grow white and whiter,
Tet comes but once a year.

—"Offering My Wife a Drink." Nguyen Duy, 1948–

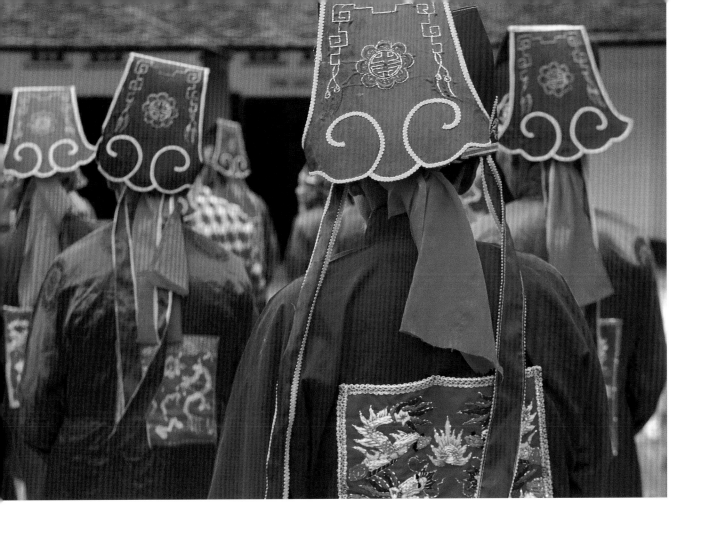

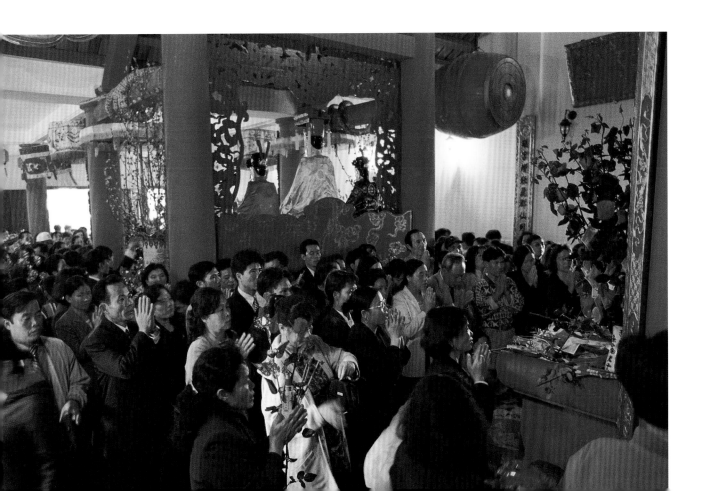

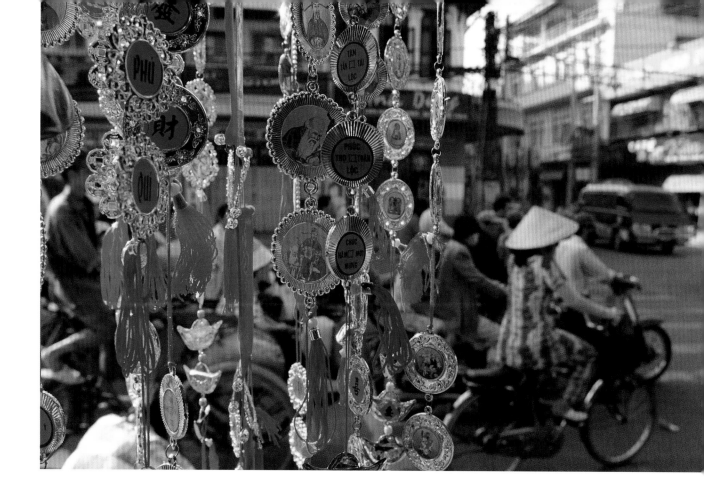

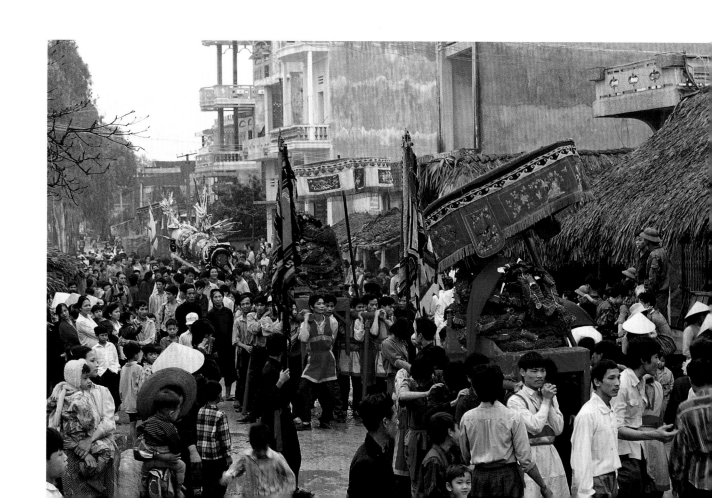

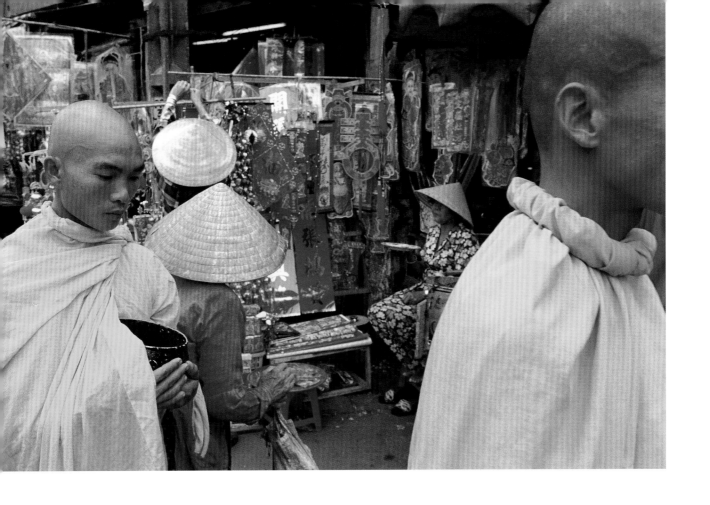

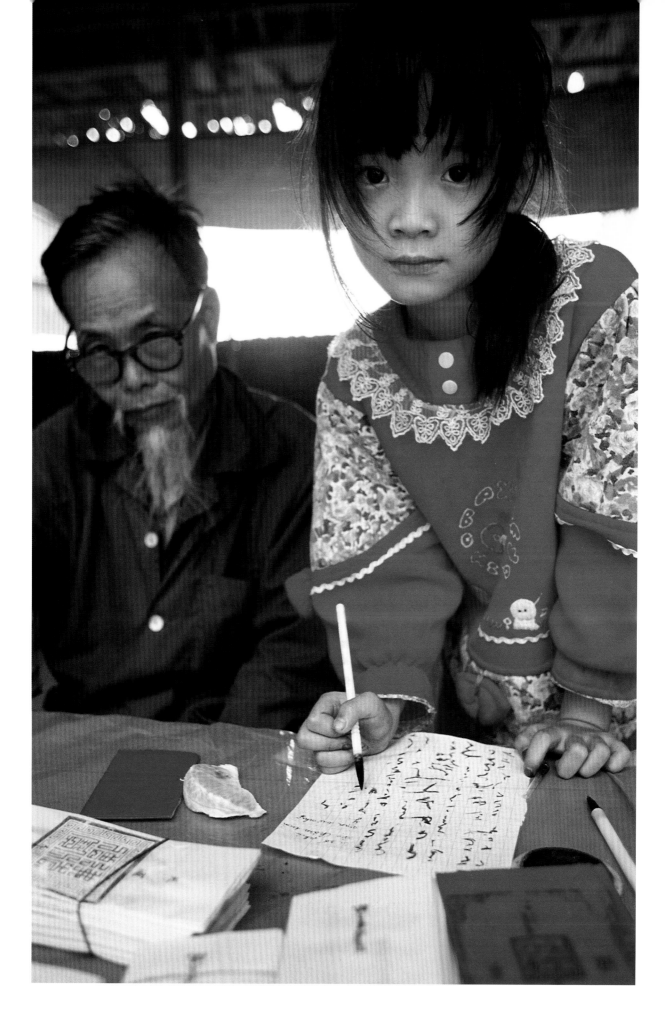

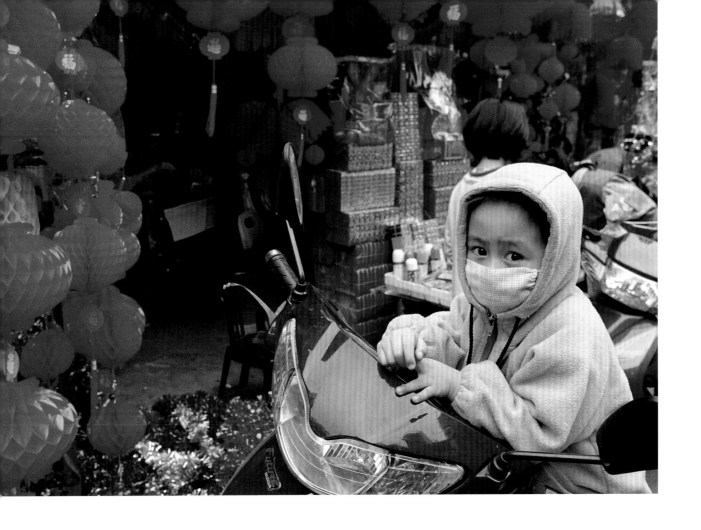

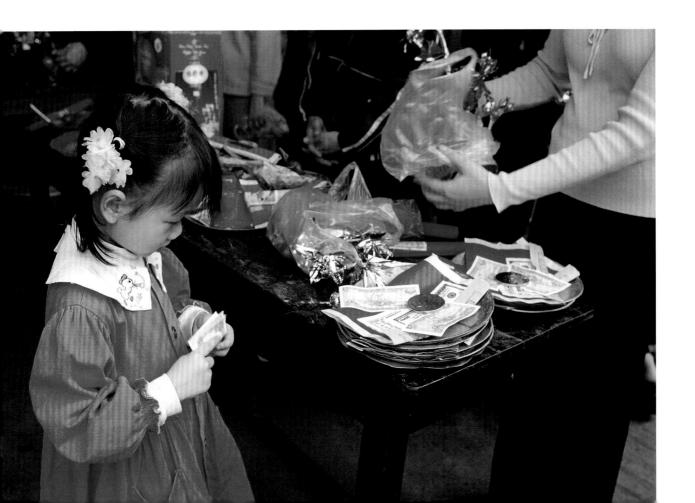

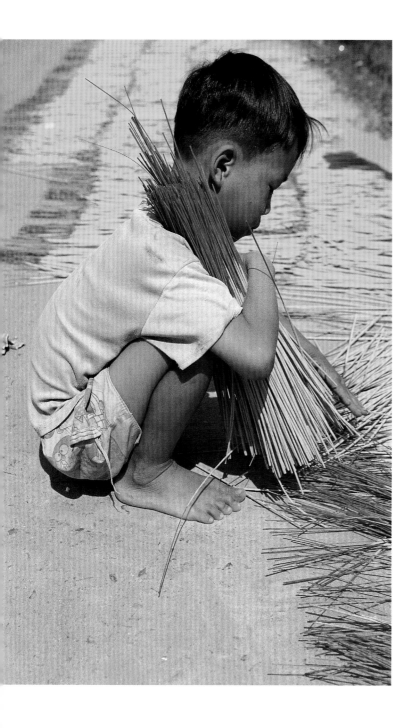

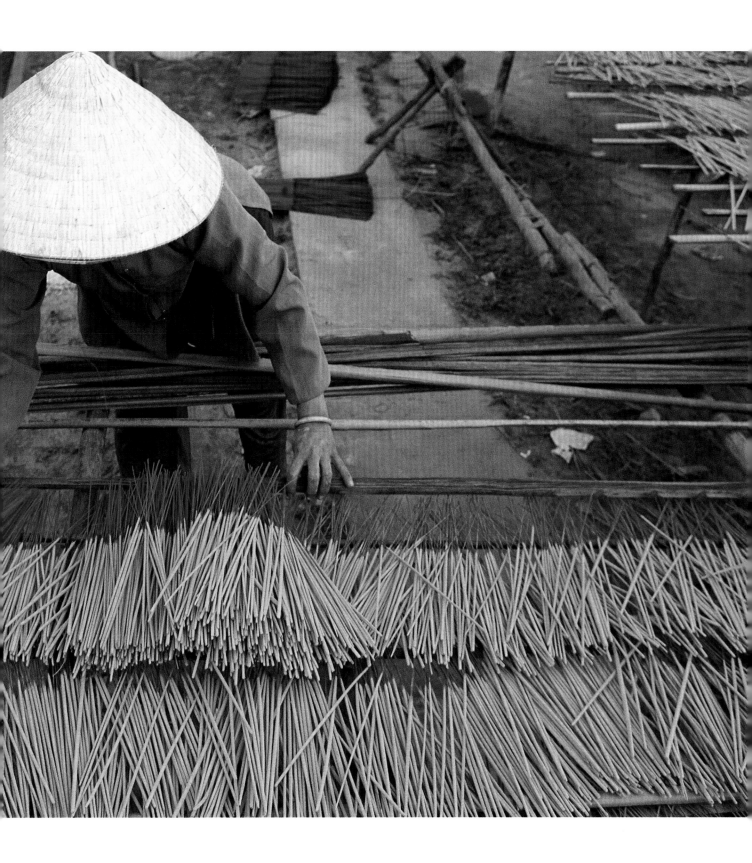

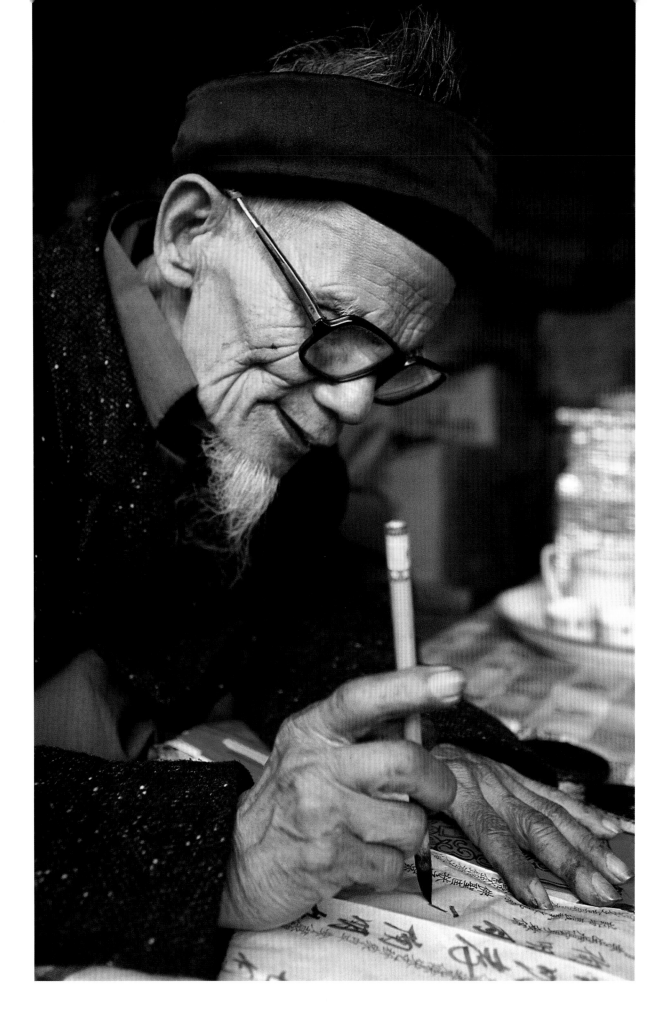

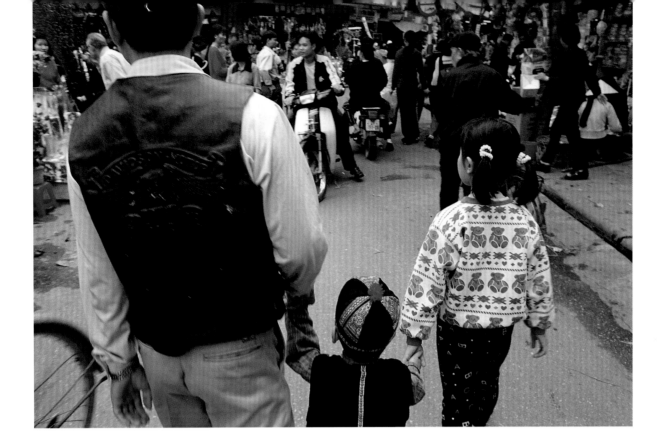

Each year when peach trees blossomed forth,
you'd see the scholar, an old man,
set out paper and black ink
beside a street where many passed.

The people who hired him to write
would cluck their tongues and offer praise:
"His hand can draw such splendid strokes!
A phoenix flies! A dragon soars!

But fewer came, year after year—
where were the ones who'd hire his skill?
Red paper, fading, lay untouched.
His black ink caked inside the well.

The aged scholar sat there still;
the passers-by paid him no heed.
Upon the paper dropped gold leaves,
and from the sky a dust of rain

This year peach blossoms bloom again—
No longer is the scholar seen.
Those people graced a bygone age—
where is their spirit dwelling now?

—"The Old Calligrapher," Vu Dinh Lien, 1913—

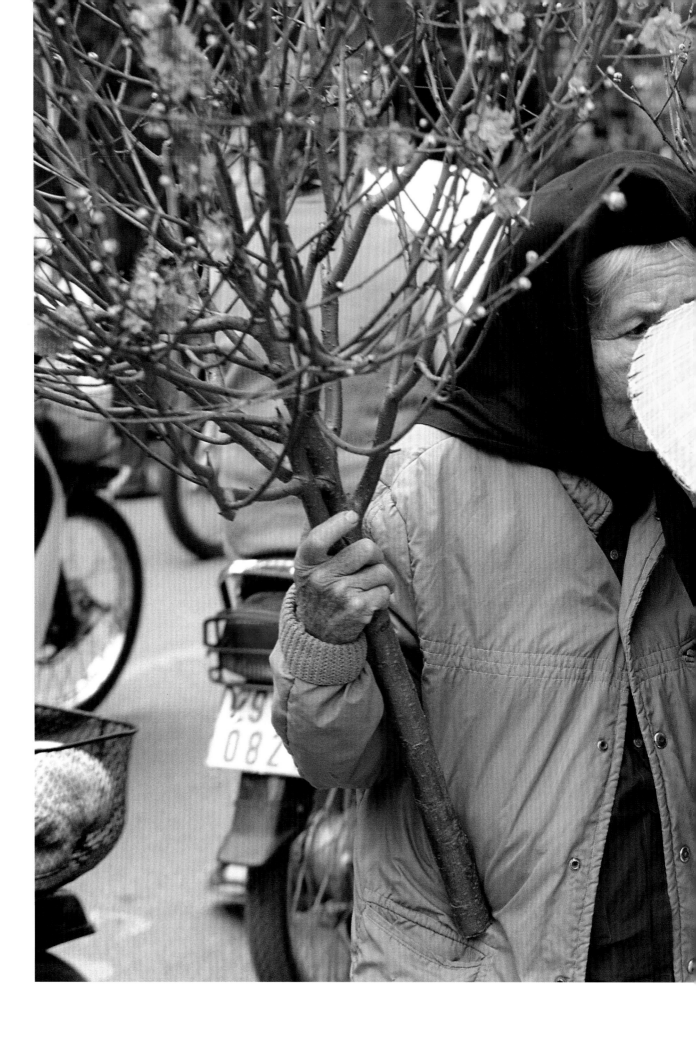

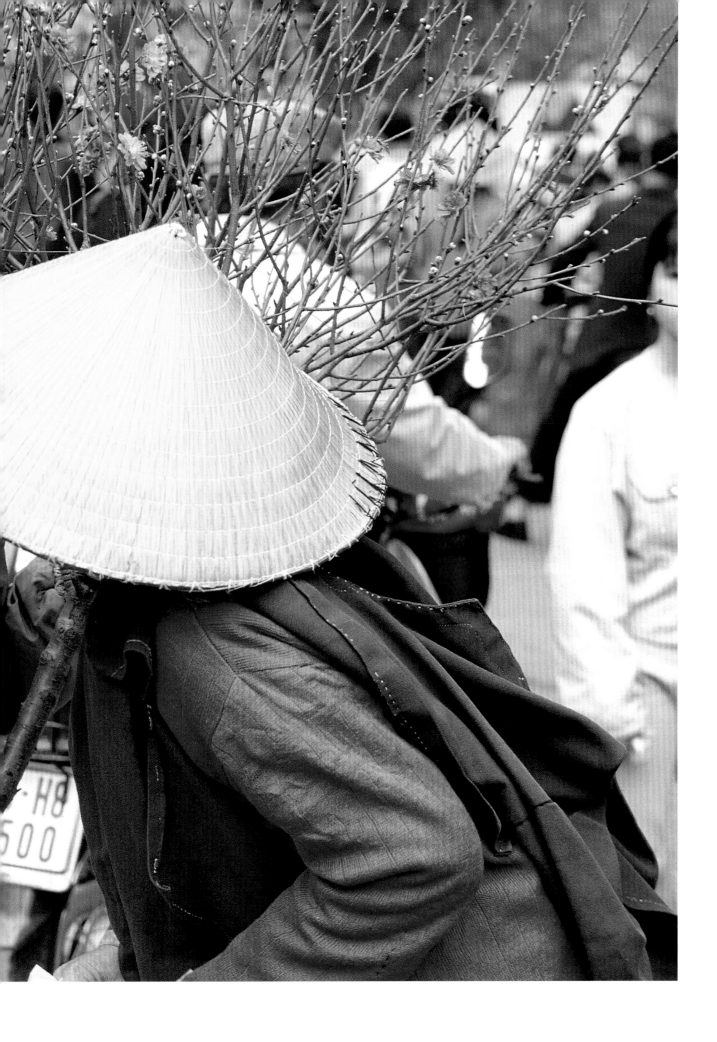

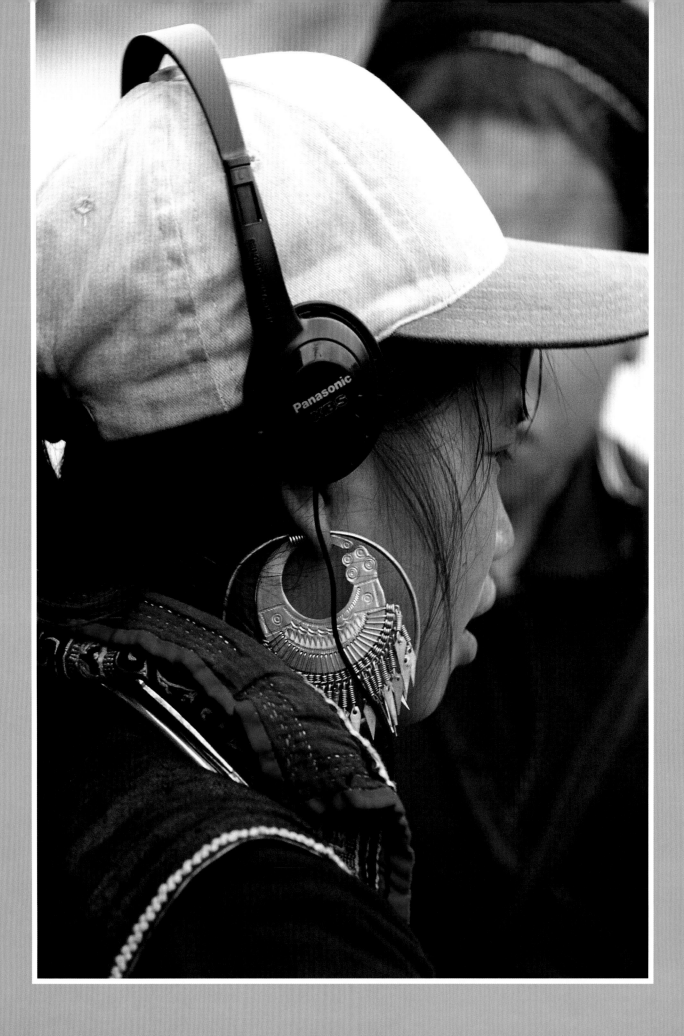

IV

Decent Dreams

A young woman (left) wears intricately hand-wrought traditional Hmong earrings and necklace, and sports the universally *de rigueur* baseball cap and the latest in Panasonic electronic fashion. We don't know what she is listening to—the foreign sounds of some "poisonous cultural product" the government periodically rails against, a local Vietnamese rock band or perhaps a self-help tape on how to start her own crafts-exporting business. She is a visual symbol of a country trying to balance tradition and change. Whatever her musical taste, she, like her lowland compatriots, harbors "decent dreams" for the future, the "weal and wealth" Kieu finally achieved—simple dreams centered on a healthy family, well-fed, living in peace and earning enough to enjoy the present and honor the past.

The Party leadership appears ambivalent, not about these dreams but how fast to move to make them a reality. The leadership is bedeviled by the past. Vietnam finds itself burdened by the glories of the past, by the very past that was the foundation of the national identity that fueled its triumphs in war. And it finds itself fighting reemergent shadows from the past that threaten the social and moral order. Ideologically ambivalent about the market road it has set out upon, Vietnam's communist leadership is struggling to extract the material benefits from development while containing the cultural and social consequences that could undermine its power.

The changes and accomplishments over the past fifteen years have been striking and impressive. Here, numbers tell a story worth listening to: In 1986, eleven years after unification, only six thousand visitors came to Vietnam—in 1997, 1.8 million people visited the country. Openness to people, foreign investment, and a mixed market economy brought economic growth in the early 1990s of over eight percent, and

in 2001, despite the post-1997 Asian economic downturn, the Vietnamese economy grew at seven percent, second only to China among the world's larger countries. Rice production and exports have steadily risen and in 1999 Vietnam surpassed Columbia as the second largest coffee producer behind Brazil. Economic growth has brought with it a reduction in poverty: in 1992 almost sixty percent of the population lived in poverty but six years later the figure was down to thirty-seven percent.

You don't have to be an economist schooled in graphs and charts to notice changes—they roar by you as you walk the streets of Hanoi and Ho Chi Minh City, especially when thousands of young people drive endlessly through the center of the metropolis on the Sunday night *chay rong rong,* "the big ride around". Two-thirds of households in the cities own motorbikes, and sometimes it seems that the entire family is perched on the back of a bike like a daring circus act. Motorbikes with passengers hugging dressers, large mirrors, crates of live pigs and chickens, weave through the increasingly crowded streets.

But beneath the aggregate economic figures and sea of young well-dressed bikers there is the hollow ping of Potemkin numbers and disturbing inequalities and trends. There may be over sixty thousand internet users but two-thirds are government and Communist Party bodies. There may be a stock market in Ho Chi Minh City but all the companies listed are state-owned. People may be driving new motorbikes but they are also spending over sixty percent of their income on food—a sign of personal economic hardship. Millions continue to be underemployed and unemployed. While bringing greater economic growth, *doi moi* has also brought greater economic inequalities, both between regions and within regions and villages. Residents of Saigon have incomes almost four times that of the rest of the country, and economic benefits have been slow to reach the Northern Highlands, where entrenched poverty among minority groups (which make up thirteen percent of the country's population) persists at rates almost twice that for the country as a whole. While the country has single digit illiteracy rates for both men and

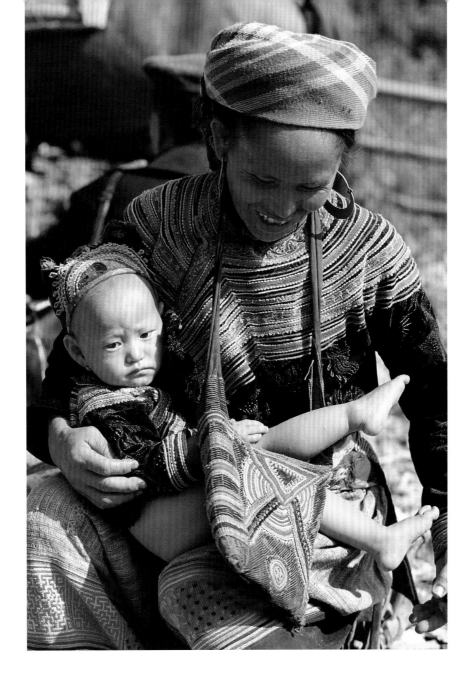

Little one, go to sleep. Sleep soundly.
Mother's gone to market, father ploughs the far field.
Our parents toil for our meals,
 rice, and clothing, making the land yield a good home.
Grow up, study hard, little one;
tend to our native place, mountains and rivers.
Become worthy of the Lac-Hong race.
Hopes met, our parents faces will widen in smiles.

—"LULLABY," FOLK POEM

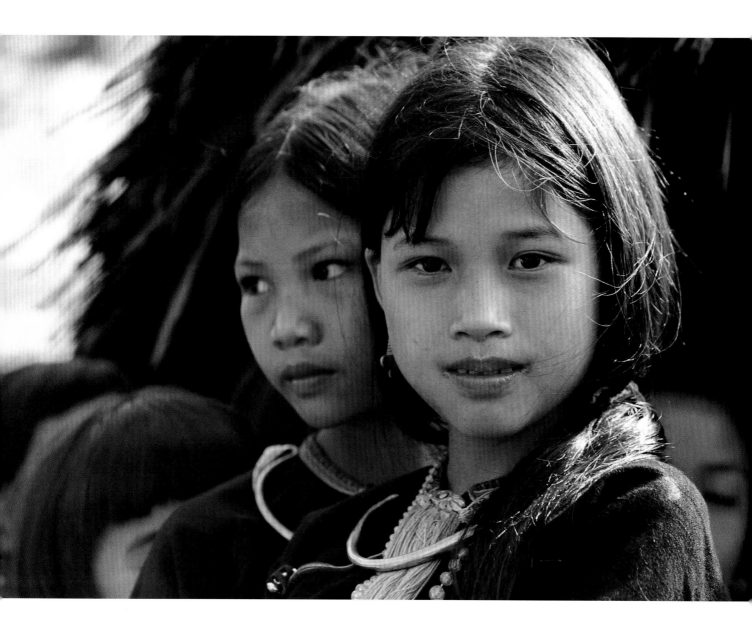

Dew-splattered faces to the sun, they bloom every year.
Thin moonlight, clear wind, and in me, peace.
Laughing at those who don't see the miracle of flowers,
I put chrysanthemums in my hair and go to bed.

—FROM CHRYSANTHEMUMS. HUYEN QUANG (1245-1334)

women, among the Hmong the illiteracy rate for men is over eighty percent and ninety-seven percent for women.

The state still legally owns all the land, but by the end of the 1990s the government had granted tradable title to over ninety percent of lowland farms. Positively, agricultural renovation has brought increased production but, negatively, has brought back the specter of class division and peasant impoverishment. An informal but illegal market in land use rights has arisen. This does allow ambitious people to sell their land and use the money to pursue opportunities in the cities, but this market has also spawned the accumulation of village lands by small numbers of families, an increase in landless peasants and landlord-tenant relations reminiscent of the pre-1945 era. Exploitation of hired agricultural workers became so troubling that in the fall of 2000 a minimum wage for agricultural labor had to be set (though below the poverty level), and there was mass peasant protest north of Hanoi against plans to build a luxury golf course. With the demise of cooperative services in the countryside, rural families now bear education and health costs, having to pay fees for deteriorating services.

Despite the five-star tourist hotels, the hip bars and restaurants, Vietnam still remains a poor country with a GNP of approximately $320 in 1999. Vietnam has the third highest rate of tuberculosis in Asia, three-quarters of all pregnant women in 1997 received no maternal health care, and eighty percent of the women in the mountains of the North delivered their babies at home. Behind scenic images of rural beauty and urban vibrancy, the majority of Vietnamese do not have access to safe drinking water. Behind the exotic attraction of their colorful clothes, the Hmong in the forests near Sapa are cutting old growth forests to survive, selling it for exploitatively low prices amounts for use in China, deforesting their own land and threatening the eighty endangered species that live in this habitat. Behind the neon of Ho Chi Minh City nightlife in the karaoke bars, massage parlors and "hugging bars," women are selling themselves in increasing numbers. "New Man," old problems; prostitution and drug use are on the rise.

The Emperor Minh-Mang in 1820 gave his court officials Western eyeglasses and bottles of perfume and urged them to read from his library "strange books from the four corners of the world." The perfume? Were they not only to look at the world through Western eyes but to smell good to Western noses? Or was it a prophylactic to protect them from the noxious ideas they might find in those "strange books"? Leaders royal and communist have had a selective, ambivalent view of Western culture, trying to winnow out the ideas underpinning material advancement from those that undercut their cultural ideals and hold on power. Add to the mix of motives, the Puritanical streak found in Communist ideology put to practice everywhere, and you have thirty years of cultural ambivalence, of "guided" freedom, doors opened then closed then opened again.

After Saigon fell in 1975, bands of youth went door to door destroying "poisonous works" of reactionary Western culture—books, tapes, records, and abstract paintings. Abstract art epitomized "art for art's sake," a theory the communists had long argued was a reactionary effort to divert the population from the revolutionary path. In 1945 Ho Chi Minh, after visiting an exhibition of paintings in Hanoi, called on the nation's artists to turn from their "highbrow" nudes and flowers and paint "the reality of our everyday life." The message was clear and at the next year's exhibition, paintings with titles like "Smashing Fetters," "General Insurrection," and "Vietnam is Free" hung on the walls. It wasn't until the late 1980s that nudes were shown in public, and it wasn't until 1992 that the first national abstract art show was held. In a recurring pattern, cultural openness would be followed by destructive reaction and retrenchment. In 1996 the government launched "war without gunfire" against a mix of social evils—drugs, prostitution, gambling, and the importation of foreign culture in music, film, video, and TV. Street marches with red flags waving, drums beating, and traditional music playing accompanied the public destruction of "immoral cultural products," including CDs, calendars, and ads. In 2002, the government finally agreed to certify as Miss Vietnam the winner of a beauty contest held by a newspaper since 1988; but then a few months later initiated

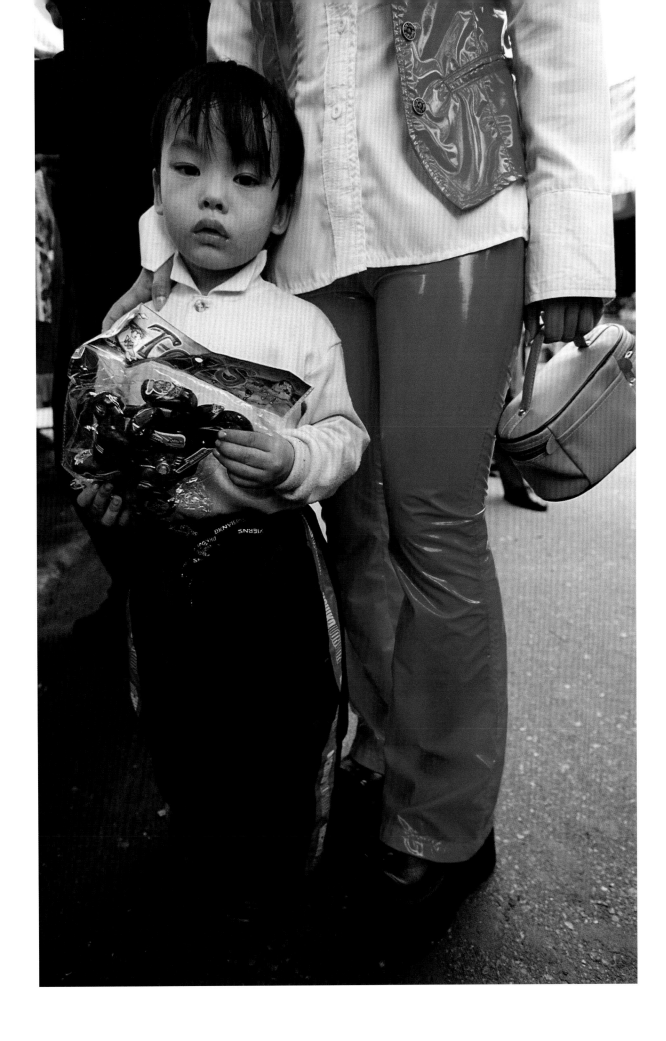

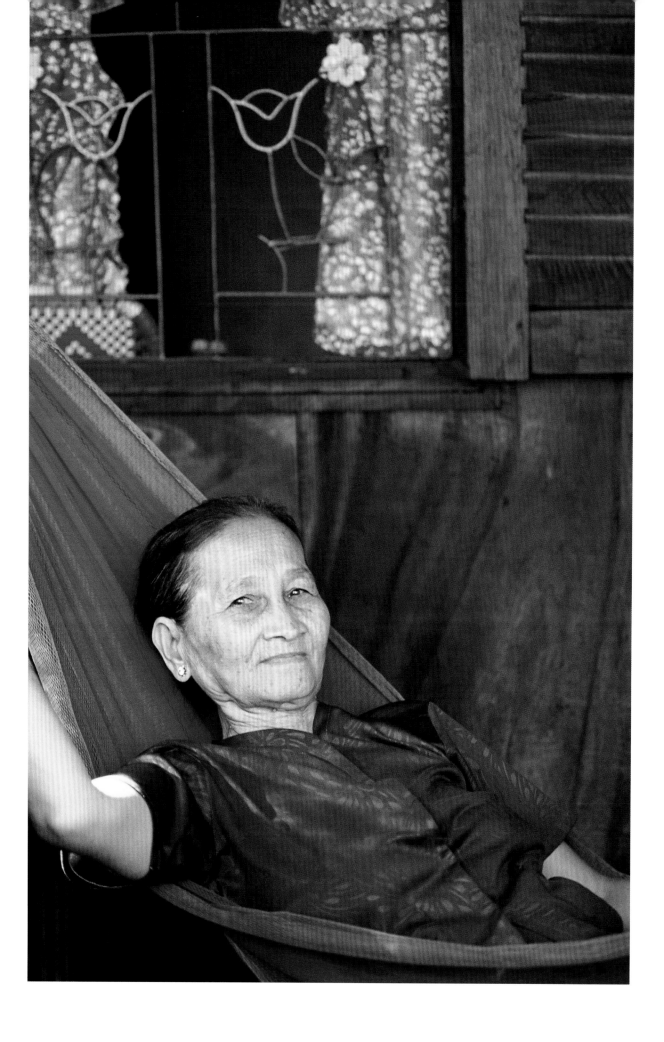

another campaign against "poisonous cultural products," burning thousands of CD's, videos, books, and advertising banners.

Schizophrenic behavior perhaps, but not without some rational foundation. Popular culture, especially from the West, does celebrate individualism and promotes in the extreme a self-absorption that an old-line revolutionary would find subversive. Vietnam's historical narrative—the story by which it defines itself—has been one of repulsing foreign aggression to maintain its freedom and national identity. When there is no geopolitical enemy, you find a cultural enemy to keep the forge of national identity blazing.

A danger is that if a country lives by the past it may die by it. Susan Sontag on first visiting Vietnam in 1968 wrote of the Vietnamese predilection of incorporating all information into a historical narrative: "Everything is either before or after something else." This historical narrative, this constant reference to the past, can sustain a country, it can also generate a burdensome nostalgia that weighs down the present. A golden age is rarely the one you are living in, at least not until it is over; "glory days" are always those behind you. "I ache thinking of this country's past," wrote Ho Xuan Huong in the early nineteenth century. Where, she sadly asked, are the "Old heroes, old deeds"? Today she would find the old heroes clinging to past deeds in hopes of preserving present power. Those, like the communist general turned dissident Tran Do, who criticized his compatriots and urged breaking from the past, find themselves expelled from the Party or worse.

While the elderly members of the Politburo debate and delay, the people dream their "decent dreams" of the future. The half built hotels, the foreign companies giving up on their investment plans are not, analysts claim, the result of the post-1997 Asian slowdown, but of Politburo division and bureaucratic foot dragging. The Party is unwilling to push *doi moi* further, to implement more fully a market economy for fear of the contamination of foreign "poisonous" culture and fear of losing its one-party hold on power.

But the dreamers have time and demography on their side. A third of the population is under fifteen years old and for well over half of the

population the "American War" is ancient history; revolutionary ideals are the ideals of parents and grandparents. Experience teaches that the Vietnamese will not jettison the past whole cloth, but tradition and modernity will be woven together in something uniquely Vietnamese. The Vietnamese have the knack for transmuting foreign influences and making them their own. Chopsticks, tea, and the literati tradition of China, berets, baguettes, café filtre, and the aesthetics of Matisse, Hanoi hip-hoppers in gold lamé blend together. Musicians in traditional costume from the Quan Ho Ha Bac area north of Hanoi performed centuries-old folk songs at the opening of Vietnam's first abstract art show 1992 — hard to imagine Ralph Stanley with his bluegrass songs of death and despair being asked to a comparable opening at a hip Soho gallery in that year. The Vietnamese make this juxtaposition of tradition and change seem natural. A cultural DNA is at work absorbing the new through a filter of tradition, creating a present related to but not a clone of the past.

In the villages of Vietnam, homes are not always built at one stroke, and it is not unusual for a young family to live for several years in an uncompleted house. The people pictured in this book are living in a country under construction. The architects are quarreling and there is no one blueprint. How long will the young couples on their new motorbikes speed around in circles of neon glitter and glitz going nowhere fast? Will the young boy (right) with his weary adult eyes, fist full of money and dragging coolly on his cigarette become the shady deal-making tycoon of a full-throttle market future? No one image can give us the future. But if Nguyen Du, the author of *The Tale of Kieu* is right and "Inside ourselves there lies the root of good," there is cause for hope in these images of patience and calm, innocent joy, and visible love.

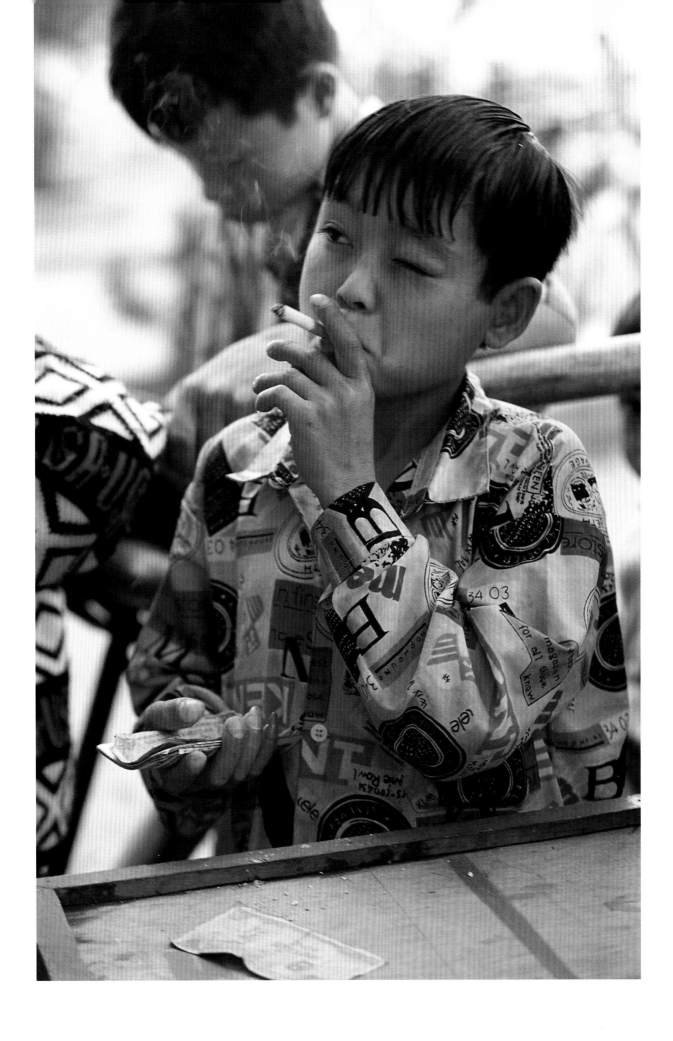

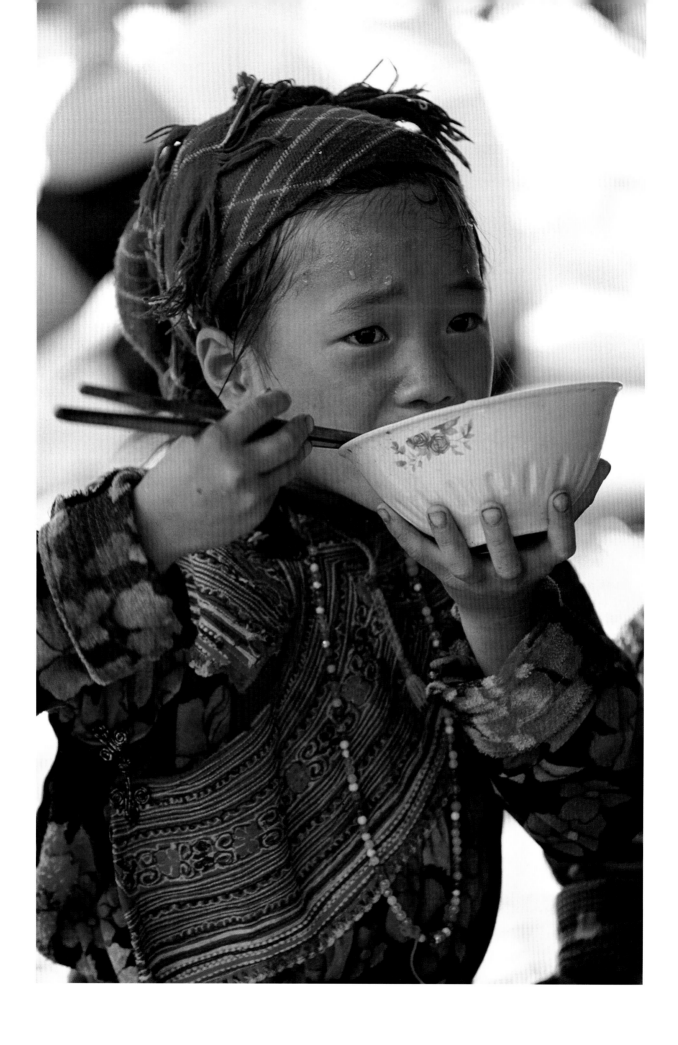

The rich eat three full meals, the poor two small bowls,
But peace is what matters.
Thirsty, I drink sweet plum tea;
Warm, I lie in the shade, in the breeze;
My paintings are mountains and rivers all around me,
My damask, embroidered, the grass.
I rest at night, rest easy,
And awake with the sun
And enjoying Heaven's heaped-up favors.

—"THE RICH EAT THREE FULL MEALS."
NGUYEN BINH KHIEM, 1491–1585

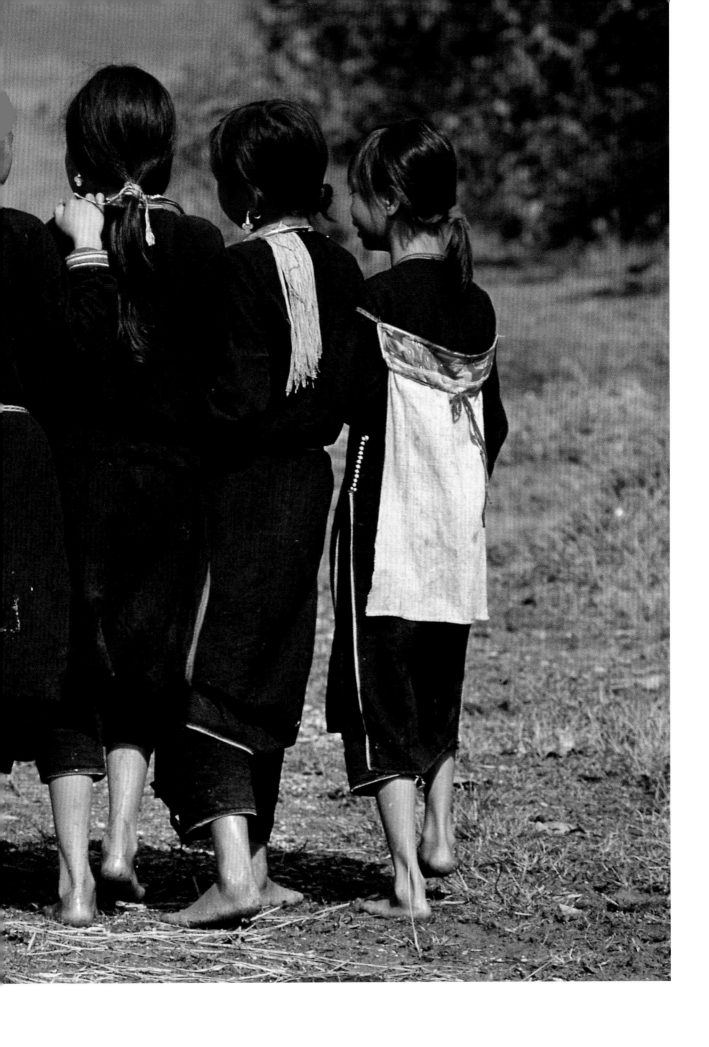

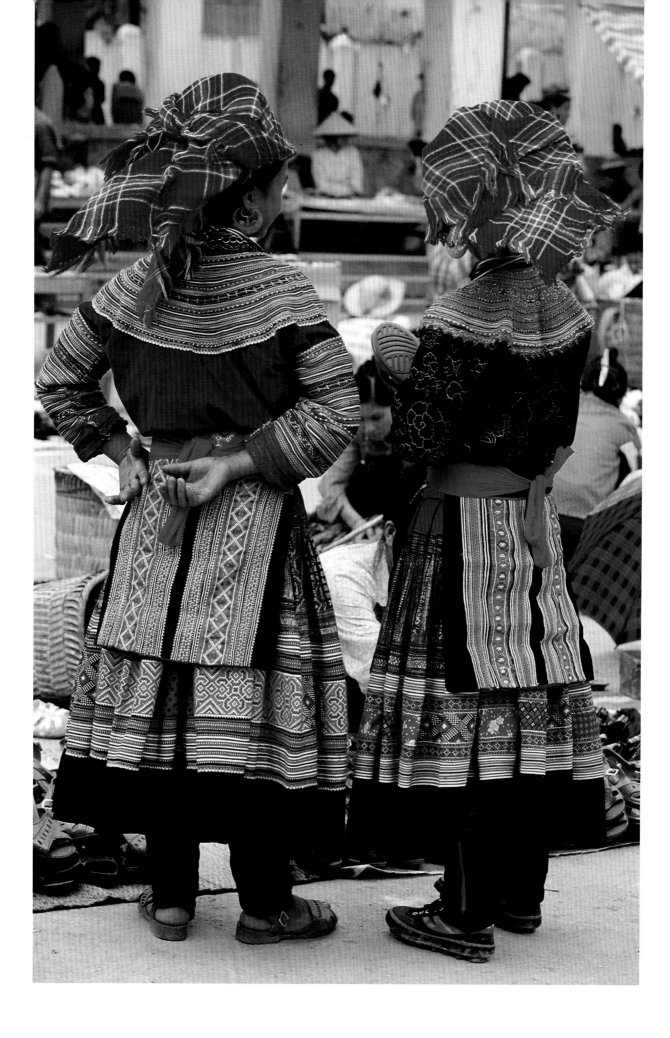

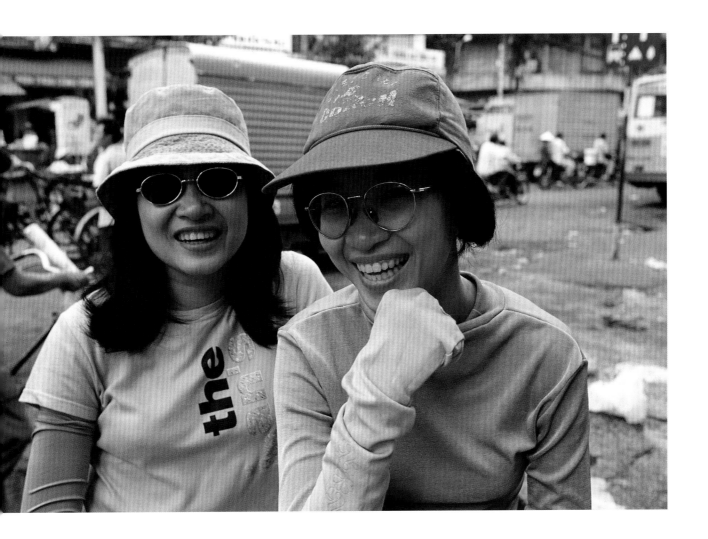

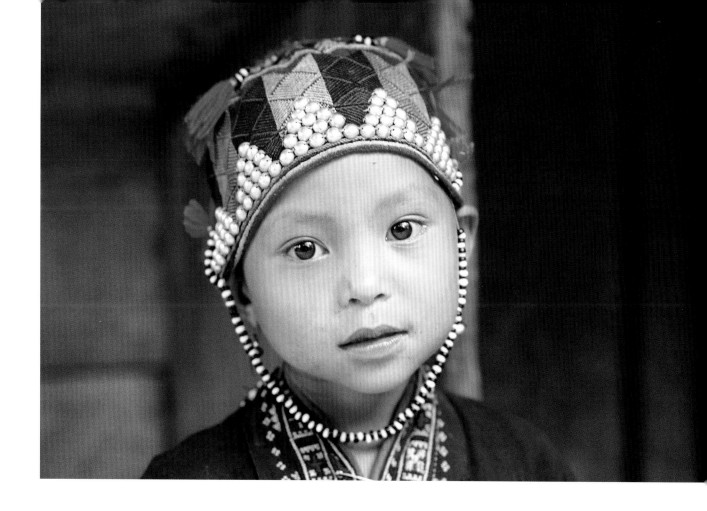

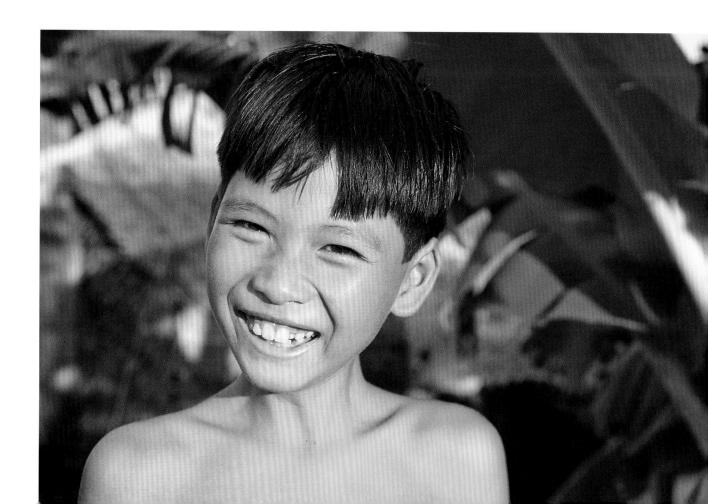

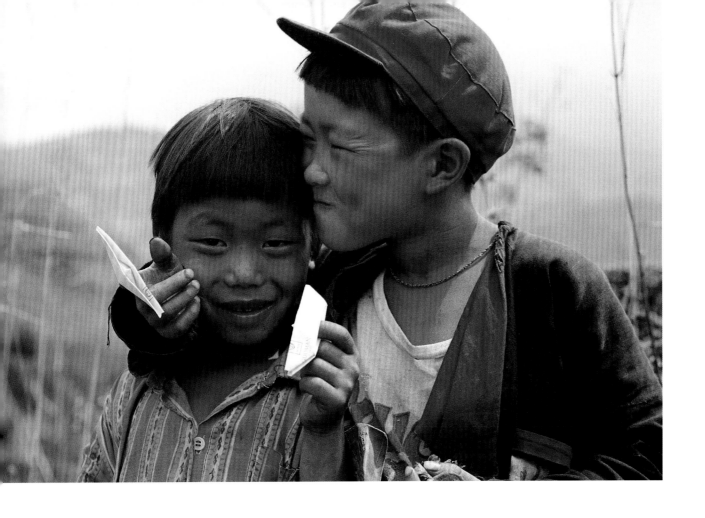

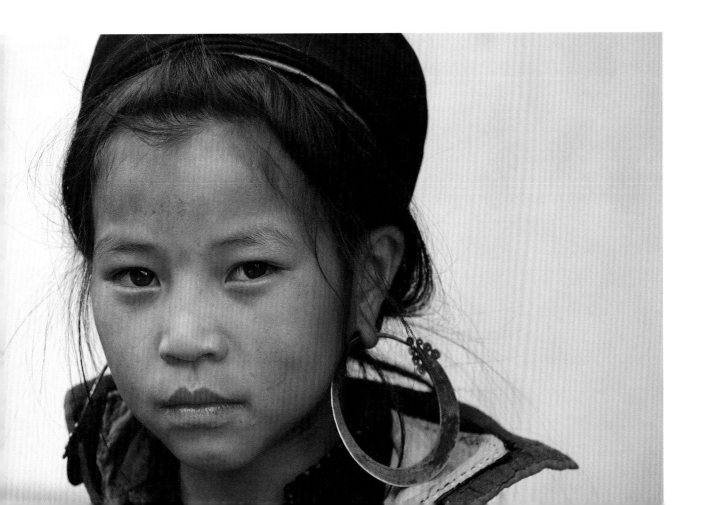

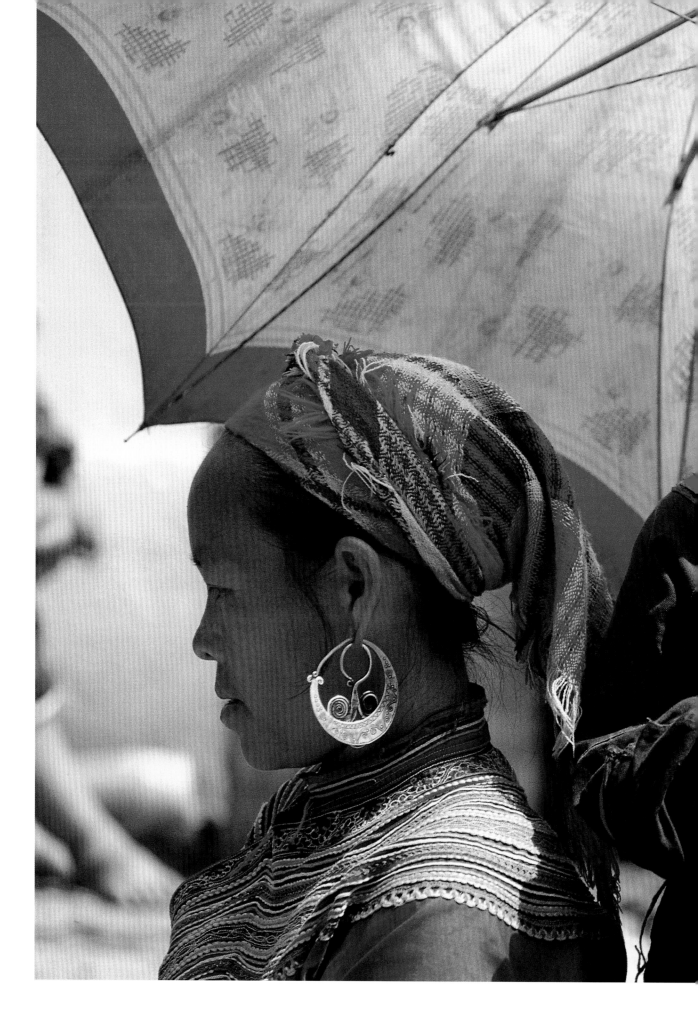

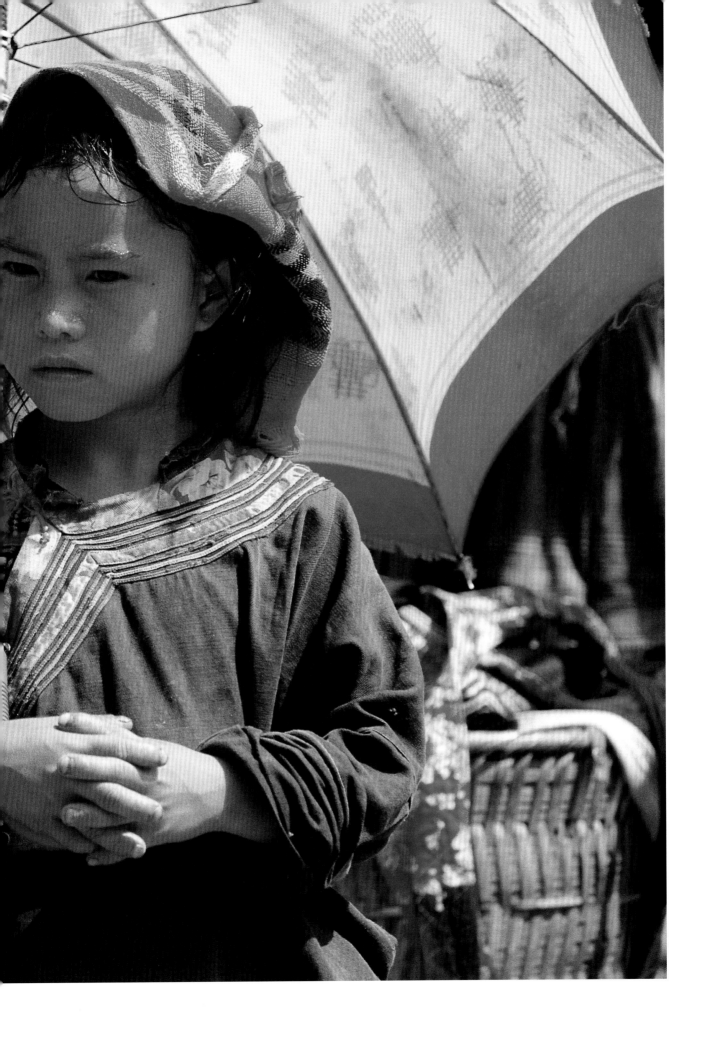

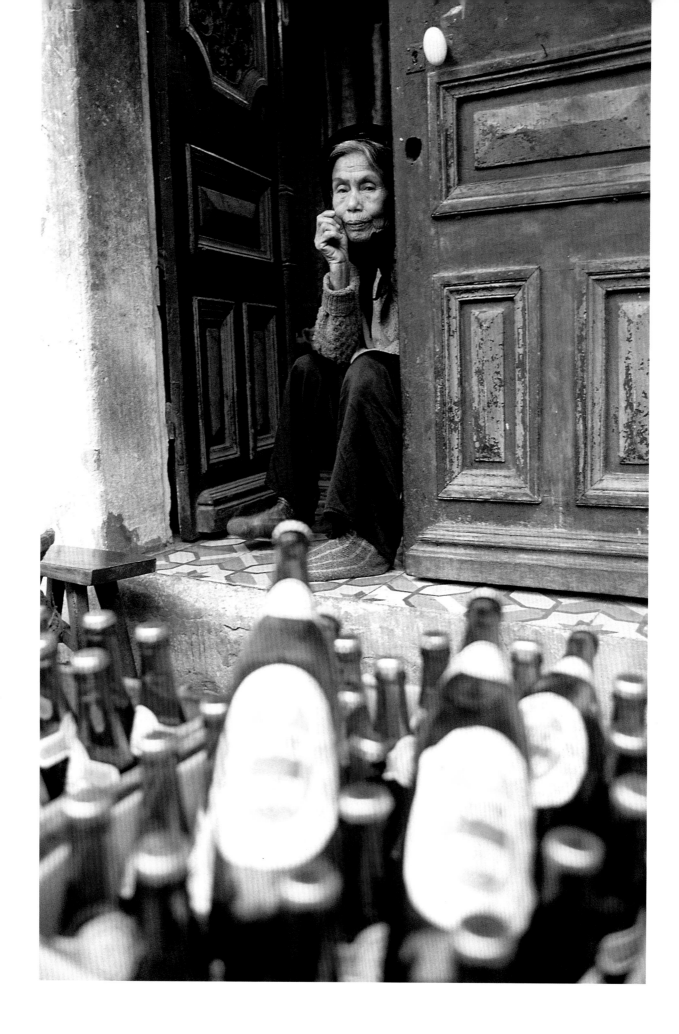

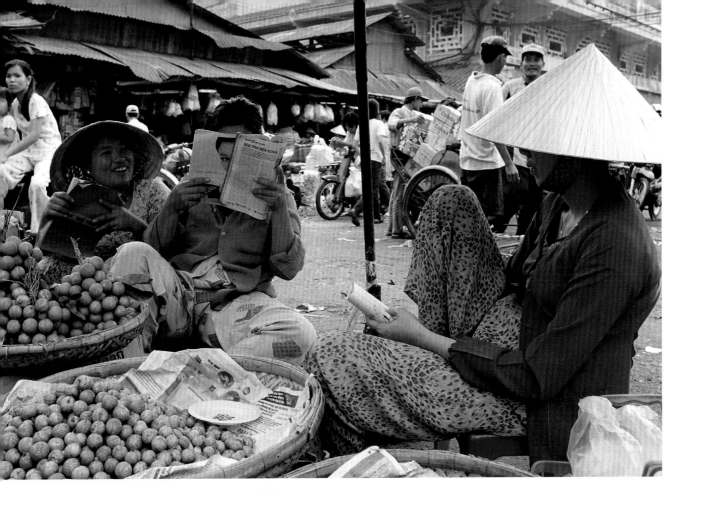

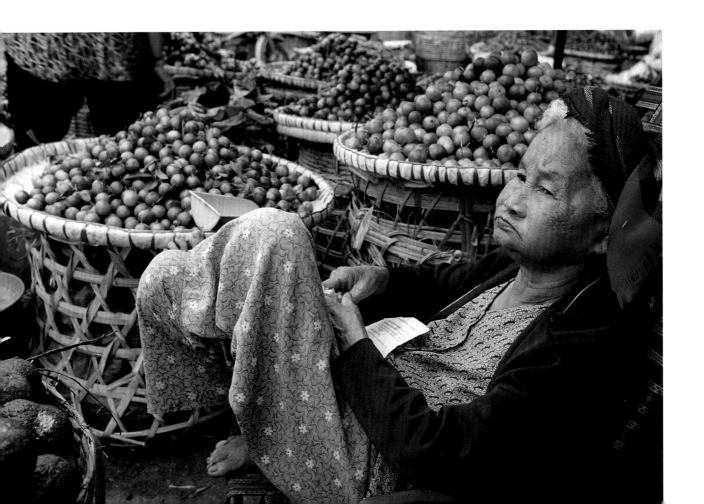

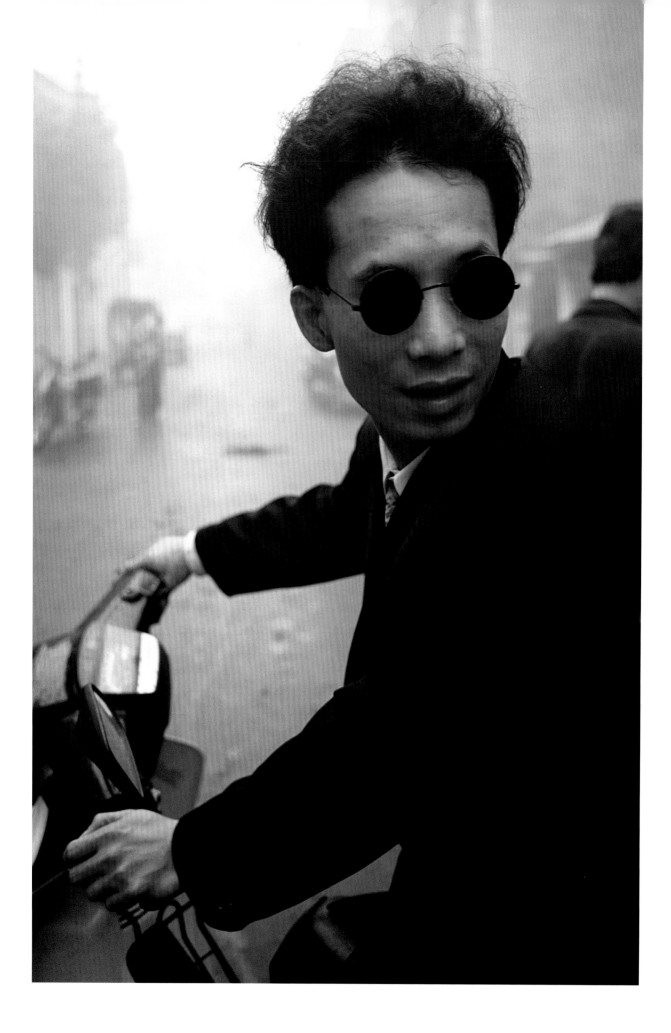

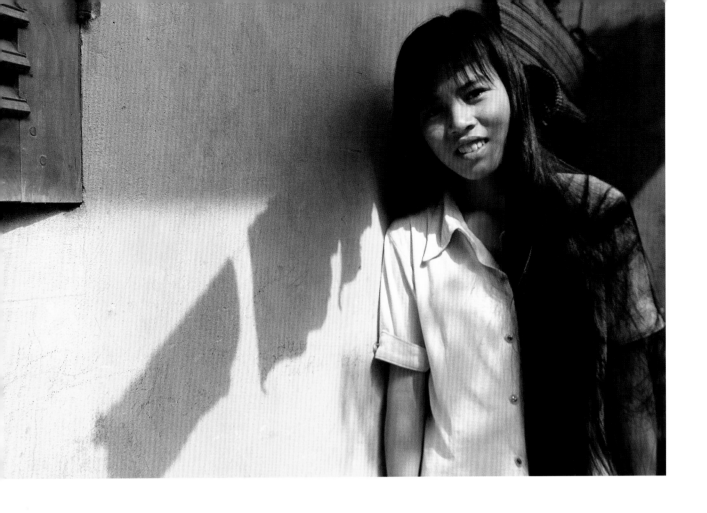

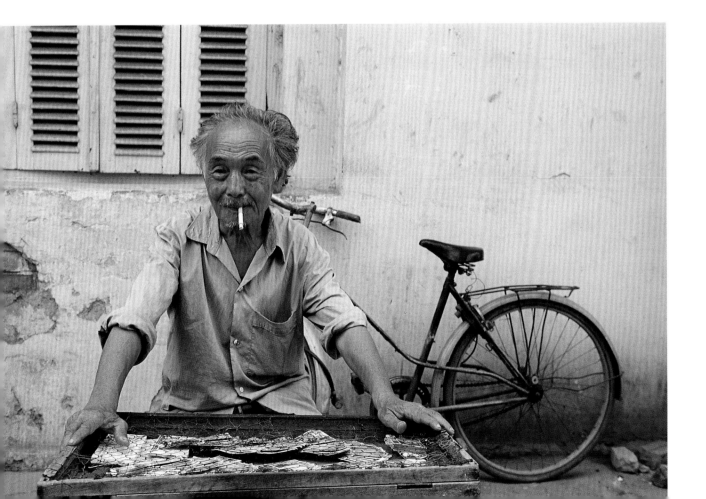

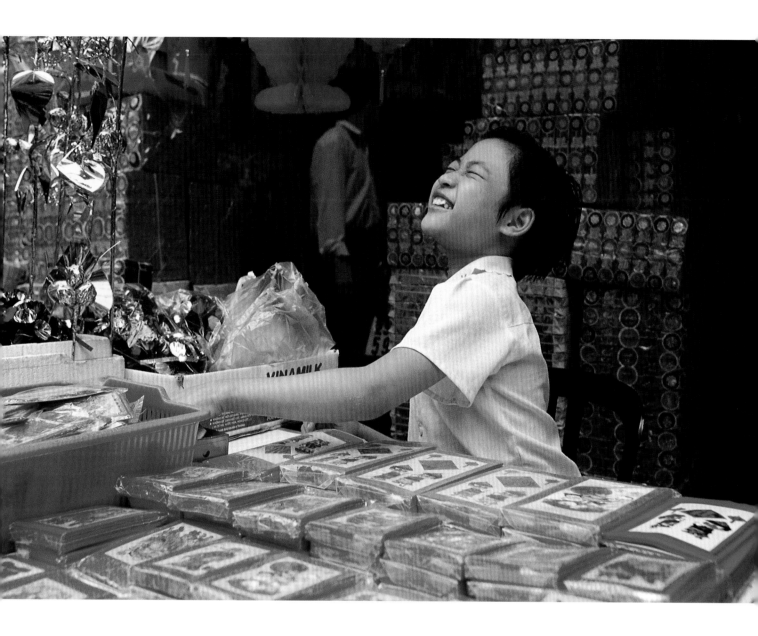

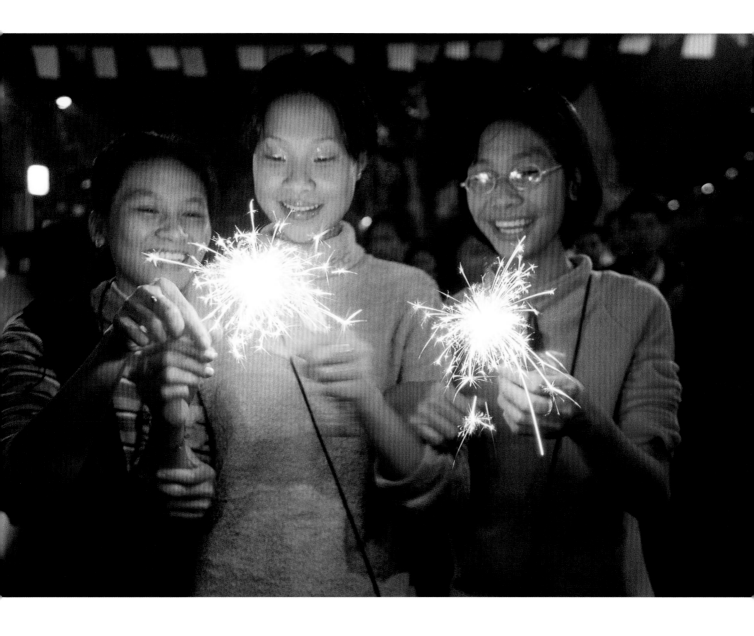

Spring dies, the hundred flowers scatter.
Spring is reborn, the hundred floweres bloom.
It is hard for me to see clearly,
Old age blinks my eyes.
Aren't flowers dead, once spring dies?
Last night, out there in the yard, a plum branch blossomed.

— "Rebirth." Man Giac, 19th century

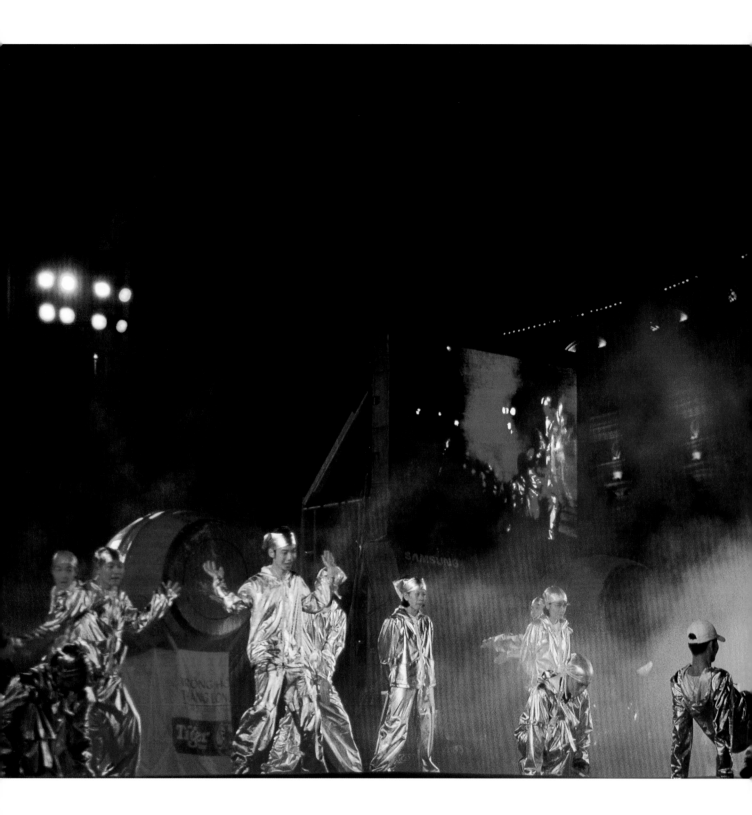

A gentle spring evening arrives,
airly, unclouded by worldly dust.

Three times the bell tolls echoes like a wave,
We see heaven upside-down in sad puddles.

Love's vast sea cannot be emptied.
And springs of grace flow easily everywhere.

Where is nirvana?
Nirvana is here, nine times out of ten.

— "Spring-Watching Pavilion."
Ho Xuan Huong, 19th century

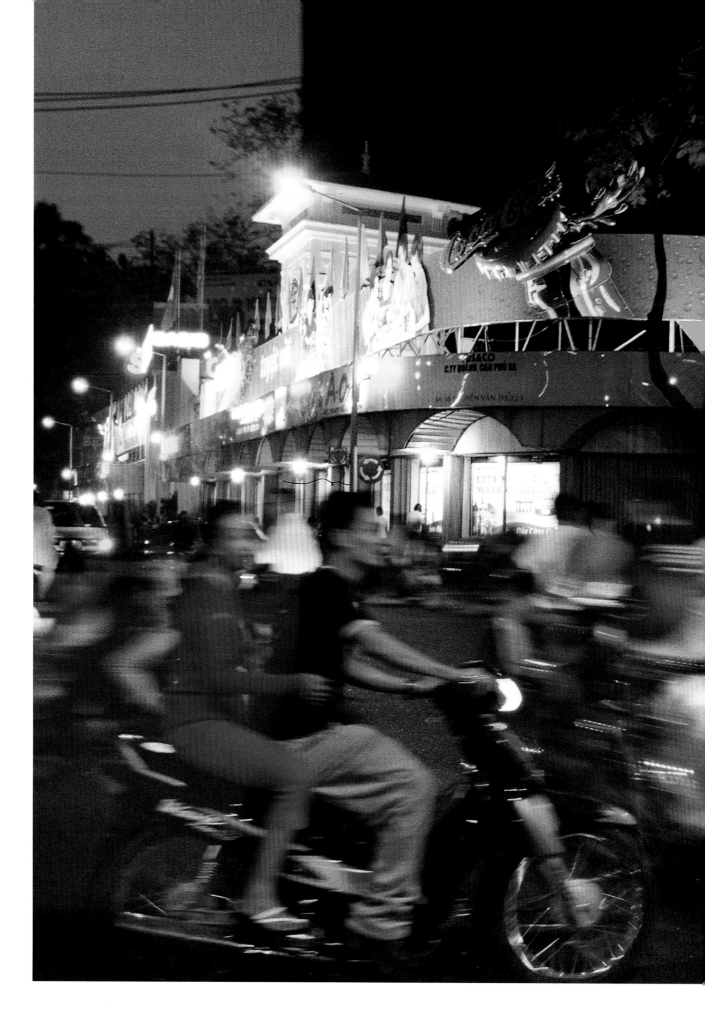

Selected Bibliography

Candee, Helen Churchill. *New Journeys in Old Asia: Indo-China, Siam, Java, Bali*. New York: Frederick A. Stokes Company, 1937.

Coates, Karen J. "One Tree at a Time." *International Wildlife* 32 (Jan./Feb. 2002): 36–42.

Endres, Kirsten W. "Local Dynamics of Renegotiating Ritual Space in Northern Vietnam: The Case of the Dinh." *Sojourn: Journal of Social Issues in Southeast Asia* 16 (April 2001): 70–102.

Greeley, Alexandra. "Pho: The Vietnamese Addiction." *Gastronomica* 2 (Winter 2002): 80–83.

Hantover, Jeffrey. "Contemporary Vietnamese Painting." *Uncorked Soul: Contemporary Art from Vietnam*. Hong Kong: Plum Blossoms (International) Ltd., 1991.

Haughton, Dominique, ed. *Health and Wealth in Vietnam: An Analysis of Household Living Standards*. Singapore: Institute of Southeast Asian Studies, 1999.

Kleinen, John. *Facing the Future, Reviving the Past: A Study of Social Change in a Northern Vietnamese Village*. Singapore: Institute of Southeast Asian Studies, 1999.

Nguyen, Du. *The Tale of Kieu*. Translated and annotated by Huynh Sanh Thong. New Haven: Yale University Press, 1983.

Nguyen, Duc Nghinh. "Markets and Villages: The Rural Markets (*cho lang*) of Northern Vietnam." *The Traditional Village in Vietnam*, edited by Phan Huy Le, et al. Hanoi: Gioi Publishers, 1993.

Nguyen, Thi Dieu. *The Mekong River and the Struggle for Indochina: Water, War and Peace*. Westport: Praeger, 1999.

Nguyen, Tu Chi. "The Traditional Nation and Village in Vietnam." *The Traditional Village in Vietnam*, edited by Phan Huy Le, et al. Hanoi: Gioi Publishers, 1993.

Osborne, Milton. "The Strategic Significance of the Mekong." *Contemporary Southeast Asia: A Journal of International and Strategic Affairs* 22 (December 2000): 429–445.

Pham, Van Bich. *The Vietnamese Family in Change: The Case of the Red River Delta*. Surrey: Curzon Press, 1999.

Sontag, Susan. *Trip to Hanoi*. New York: Straus and Giroux, 1968.

Sterling, Richard. *World Food: Vietnam*. Victoria: Lonely Planet Publications, 2000.

White, Peter T. "Hanoi: The Capital Today." *National Geographic* 176 (November 1989): 558–594.

Woodside, Alexander Barton. *Vietnam and the Chinese Model: A Comparative Study of Vietnamese and Chinese Government in the First Half of the Nineteenth Century.* Cambridge: Harvard University Press, 1988.

POETRY AND PROSE SOURCES

"Lullaby," "The Saigon River," and "Testing the Confucian Ideal" from *Vietnamese Folk Poetry,* edited and translated by John Balaban. Greensboro: Unicorn Press, 1974.

Paradise of the Blind by Duong Thu Huong, translated from the Vietamese by Phan Huy Duong and Nina McPherson. New York: William Morrow, 1993.

"Dusk" by Ho Chi Minh from *Prison Diary.* Hanoi: Foreign Languages Publishing House, 1972.

"The Condition of Women," "Questions for the Moon," and "Spring-Watching Pavilion" by Ho Xuan Huong from *Spring Essence: The Poetry of Ho Xuan Huong,* edited and translated by John Balaban. Port Townsend: Copper Canyon Press, 2000.

"House of Bamboo, Eaves with Plum Trees—Days Pass," by Nguyen Trai from *Heritage of Vietnamese Poetry,* edited and translated by Huynh Sanh Thong. New Haven: Yale University Press, 1979.

"Harvesting at Sunset" by Anh Tho, "Remembering the Past in the City of Soaring Dragons" by Lady Thanh Quan, "Beauty and the Poet" by Nam Tran, "Bamboo Hedgerow" by Nam Xuyen, "My Hair Has Thinned, My Teeth Have Worn Away" by Nguyen Binh Khiem, "The Ricksha Man" by Phan Van Hy, "The Country Road" by Te Hanh, and "Eight Views of Hsiao Hsiang" unattributed, from *An Anthology of Vietnamese Poems: From the Eleventh through the Twentieth Centuries,* edited by Huynh Sanh Thong. New Haven: Yale University Press, 1996.

The Ideal Retreat" by Khong Lo from *Selected Translations 1948–1968,* translated by W.S. Merwin. New York: Antheneum, 1968.

"Offering My Wife a Drink" and "A Song for Mother" by Nguyen Duy from *Distant Road: Selected Poems of Nguyen Duy,* translated by Kevin Bowen and Nguyen Ba Chung. Willimantic: Curbstone Press. 1999.

"Run River Run" by Nguyen Huy Thiep from *The General Retires and Other Stories,* translated from the Vietnamese with an Introduction by Greg Lockhart. Singapore: Oxford University Press, 1992.

"A Farmer's Calendar," "A Message," and "My Husband is Normal," folk poems; "Chrysanthemums" by Huyen Quang; and "To An Old Fisherman" and "The Rich Eat Three Full Meals" by Nguyen Binh Khiem from *A Thousand Years of Vietnamese Poetry,* edited by Nguyen Ngoc Bich, and translated by Nguyen Ngoc Bich with Burton Raffel and W.S. Merwin. New York: Knopf, 1975.

"Rebirth" by Man Giac from *From the Vietnamese: Ten Centuries of Poetry,* edited and translated by Burton Raffel. New York: October House, 1968.

Captions

JACKET AND FRONT MATTER

Jacket front, top Black Hmong woman returning from market, north Vietnam *Jacket front, bottom* Fisherman in a basket boat, north Vietnam *Jacket back, top* Rainy rice field in north Vietnam *Jacket back, bottom* A fruit stand in the Old Quarter of Hanoi City *ii* Building in Hoi An City *iii* Black Hmong woman returning from market, north Vietnam *iv–v* Street in Hoi An City *vi–vii* Rice fields and mountains in north Vietnam *vii–ix* Landscape in north Vietnam *x* The bicycle, an important mode of transportation, Hoi An City *xiv* Woman carrying rice seedlings, north Vietnam *xix* Two woman working in rice fields, south Vietnam *xx* Rice terracing in the mountains of Sapa, north Vietnam

A CLEAN PLAIN WORLD OF TOIL

3 Rice fields viewed from inside a home in north Vietnam 4 Flower Hmong woman working in the field, north Vietnam 7 Woman preparing *banh chung*, a special dish for Tet celebration, north Vietnam 8 Flower Hmong people at the Bac Ha market, north Vietnam 11 Boy getting a haircut by the side of the road 12 Woman cooking near Ho Tay lake, Hanoi City 15 Man resting in Ho Chi Minh City 16–17 Rainy rice field in north Vietnam 18 Woman working in muddy rice field, north Vietnam 19 Man ploughing with buffalo, north Vietnam 21 Women working in rice fields, north Vietnam 22–23 Woman working in rice field, south Vietnam 24 Black Hmong woman and her child finished working in the field, north Vietnam 25 White Hmong girls walking home from market, north Vietnam 26–27 Black Hmong girl taking her horse to market, north Vietnam 28 Woman finishes working in rice field, north

Vietnam 29 Red Yao woman and daughter carrying wood home, north Vietnam 30 Black Hmong girl wrapping hemp, Sapa, north Vietnam 31 Red Yao women embroidering cloth, Sapa, north Vietnam 32 Young Black Hmong girl riding buffalo to the field, north Vietnam 33 Boy carrying vegetables to the market, north Vietnam 34 Black Hmong girl walking home over a mountain, north Vietnam 35 Rice fields at sunrise, north Vietnam 36–37 Traffic in Ho Chi Minh City 38 Old soldiers riding in a cyclo, Hanoi City 39 Woman carrying fruit, Hanoi City *40 top* Chickens carried on a motorbike, Hanoi City *40 bottom* Woman shopping, Ho Chi Minh City 41 Young schoolgirl covering herself from the sun, Vinh Long City 42 Façade of a building in the Old Quarter, Hanoi 43

Fruit stand in the Old Quarter, Hanoi City *44–45*
Pho ga shop, Hanoi City

FISH SHINE IN THE CURRENT

46 Boats by the river outside Hanoi City *49* Fisherman throwing nets at sunrise, Cantho *50* Wooden boats at the harbor, outside Hanoi City *53* Families living on the boats, outside Hanoi City *54* Fishing nets on the Mekong River, Cantho *57 top* Selling melons at the early river market, Mekong Delta *57 bottom* Woman selling breakfast from her boat, Mekong Delta *58* Family living on their boat, Mekong River *60* Family inside their boat, Mekong River *61* Woman selling bread from her boat, Mekong River, Vietnam *62* Man fishing in his basket boat, Red River, Vietnam *63* Fisherman throwing his net, Vinh Long, Vietnam *64–65* Fish drying on the roof of a village in the Mekong Delta

66–67 Woman rowing to morning river market, Mekong Delta *68–69* Mother with her children on their river boat, Cantho *70* Woman rowing to river market, Cantho *71 top* Woman in her boat, Vinh Long *71 bottom* Sister and brother on their boat, Cantho *72* Girl leaning against a piling in the river, Mekong Delta *73* Boat coming down the Red River with bamboo lining the riverbanks, north Vietnam *74* Sapa, Sunset on the Mekong River *75* Boy rowing his grandmother home at sunset on the Mekong River *76–77* Woman pulling flowers from the river, Mekong Delta

LOYALTY, PIETY, LOVE

78 Flower Hmong girl dressing her sister, north Vietnam *81* Bride and groom in Ho Chi Minh City *82 top* Bride and groom at their wedding, Mekong Delta *82 bottom* Bride and groom paying their respects to their elders, Mekong Delta *85* Bride in south Vietnam *86 top* Mother and baby, south Vietnam *86 bottom* Father and baby, south Vietnam *89 top* Woman at her father's funeral, Ho Chi Minh City *89 bottom* Burning paper money as an ancestral offering during Tet, Perfume Pagoda, outside Hanoi *90* Woman at her father's funeral, Ho Chi Minh City *91* Funeral casket, Ho Chi Minh City *92* Grandmother and baby in their home, south Vietnam *93* Family doing their chores, north Vietnam *94 top* Old man, south Vietnam *94 bottom* Woman lighting her cigar, Hoi An *95* Old man living in Hoi An *96* Huge incense coils hanging in Phung Son Tu Pagoda, Cholon, Ho Chi Minh City *97* Monk at Bat Pagoda, near Soc Trang *98–99* Cao Dai Great Temple, Tay Ninh *100* People praying and making offerings during Tet, outside Tran Quoc Pagoda, Hanoi City *101 top* Community elders honoring the community tutelary god, My Duc *101 bottom* People praying in the Tran Quoc Pagoda, Hanoi City *102 top* Good luck coins for Tet hanging from shop fronts, Ho Chi Minh City *102 bottom* Villagers carry huge firecrackers for a festival now banned, Dong Ky *103*

DECENT DREAMS

BACK MATTER

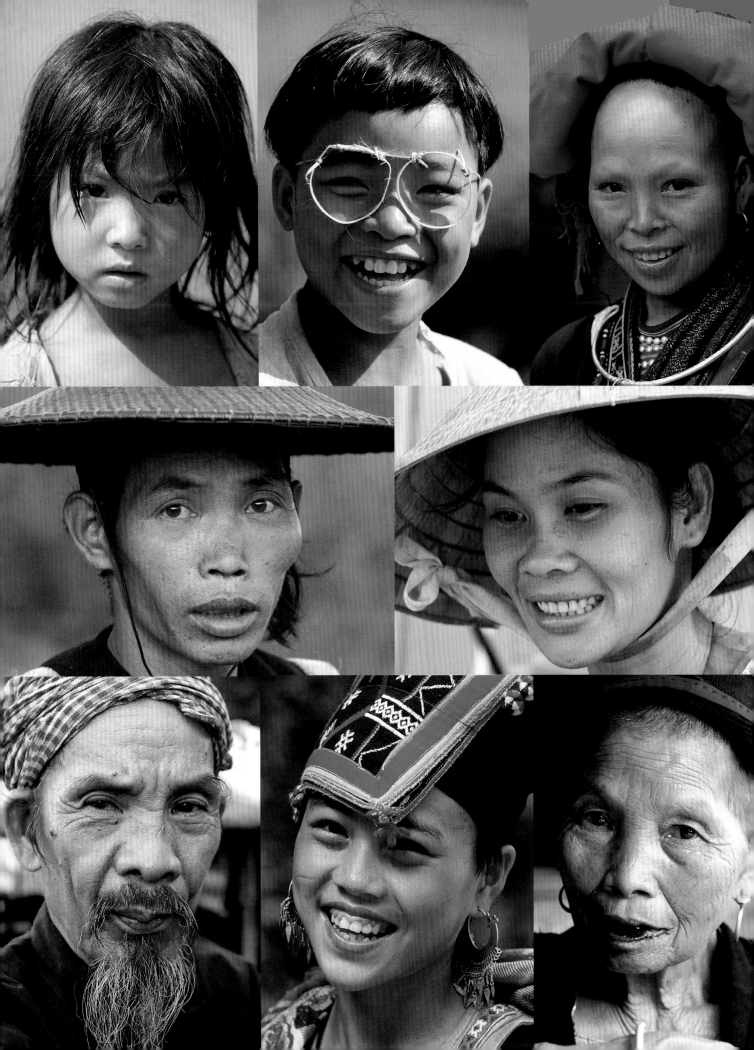

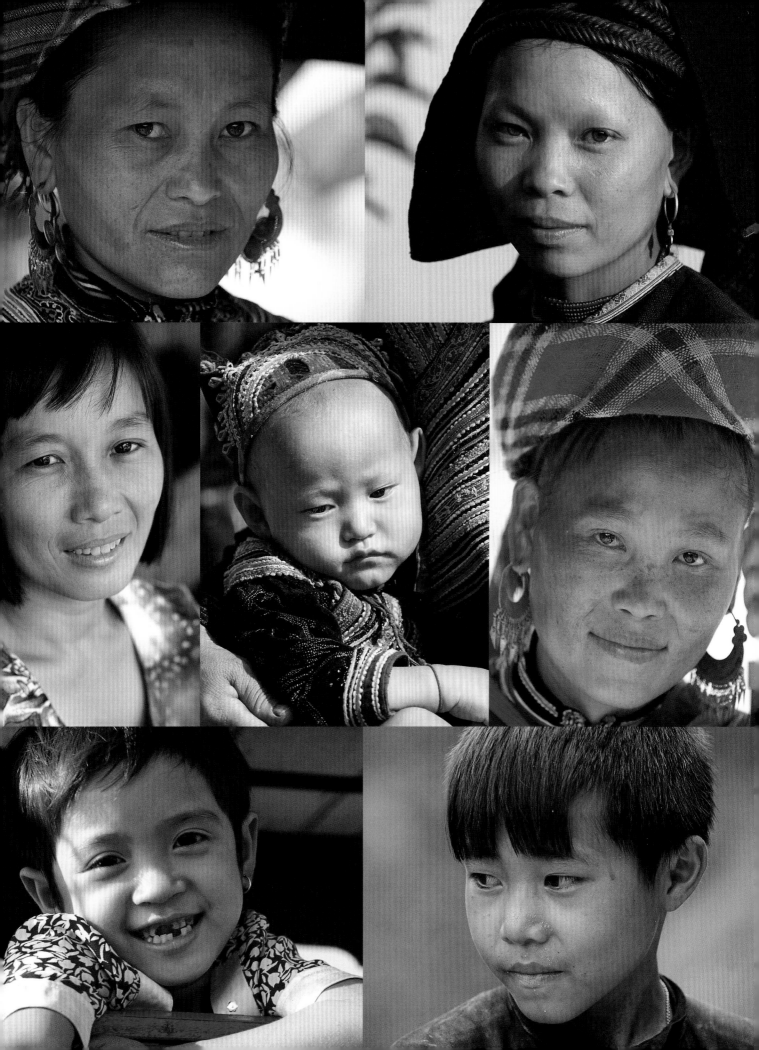

The "weathermark" identifies this book as a production of Weatherhill, Inc., publishers of fine books on Asia and the Pacific. Editorial supervision: Ray Furse. Book and cover design: Liz Trovato. Production supervision: Bill Rose. Printing and binding: Oceanic Graphic Printing, China. The typefaces used are Electra and Tiepolo.